German Romantics

DD66.C2(2)

Roger Cardinal

German Romantics
in Context

Studio Vista

Front cover Caspar David Friedrich *Chalk Cliffs at Ruegen* 1818–20
Back cover Caspar David Friedrich *The Wanderer above the Sea of Mist* 1810

Studio Vista
Cassell & Collier Macmillan Publishers Ltd
35 Red Lion Square, London WC1R 4SG

© Roger Cardinal 1975

Designed by Gillian Greenwood

ISBN 0 289 70484 7 (paperback)
ISBN 0 289 70382 4 (hardback)

Printed in Great Britain by
Fletcher & Son Ltd, Norwich

Contents

Foreword

Romanticism flourished in Germany in the period from about 1800 to 1830, after which it remained a dominant in German culture for at least another thirty years, ramifying in a way unparalleled in other countries: it is hard to conceive of an aspect of art or thought that it did not affect in one way or another. In literature it stimulated a proliferation of works – lyric poems, ballads, hymns, tales, historical novels, comedies, tragedies, aphorisms, essays, works of criticism, and a good deal of unpublished writing, such as diaries, notebooks and letters. In the visual arts, it restricted itself by and large to the impressive landscape painting of the Dresden school. Musically, it ranged between such contrasted forms as the *Lied* for single voice and piano, and the mammoth music-drama pioneered by Wagner. Within the spheres of thought and scientific research, Romantic influences were felt in metaphysics, moral philosophy, aesthetics, theology, psychology, parapsychology, political theory, sociology, education, the study of myth, medicine, zoology, botany, chemistry, optics, electro-magnetism, geology – the list seems endless.

To chart such an ocean within the limits of a small book is clearly a hopeless task. What I have done is to take a few selective soundings in what I feel to be sensitive areas, in the hope that this will give some encouragement to further navigation. The first chapter of the book is a highly condensed summary of the general features of Romanticism: the historical, social and cultural context that gave rise to the movement; the way in which it flourished as a constellation of groups in different towns; the imprint it has left on artists and thinkers of more recent times, within and beyond Germany. The second chapter evokes the poetic imagination, the central motor of Romantic creativity, and describes the characteristic patterns of Romantic thought and feeling. This synthesizing approach is then complemented by a sequence of studies of Romantic individuals. These have been chosen to represent a variety of spheres – literature, painting, music, philosophy, natural science – some figures being active in more than one of these.

A selective survey of this kind is bound to be unsatisfactory, not least to its compiler. There are many attractive writers I should have liked to discuss in detail, such as Moritz, Jean Paul, Kleist, Heine and Tieck. Among the thinkers and scientists, I regret not having had space to feature Baader, Schubert, Oken and Goethe (who despite being the very incarnation of

literary Classicism, was a Romantic in his scientific work). Of the composers, I have neglected Weber and Wagner in favour of Schumann. As far as general coverage of ideas is concerned, I am particularly aware of how little has been said on the subjects of medicine, religion, politics, love, the theatre and mythology. These exclusions are due to reasons too numerous to list; at best they are purely tactical ones (a given figure being omitted as being too similar to one included); at worst, ignorance and caprice are involved. Fragmentary and subjective the book certainly is, though I doubt that a short evocation of Romanticism can hope to be anything else. But perhaps incompleteness is after all permissible, under the Romantics' own rule that an organic whole, being a network of interdependent links and affinities, is unmistakably present in each of its parts? If this is so, there is hope that Romanticism may be recognizable even in its most fragmented image.

Roger Cardinal, Chartham Hatch, August 1973

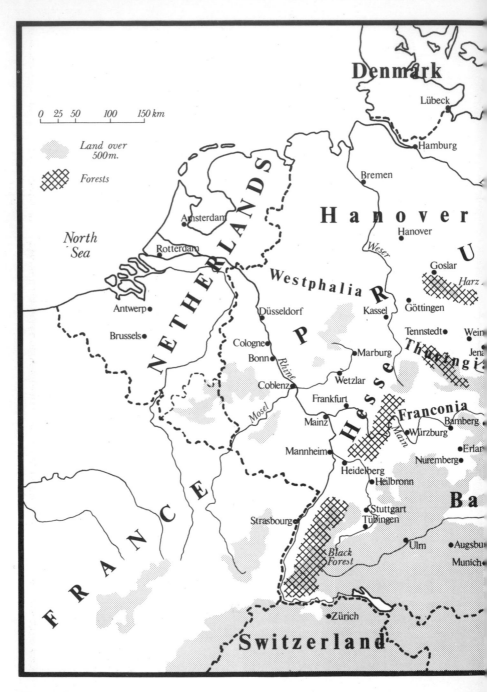

Romantic Germany

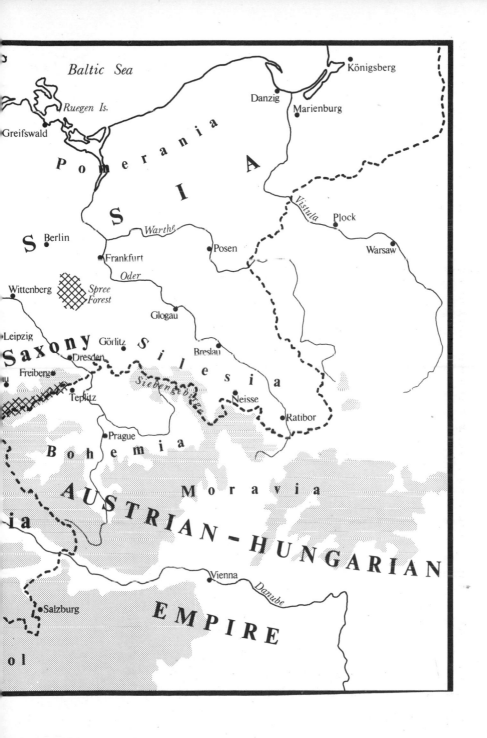

1 The Romantic Movement in Germany

The Context of Romanticism

The political context of Romanticism in Germany was coloured at first by enthusiasm for France, and later by feelings of revulsion. Enthusiasm was excited by the 1789 Revolution, which impressed most thinking minds in Germany as a marvellous promise of freedom. Germany was at that time a loose conglomeration of some 300 distinct territories, ranging from dwarf duchies to the giant states of Prussia and Austria, all of these adding up to a notional Holy Roman Empire led by Francis 1 of Austria. The scattering of energies, the lack of any cultural centre, the absence of any real sense of Germany as a nation, meant that Germans took the revolutionary events to the West as an announcement of an alternative society, unified and self-determining. Then, as the Revolution grew older, its face changed. The symbol of revolt against the rationalistic old order began to lose its attraction as the ideals of liberty, equality and fraternity were horrifyingly debased by the Terror. Even so, the rise of Napoleon and the subsequent wars of conquest directed against the southern German states were not in the first instance a signal for feelings of hostility towards French ideas: Napoleon was after all injecting decisive change into a stagnant situation, and for many German thinkers this raised hopes of establishing republican principles east of the Rhine. After scattering Austrian resistance at Ulm and Austerlitz, Napoleon set up the Confederation of the Rhine in 1806, grouping sixteen southern and western states of Germany under one administration and effectively abolishing the Holy Roman Empire. Bavaria and Westphalia were made into kingdoms in their own right, and generally the small territorial units were gathered into larger ones, in a significant step towards eventual unification of the country.

To the north, Prussia held back as a separate power and then, playing its hand too late, was brutally crushed at Jena and Auerstädt in 1806. The collapse of Germany's most proudly militarist state created a sense of demoralization that deepened as the occupation dragged on. If the French armies had been welcomed in some quarters as a liberation force, the domination of everyday life by foreigners speaking an alien tongue gradually

drew even revolutionary sympathizers into the growing mood of resistance. The disastrous failure of Napoleon's Russian campaign prompted German patriots to seize the chance of expelling him: there was a great rush to arms on all sides and, facing a determined coalition of different German states under Prussian leadership, Napoleon was defeated at Leipzig in 1813; his revival a hundred days later led only to his final rout at Waterloo. The patriots and freedom fighters settled back while the Congress of Vienna sorted out the chaotic map of Germany, expecting that there was a good chance that a united nation would emerge. But the Austrian chancellor Metternich saw to it that Austria retained control by engineering a German Confederation of thirty-nine states which was only nominally a single unit; its Diet at Frankfurt had no real power over the territories. Despite the promises the German princes had made that after the removal of Napoleon there would be reforms and the granting of a written constitution to guarantee civil rights, the position after 1815 speedily reverted to one of absolutism and stagnation. The Carlsbad Decrees of 1819, which clamped down on the *Burschenschaften* (the nationalist student leagues) and imposed rigorous censorship, effectively suppressed liberal hopes for a generation. Censorship deadens invention, and within Austria new ideas developed slowly, even in the comparatively relaxed atmosphere of Vienna. Prussia was somewhat less reactionary, though a period of reforms under Stein and Hardenberg was curtailed under pressure from the *Junkers*, the landed nobility. Despite censorship, Berlin became a lively centre of intellectual life. Elsewhere, the situation varied: some states, such as Saxe-Weimar, definitely encouraged culture, whereas others, such as Hanover, were repressive in the extreme.

Though there was a wave of popular uprisings all across Germany in 1848–9, these were ultimately inconclusive. No government fell, and few conceded reforms; many even tightened up their restraints. All in all, the political horizon was a very dismal one for the whole Romantic generation. The period certainly manifested some social unrest and the loosening of certain strictures: total provincial rigidity is not easily re-established after massive foreign armies have ridden through. But the individual's urge to expand his horizons, to bring about change, to participate in creative politics, was almost entirely stifled by a leadership that refused to countenance any real changes. The French example had stirred people's minds without offering them any outlet. They therefore turned to art, philosophy, metaphysics and scientific theory. If German patriotism were not politically viable, at least it could be so culturally. Romanticism sprang up within this context of physical constriction and enforced speculativeness: its adherents turned from the finite, immutable, real world of philistine conservatism to orient their thoughts in the one direction where progress was possible, that of the ideal and the infinite.

Already in the last decades of the eighteenth century hidden under-currents had begun to undermine the rationalistic rigidity of Enlightenment thought. There was a swing from orthodox religion to passionate mysticism; many Protestants were going ecstatically over to Catholicism. The ideas of the German mystic Jacob Boehme and the French theosophist Claude de Saint-Martin were revived, as men sublimated their yearning for a better world into a search for the spiritual harmony presumed to have existed on earth before the Fall. In the scientific field, empirical observation was being challenged by a speculative approach that Schelling in due course defined as Nature Philosophy. Poetic rather than scientific explanations of the physical world gained increasing currency, as, for example, Mesmer's notion of animal magnetism, a doctrine that posited a real connexion between the mind and the body; Lavater's ideas on physiognomy, based on the supposed analogy between an individual's face and his character; and Werner's Neptunian theory of geological creation, which was widely accepted because of its aesthetic appeal, despite its total lack of scientific foundation. In philosophy, Kant's meditations on mind and reality led him to the tentative suggestion that since to some degree it is our mental functions that create our knowledge of the external world, the conditions under which things appear as objective are in fact dependent on the subject. Though Kant's method was as rationalistic as could be wished, his ideas were cheerfully adapted by less imaginatively inhibited thinkers into a philosophy of subjectivity that offered a persuasive justification of fantasy. More deliberate opponents of the Enlightenment were Hamann and Herder. The former, known as the 'Magus of the North', rejected knowledge derived from reason in favour of the knowledge of the senses and the emotions. He sketched an analogy that the Romantics would eagerly develop, that between God's creation and the creation of the poet. The poet, argued Hamann, is a self-sufficient creator, just as God is himself a poet. A student of Hamann's, Herder worked out from these premises a whole theory of literature in which the primitive poetry manifested in traditional folk-song was characterized as the only true poetry, inasmuch as it alone springs spontaneously from the creative genius of a people.

Irrational commitment to primitive emotion is the keynote of the Storm and Stress movement in which Herder, the young Goethe and others were engaged in the 1770s. The movement stood for a dynamic, non-rational, enthusiastic approach to literature, and was in many ways a trial run for Romanticism. Goethe's early poems resemble folk-songs in their deliberate lack of sophistication; his medieval play *Götz von Berlichingen* (1773) is an almost uncontrolled explosion of shifting scenes and rich Shakespearian colour. The dramatist Lenz produced chaotic dramas that deny all conventional formalities, whether artistic or social. The poet Bürger brought out the prototype of all eerie ballads with his 'Lenore',

about a girl being borne off by the horseman of death to the sound of thundering hooves; and the young Friedrich Schiller made a passionate outcry against social corruption in his play *The Robbers* (*Die Räuber*), 1781.

Schiller's development into Classicism did not cause him to suppress the message of freedom in his plays, for the idealism of *Wallenstein* (1798–9), the moral heroism of *Maria Stuart* (1800) and the revolutionary spirit of *Wilhelm Tell* (1804), the story of the Swiss popular struggle for independence, are no less fiery in their impact for being expressed in austere and monumental form. Schiller met Goethe in 1794, and remained his partner in Weimar Classicism until he died in 1805. Goethe himself lived on for many more years, and was in touch with so many writers and artists that his form of Classicism was far from remaining inflexible and aloof. Though based on notions of harmony and perfection, it also recognized the principle of dynamic change, a principle to which Goethe was drawn by his researches into animal and plant life. In his eyes, the work of art had to be organically coherent, not just statuesque. Many of Goethe's later works exerted an influence on the Romantics such that it is difficult to dismiss them as entirely alien to Romantic concerns, even though their temper is rather sedate and cautious. The novel *Wilhelm Meister's Apprenticeship* (*Wilhelm Meisters Lehrjahre*), 1795–6, was particularly important to the Romantics; it offered a blueprint for the *Bildungsroman*, the novel of development, combining realistic and imaginary elements, that was flexible enough for the Romantics to use it again and again. The more moralizing *Elective Affinities* (*Die Wahlverwandschaften*), 1809, patiently developed the notion of correspondences between natural and moral laws, associating outer and inner reality in a way that appealed strongly to minds drawn to post-Kantian idealism and Nature Philosophy. Friedrich Hölderlin, though often labelled a 'Classical' poet on the strength of his passionate Hellenism, also had affinities with Romanticism, with his pantheistic vision of nature, and his celebration of the poet as prophet and visionary.

Other writers were even more obviously moving towards the subjective, imaginative mode that would be characteristic of Romanticism. Karl Philipp Moritz, a friend of Goethe's, was fascinated by dreams and memory, and wrote two remarkable novels, *Anton Reiser* (1785–90) and *Andreas Hartknopf* (1786), which place a quite Romantic stress on imagination and sensibility. The Bavarian writer Jean Paul (Jean Paul Richter), a rather retiring provincialist, participated in several Romantic ventures; his novels combine gentle mockery with amiable sentimentality in a mixture that is still too idyllic and restrictive to qualify unreservedly as Romantic, but which none the less drew admiration from his young contemporaries. Jean Paul's arabesque style of divagation, his musical prose, and in particular the unsettling way he introduces characters who are perfect twins

(*Siebenkäs*) or the idea of multiple selves and disguises, as in *Unfledged Years* (*Flegeljahre*), 1804–5, are important influences.

Before Romanticism finally emerged in Jena, there came an overture to announce its themes, in the form of a book by the young poet Wilhelm Heinrich Wackenroder. While on a tour of Franconia with his friend Ludwig Tieck, during which they visited old churches and medieval towns like Bamberg and Nuremberg, Wackenroder had experienced the 'revelation' of German medieval art, and, merging this with an enthusiasm for the Italian Renaissance, produced an influential book of aesthetico-religious outpourings, the *Effusions from the Heart of an Art-Loving Monk* (*Herzensergiessungen eines kunstliebenden Klosterbruders*), 1797. Based on researches but informed above all by emotion, the book portrays Wackenroder's heroes (Da Vinci, Raphael, Michelangelo, and Dürer, their German peer) and argues ecstatically that art is a form of religion. For Wackenroder, the artist communicates his experience of nature, which is both sensual and spiritual, to his fellow man, whose individual being is similarly a sensual and spiritual whole. The fictional musician Joseph Berglinger represents the introspective, ultra-sensitive nature of the artist; with his total submission to the rapturous experience of art, he announces a whole line of Romantic artist-figures, such as Hoffmann's Kreisler, who fail to reconcile the experience of art with normal life. After his friend's early death, Tieck published the papers he left under the title *Fantasies on Art* (*Phantasien über die Kunst*), 1799, inserting material of his own, and himself carried on the themes of medievalism and Italian yearning in another of the artist-novels of Romanticism, *Franz Sternbald's Wanderings* (*Franz Sternbalds Wanderungen*), 1798.

The Centres of Romanticism

It was Tieck who introduced Wackenroder's ideas on music and art into the Romantic circle at Jena, where he arrived in 1799. The mention of the place-name is a reminder that from now on the definition of the movement must take account not of figures in isolation, but of figures in vital and creative contact; to do this, one needs to survey the towns where contact was made and energies discharged. Berlin should be mentioned as the place where Tieck first met Wackenroder, but it is Jena that most deserves the name of birthplace of the Romantic school. For it was here that, in the space of a few years, a meeting of unique talents brought about the rapid and

spectacular definition of the movement. Some time before, Schiller had settled in Jena to teach history and to be close to Weimar and Goethe; Schiller's invitation to Friedrich Schlegel's brother August Wilhelm to come to Jena in 1795 and collaborate on his journal *Die Horen* probably decided Jena's role as the Romantic centre. For Friedrich, who was to be the chief animator and theoretician of the movement, followed his brother there in 1796. The Schlegels' house at once became the meeting-place for all the Romantics. Novalis appeared, renewing relations with Friedrich which had begun a few years before; the young physicist Ritter was there; Tieck soon came upon the scene; and the philosopher Fichte taught in Jena until 1799, after which his position was taken over by Schelling, another fervent member of the circle. August Wilhelm's wife Caroline and Friedrich's mistress Dorothea Veit completed the circle. Less intimate sympathizers in Jena at the time were the Nature Philosopher Lorenz Oken, who was Professor of Medicine, the young poet Clemens Brentano, and the budding Nature Philosophers Henrik Steffens and Ignatius Troxler, who were still students. Goethe himself maintained a benevolent neutrality in near-by Weimar, where he received visits from time to time. The collaboration of Schiller was unfortunately ruled out by Friedrich Schlegel's quarrel with him: in any case most of the group found him too serious, and a bit self-righteous.

Within a few months, the circle had established its own journal, the *Athenaeum*, the first issue of which came out in May 1798, a date which can usefully serve to pinpoint the establishment of an organized Romantic school. Its members were now active: Schlegel was writing the *Fragments* which gave Romanticism its proper theoretical foundation; his brother was producing his famous translations of Shakespeare; in 1798 Novalis had written the *Apprentices at Sais (Die Lehrlinge zu Sais)* and was at work on his symbolic novel *Heinrich von Ofterdingen* (both of which were published posthumously in 1802); Tieck was producing a string of stories and plays, and Schelling a fertile sequence of philosophical works; and most of them tried their hand at poetry. The members of the circle were also, in fact, engaged in other outside activities; in Novalis' case, for example, professional duties prevented his spending a lot of time in Jena. Yet there were important moments of collective activity, as when Friedrich, Dorothea, August Wilhelm, Caroline, Schelling, Novalis and even Fichte journeyed to Dresden together to see the pictures in the gallery there. The peak of the group's evolution was reached in the autumn of 1799 when all its members, including Tieck and Ritter, were able to spend several days together at the Schlegels' house, a period of emotional intimacy and intellectual intensity which was never to be surpassed. Soon a series of developments led to the dissolution of the group. Novalis died in 1801; August Wilhelm decided to leave for Berlin; Caroline divorced him to marry Schelling; Tieck went

II. Blüthenstaub.

Freunde, der Boden ist arm, wir müssen reichlichen Samen
Ausstreun, daß uns doch nur mäßige Erndten gedeihn.

Wir suchen überall das Unbedingte, und finden immer nur Dinge.

Die Bezeichnung durch Töne und Striche ist eine bewundernswürdige Abstrakzion. Vier Buchstaben bezeichnen mir Gott; einige Striche eine Million Dinge. Wie leicht wird hier die Handhabung des Universums, wie anschaulich die Konzentrizität der Geisterwelt! Die Sprachlehre ist die Dynamik des Geisterreichs. Ein Kommandowort bewegt Armeen; das Wort Freyheit Nazionen.

Der Weltstaat ist der Körper, den die schöne Welt, die gesellige Welt, beseelt. Er ist ihr nothwendiges Organ.

Novalis. The text of *Blüthenstaub* (*Pollen*) as it appeared in the first issue of the *Athenaeum*, May 1798

off to Rome; finally Friedrich and Dorothea left on a series of journeys which eventually led them to Paris. When Ritter moved to Munich in 1805, none of the original Jena circle was left.

Though Romanticism was growing concurrently in Berlin and Dresden, the initiative may be said to have next passed to Heidelberg, where Brentano arrived in 1804. Arnim, whom he knew from Göttingen, arrived the following year, and together they published a collection of folk-songs in a volume called *The Young Lad's Magic Horn* (*Des Knaben Wunderhorn*), thus

furthering the cause of popular art which Herder had initiated. Further efforts in a similar direction came from Joseph von Görres, who published his research on medieval chap-books in 1807. The three joined forces in 1808 to edit a short-lived but very lively publication called *The Hermits' Journal* (*Zeitung für Einsiedler*), which received contributions from all the major Romantics who had thus far declared themselves. The young poet Eichendorff, a student of Görres at this time, looked on enthusiastically, and it is worth noting that these were the years when the artist Carl Philipp Fohr was spending his childhood roaming the country around Heidelberg. The town itself has a beauty that has never ceased to attract Romantics.

Dresden has been mentioned as the cultural centre to which the Jena circle made a pilgrimage in 1798. It was in that year that the landscape painter Caspar David Friedrich settled there, and helped establish the city as the great centre of Romantic painting. His contemporary was the allegorical artist Philipp Otto Runge, who worked for years on a vast but never completed project, *The Times of Day* (*Die Tageszeiten*). Dresden Romanticism was perhaps at its most active in 1807–8, when the dramatist Heinrich von Kleist was there. He produced a historical play *Catherine of Heilbronn* (*Das Käthchen von Heilbronn*) in 1810, with a somnambulistic heroine born of

Dresden. A view of the city by moonlight by Johann Christian Claussen Dahl, 1839

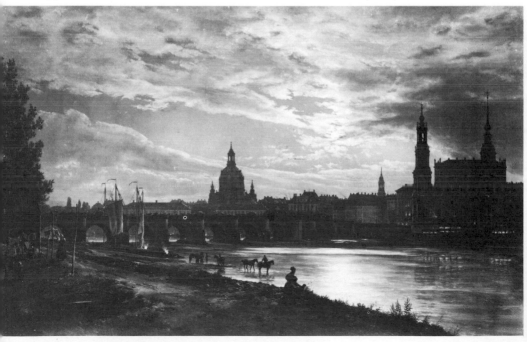

suggestions advanced by the curious lectures given by Gotthilf Heinrich Schubert on 'The Night-Side of the Natural Sciences'. Kleist knew Friedrich, who also attended the lectures, and it was in his studio that he read out some of his plays. Kleist was also editor of the art journal *Phoebus*, which he ran with his friend Adam Müller, a Catholic convert and author of a violently reactionary political book *Elements of Statecraft (Elemente der Staatskunst)*, 1810. There was a lull in cultural life during the French siege and occupation of Dresden, after which the doctor and artist Carl Gustav Carus arrived, and was befriended by Friedrich, who also knew the Norwegian painter Dahl and his pupil Oehme. In another field, the early Romantic composer Carl Maria Weber scored his first operatic success in Dresden with *Der Freischütz* in 1821, eclipsing the musical efforts of the less fortunate E. T. A. Hoffmann. As a Romantic centre, Dresden faded after the twenties, though Friedrich Schlegel chose to settle there in the last year of his life, as did the older Tieck. Schumann, however, found it very quiet when he moved there in 1844, though his friend Richard Wagner tried to inject life into the atmosphere with his opera *Tannhäuser* (1845) and, in the 1849 disturbances, by joining in the street fighting. The last survivor of the Romantic period was Carus, who lived on into the 1860s, publishing important syntheses of Romantic thought.

As the capital of the largest German state in the Confederation, Berlin was naturally always an attraction to young intellectuals, and during the Romantic period it saw the comings and goings of most of the Romantic poets. The earliest signs of collective activity were in 1797, when Friedrich Schlegel, in town on an extended visit, gathered a small circle around him. They included Tieck, who had several published works to his credit even then; the hostesses Rahel Levin and Henriette Herz, both renowned for their lively salons; Dorothea Veit and the young theologian Friedrich Schleiermacher, author of the emotionally-tinged *Speeches on Religion (Über die Religion. Reden an die Gebildeten unter ihren Verächtern)*, 1799. Some of the group met the young Hoffmann, who was tied to a legal job. Cultural activities lapsed, of course, under the occupation; then the philosopher Fichte, who had moved to Berlin from his post at Jena, delivered his famous *Addresses to the German Nation (Reden an die deutsche Nation)*, 1808, calling for a nationalist (and not merely Prussian) resistance to the French invader. Another campaigner for a united Germany was the poet Ernst Moritz Arndt, whose resistance songs were so successful that French agents pursued him into a Swedish exile. Then a new circle of writers was formed when Achim von Arnim joined with Kleist and Müller to form the Christian-German Dining Club, a consciously élitist political group which opposed internal reform and advocated resistance to Napoleon only in terms of strict loyalty to the Prussian fatherland. This particular group, in which aristocratic idealism and anti-semitism flourished, lasted till

Kleist's death in 1811, and Arnim's retirement to the country after the War of Liberation. In the post-war city, Hoffmann formed a rather less sinister group, a drinking club called the Brotherhood of Serapion, which included the fantasy writers Adalbert von Chamisso and Friedrich de la Motte Fouqué. Yet another period of Romantic activity may be regarded as opening in the thirties when Bettina von Arnim opened a political salon that attracted left-wing intellectuals and became an important centre for liberal agitation. One of the lessons of Berlin Romanticism is that it is hard to generalize about Romantic politics, for at least three tendencies can be distinguished within the above activities.

The list of Romantic centres of lesser importance than the four so far mentioned is by no means short, for the movement spread with great rapidity, eventually reaching almost every German cultural centre of note. In Leipzig, Novalis, Schlegel, G. H. Schubert, his friend Friedrich Gottlob Wetzel, thought to be the anonymous author of the bizarre *Night-Watches of Bonaventura* (*Die Nachtwachen des Bonaventura*), 1804, and Carus were all students at various times, though none stayed long. Only after Schumann

Leipzig. Anonymous drawing of the Neukirche quarter

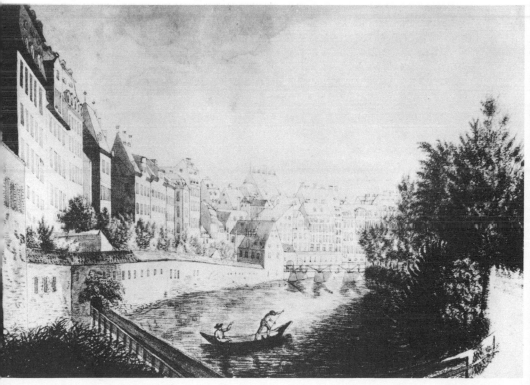

had settled here in 1830 and founded the League of David, laying down the challenge to the Philistines through the *New Journal of Music*, did the city become a centre for musical Romanticism. The lively university town of Halle saw several Romantics: Arnim, Tieck, Eichendorff, Schleiermacher and Steffens. At Giebichenstein outside Halle lived the musician Johann Friedrich Reichardt; his romantically-situated house, set high above the Saale beside a ruined castle, was for many years an elective site for Romantic visitors. Guests at different times included Novalis, Tieck, Schelling, Arnim, Bettina, Jean Paul, and Steffens, who married one of Reichardt's charming daughters. The university of Göttingen can claim to have taught several of the Romantics, notably the Schlegel brothers, Wackenroder and Tieck, Arnim and Brentano; Heinrich Heine completed his studies here, and lampooned the philistines of the town in a witty travel book, *The Harz Journey* (*Die Harzreise*), 1824. The word 'philistinism', however, is hardly strong enough to describe the events of 1837 that led to the expulsion of the Grimm brothers and five other professors from Göttingen when they protested against the King's violation of the constitution; troops had to be called in to pacify the students as the professors were escorted to the border. Freiberg was the home of a renowned mining institute, attended at different times by Baader, Novalis, Steffens and Schubert. The outstanding teacher there was the mineralogist Abraham Gottlob Werner, a Romantic among scientists, whose speculative geology (or 'geognosis' as he preferred to call it) is a striking case of pure intuition being brought to bear on one of the most down-to-earth sciences. Werner is the model for the portrait of the wise Master in Novalis' *The Apprentices at Sais*.

To the south, Munich was a place to which Romantics gravitated, especially in the later period; Ritter conducted research there at the Academy of Sciences; Schelling worked there for several years and held open house for friends; Bettina lived for a few years in Munich; the painter Fohr studied at the Academy of Arts; and Oken, Schubert, Görres and Baader were also active there. From about 1812 the Swabian town of Tübingen was the centre of Swabian Romanticism: the poet Gustav Schwab was a collector of local folklore; Ludwig Uhland wrote ballads and edited a folk-song anthology; and the young Wilhelm Hauff wrote fairy-tales and an historical novel, *Lichtenstein* (1826), a vivid panorama of the sixteenth-century Swabian wars. The last of the Swabians is Eduard Mörike, a late but major lyrical poet.

The Romantic importance of Vienna lies in two areas. The first is music, since Vienna was the mecca for a whole line of great composers, from Mozart through Schubert and Beethoven to Brahms and Bruckner, though it must be said that Schumann found the city very boring when he tried to settle there in 1838. The other Romantic function of the Austrian capital

was as the meeting-place of the Catholic group which Friedrich Schlegel established in 1820, with the conservative magazine *Concordia*. Members were Franz Xaver von Baader, a mystic steeped in Boehmian ideas; Adam Müller, who like Schlegel had offered his services to the Metternich government; and Zacharias Werner, author of highly rhetorical fate-tragedies, who was such an enthusiastic convert that he entered the Catholic priesthood so that he could preach sermons.

Further south lay Italy, where, in 1786, Goethe had made his famous journey which had opened his eyes to the organic structure of life. The persistence of the theme of the 'journey southwards' in Romantic literature testifies to the strength of the idea of Italy in the Romantic mind; interestingly enough, not many Romantics actually made the trip. One group certainly did, the band of painters known as the Nazarenes, led by Friedrich Overbeck and Franz Pforr. Inspired by Wackenroder's art-loving monk, they took over a monastery in Rome where they lived the life of simple Catholic craftsmen, painting pictures in the idiom of the Italian Pre-Raphaelites, often on subjects from German mythology. The younger artists, Julius Schnorr von Carolsfeld, Philipp Veit, and Fohr, were drawn to Rome by its growing reputation as a centre for German art.

Robert Schumann. Manuscript score of the song 'Du bist wie eine Blume'

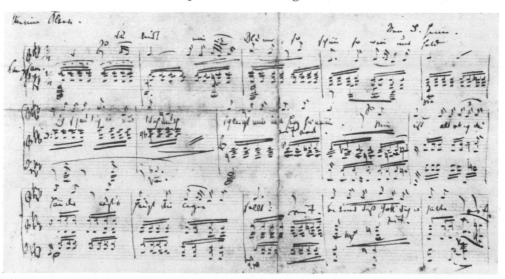

The only other foreign town of any importance to German Romanticism is Paris, where Friedrich Schlegel settled for a few years after the Jena period, publishing the magazine *Europa* (1803–5) and giving private tuition to the brothers Boisserée, who later became important collectors of old German art. Finally, there is the poet Heinrich Heine, who came to Paris to work as a journalist in exile from 1831 till his death in 1856. By that time the sophisticate-naïf of the *Book of Songs* (*Buch der Lieder*), 1827, was becoming more and more the joker and ironical divagator, following a path from what might be called 'pure' Romanticism to its later stage of disillusionment and self-ridicule. It was from a position of satirical detachment that Heine wrote *The Romantic School* (*Die Romantische Schule*), 1832, a cool, wry, teasing survey of the ideas and personalities of the movement, which may be said to round off the Romantic period proper.

The Legacy of Romanticism

So manifold and, again, so subterranean have been the influences exerted by Romanticism that an account of them must be advanced in a suggestive rather than dogmatic spirit. It is often impossible to know whether to speak of direct influences as distinct from affinities and echoes, and the further one moves away from the Romantic period itself, the more subjective one's impressions become. None the less, some indications as to its rich legacy ought to be hazarded.

Romantic painting had few significant repercussions, apart from the influence of the pious medievalism of the Nazarenes, which affected the work of book illustrators like Moritz von Schwind and Ludwig Richter, before degenerating into the genre scenes of the Biedermeier period. Interestingly enough, the slackening of visual intensity was compensated by the extraordinary rise of Romantic music, which of course the Romantics themselves, from Wackenroder on, insisted was the superior art form. It

was in Wagner that Romanticism achieved its musical apotheosis, for in his vast music-dramas, Wagner embraced all the Romantic preoccupations with medievalism, German myth, passionate love and the temptations of death and night, in a synthesis of the verbal, the musical and the visual media, the *Gesamtkunstwerk* or total art-work. The bringing-together of all these represents one of the artistic triumphs of Romanticism, although, for some, it also represents a tendency to emotional instability. To the non-Romantic, Wagner's *Tristan and Isolde* (1859) must inevitably suggest a dangerous wallowing in passion; though the Romantic would revel in such music, whose effect, ultimately an ultra-musical one, is to bear the listener over the line that separates actuality from ideality. In this, Romantic transcendence is most perfectly fulfilled.

The intended effect of Wagner's music, to coax human consciousness into surrendering to a kind of impersonal Nirvana, was a direct reflection of the theories of the philosopher Arthur Schopenhauer, who took the idealist view that material reality was nothing more than an illusory 'Representation' without solidity; while man was seen as being helplessly impelled by the vital instinct or non-rational 'Will'. His pessimistic viewpoint allowed for man to transcend the rule of Will only through allowing his individual self to be absorbed within the greater non-individuated state of Nirvana or oblivion. The notion of the eclipse of the individual consciousness in this way is both fascinating and menacing. The thinking of Friedrich Nietzsche was more robust. Like Schlegel, he began with a reappraisal of Greek culture, seeing therein an exemplary conflict between man's Apollonian, or shaping energies, and his Dionysiac, or instinctual urges. Nietzsche took up the idea of the Will, or vital energy, and proposed a cult of the Superman as the means of transcending the triviality and weakness of contemporary civilization. He did this in terms which unwittingly provided ready-made slogans for Prussian militarism and Nazism in the two world wars. Embroiled in this same ethic of irrationalism and heroism was the writer Ernst Jünger, an officer in the Wehrmacht. His mysterious novel *On the Marble Cliffs* (*Auf den Marmorklippen*), 1939, reads like an allegory of the conflicts between individualism and self-abnegation, aggression and pacifism. A direct link with Nature Philosophy may be traced in Jünger's collections of meditative fragments, such as *The Adventurous Heart* (*Das abenteuerliche Herz*), 1938: these analogical speculations read rather like Ritter or Novalis, and contain frequent allusions to botany, in which Jünger, like Goethe, was an expert. Romanticism leaves its mark on practically all poets in Germany up to and indeed including the Expressionists. It may be sensed in the Symbolists Stefan George and Hugo von Hofmannsthal; it affected novelists like the mystically-oriented Hermann Hesse, and the ironist Thomas Mann. The latter's obsession with Schopenhauer, Nietzsche and Wagner and the question of the moral and social

position of the creative artist shows the persistence of the cultural and aesthetic issues first raised by the Romantics.

In France, German Romanticism had little impact at first, despite the good intentions of Madame de Staël, whose *On Germany (De l'Allemagne)*, 1810, concentrated on Goethe and Schiller rather than the younger writers. Where the poets Nerval, Gautier, Hugo and Baudelaire are concerned, it seems less helpful to look for evidence of direct contact with German poetry than to attend to the affinities between the two sets of poets, affinities which are often explicable in terms of the powerful undercurrent of occultist ideas (Swedenborg, Saint-Martin, Boehme) which were affecting most continental Romantics. Baudelaire's picture of the world as a pattern of 'correspondences' whereby objects relate to the senses, each sense to each other sense (synaesthesia), finally each object to each other object, is one that is hardly foreign to Romantics like Hoffmann or Novalis. Later in the century, the French Symbolist writers were strongly affected by idealist thought originating in Fichte and Schelling, and by the music of Wagner, with its attempt to subsume all the arts within music – an attempt which Stéphane Mallarmé sought to outdo by submitting all arts, and indeed all reality, to the dominion of the poetic Word. In the twentieth century, affinities with the German Romantics may be observed in the works of the mystical Symbolist Maurice Maeterlinck (who translated Novalis' *Fragments*); of Marcel Proust, whose massive novel *In Quest of Lost Time (A la Recherche du Temps perdu)* is mainly concerned with the secret growth of an artist's sensibility, seen through the perspectives of inner consciousness; of Jean Giraudoux, who studied in Germany, and wrote ironic fantasies reminiscent of Jean Paul; and of the solitary Mauritian poet Malcolm de Chazal, whose aphorisms and fragments issue forth from the shadows of Romantic analogy to illuminate a mystique of sexuality. The principal heirs to German Romantic thought in France have been the Surrealists, their chief spokesman, André Breton, being an admirer of Arnim in particular. The surrealist theory of automatic writing, or transcription of messages from the unconscious, was more or less formulated in Ritter's theory of 'passive consciousness'. Breton's work as a whole is dominated by the Romantic image of reality as a system of signs which the poetic imagination alone can interpret and learn from. Most of Breton's writings bear eloquent witness to his faith in the inherent 'rightness' of poetic analogy, a faith that shines as strongly through the notebooks of Novalis.

The influence of German Romanticism in Russia and England was less strong. Of the Russian Germanophiles, most tended to respond to the example of Goethe, though Pushkin's tale *The Queen of Spades* (1834) is obviously in the Hoffmann lineage, and Turgenev's story *Asya* (1858), which is indeed set in Germany, represents a perfect late crystallization of the Romantic theme of *Sehnsucht* (yearning). The majority of English

Romantics were scarcely aware of what was going on in Germany, notable exceptions being Thomas De Quincey and Samuel Taylor Coleridge. The latter studied for a year at Göttingen, and read Kant, Schelling and Boehme. His writings on poetry, often in the form of fragments, show affinities with the German poets in their subtle exploitation of resemblances between natural and spiritual reality; and the concept of the organic imagination that became the keystone of Coleridge's critical theory derives from ideas advanced by Goethe and Schelling and transmitted through A. W. Schlegel. Another receptive figure was Thomas Carlyle, who wrote enthusiastic reviews of works by Novalis, Z. Werner, Jean Paul, Heine and Goethe. He also translated the *Wilhelm Meister* novels, published a critical anthology of extracts from Fouqué, Tieck, Hoffmann and Jean Paul under the title *German Romance* (1827), and wrote his own whimsical *Sartor Resartus* (1836) in the wayward manner of Heine. Finally, the German Nazarenes were an inspiration to the English Pre-Raphaelite Brotherhood. And their critical champion, John Ruskin, is something of a Nature Philosopher: in *Modern Painters* he applies the same scale of aesthetic values both to art and nature.

In the general area of investigation into the resources of the human mind, the several paths opened by German Romanticism have been well travelled. Carus' theory of the Unconscious was expanded by the philosopher Eduard von Hartmann, and the psychologist Carl Gustav Jung came very close to Carus in his theory of the collective unconscious. Freudian psychoanalysis was based on the Romantic premise that the individual personality, with its conscious and unconscious constituents, forms a total organism; Romantic research into hypnosis and dream symbolism may well be counted an anticipation of Freud's scientific work. Freud was fond of literary example, and his follower Otto Rank based his analysis of the Don Juan complex on a study of the theme of the lost shadow, which originates in Chamisso's *Peter Schlemihl* (1814) and has a long literary lineage. Whereas Romanticism gave a clear stimulus to the sciences of the mind, it is not surprising that Nature Philosophy should have been outstripped by the empirical exigencies of a developing industrial age. There is, however, a sense in which its principles have been revived in this century, inasmuch as the Romantic practice of looking at external phenomena as being in intimate relation to the observing mind is close to that of modern physicists in their approach to the atom. The more philosophical of these occasionally sound very much like Romantics when they suggest that the great insights into the nature of atomic structure were the fruit not of empirical observation, which was impossible, but of intellectual intuition, explicable in terms of an attunement of mental dynamics to the dynamics of matter.

Some sciences have benefited immensely from a Romantic incentive, in particular the disciplines of German philology and etymology, and the

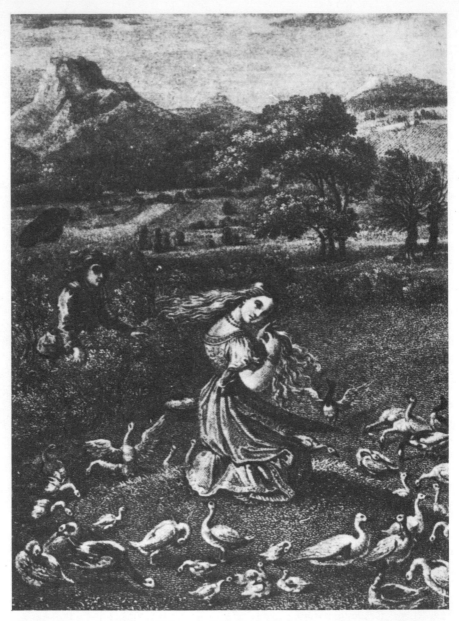

Illustration to the Grimm fairy-tale *The Goose Girl* engraved by L. E. Grimm

study of Germanic mythology, which were founded by Wilhelm and Jacob Grimm, the editors of the world-famous fairy-tale collection and of the great *German Dictionary* (*Deutsches Wörterbuch*), begun in 1854, the sixteenth and final volume being completed a century later. Where recognition of the *Volksseele* (the popular spirit) is concerned, Romanticism may be said to have been a strong contributing force in the emergence of a national consciousness and hence of the German political state in the latter part of the nineteenth century. Some may wish to trace a line from Romantic patriotism to Nazism, which took up Teutonic folk-myths, Wagnerian trappings and all, and pressed them into the service of a horrendous racialism. It must be granted that Romantic circles did contain right-wing extremists. Yet it could be argued that the demand for national self-affirmation is something of a perversion of Romanticism's original demand for the self-affirmation of the individual, echoing French Revolutionary principles. Since the true logic of Romanticism lies in the reconciliation of polarities, the authentic aim of Romantic politics should be to preserve individual freedom while pursuing collective aims.

The rest of this book examines Romanticism in the light of the paradox that it was at once a collective and an individualistic phenomenon. The following chapter deals with Romantic ideas on the assumption that a consensus of thought can be identified, almost as though it were the thought of a single mind. This assumption is then balanced by its antithesis, that Romantic figures should be investigated as separate and specific cases. Should correspondences of thought and temperament then emerge, this will suggest quite spontaneously that the movement was an intellectual democracy in which individual ideas were exchanged and developed organically within a circle of elective affinities.

2 The Romantic Imagination

The Darkness of Yearning

Romanticism is rooted in a sense of the rift between the actual and the ideal. Its starting-point is the desire for something other than what is immediately available, a desire for an alternative which will completely reverse that which is. Thus the Romantic may turn from the disappointments of the present to seek solace in dreams of the past: the Europe of medieval Christendom, of the Crusades, of Renaissance art, offers a wide scope. An alternative dream is that of a future Golden Age when men will live in perfect harmony with their surroundings. These dreams of another and better time run parallel to the dream of another place. This can be an irrecoverable site of childhood, as in Eichendorff's dream of the castle in the forest where he was born, or exotic lands, the Orient, Italy. Often such dreams are associated with a desire for direct primitive relationships with the material world and especially nature, such as simple folk – shepherds, peasants – are deemed to enjoy; or again, the dream will be of great heights that leave present limitations far below, a dream represented in the lofty crags of Friedrich's mountain scenes, where wanderers gaze out into infinity.

The longing to pass beyond the bounds of the immediate may be envisaged in its social dimension: for all his heightened sense of individuality the Romantic longs to expand his being into a community. The manifestations of this desire are many: the circles, the Brotherhoods, the collective publications, the value placed on intellectual friendships. Even where broader political views diverge, Romantics are agreed on the basic principle that some means of healing the rift between men must be sought. But all these are symptoms of a *malaise* which is not psychological or social, but metaphysical. The Romantic faces a reality which is chaotic, fragmented, without meaning. He cannot accept the explanations of rationalism, for they seem to censor authenticity and amputate feeling, reducing man and the world to a mechanism. Yet he does not know, at least not at first, what sort of explanations would be acceptable. Certain signals alert him to the possibility of meaning: certain moods, certain places, certain words induce a state of absorption and contemplation which seems to give a promise of release from constriction. In a celebrated passage from his

28

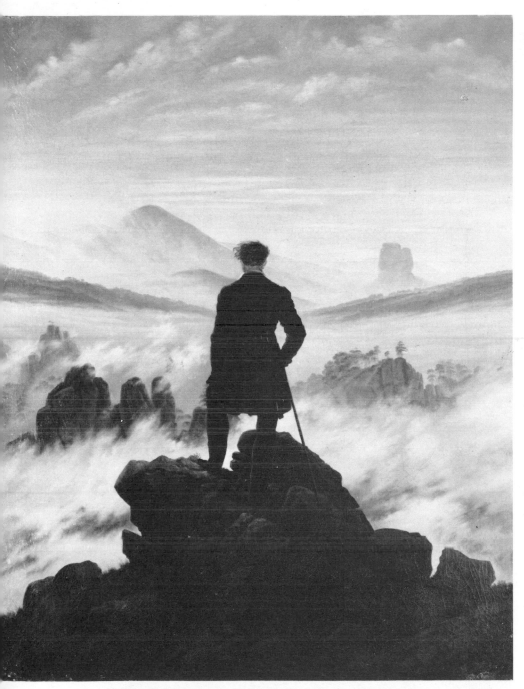

Caspar David Friedrich *The Wanderer above the Sea of Mist* 1810

Critique of Practical Reason (*Kritik der praktischen Vernunft*), 1788, Kant speaks of looking up at the night sky and feeling a dual awe before on the one hand the infinity of starry space, and on the other the moral law within himself. As Alexander Gode-von Aesch has suggested, much Romantic thinking could be taken as a gloss on this passage, which identifies the two extremes which Romantic yearning seeks to reconcile – the infinity of external reality and the infinity of the human soul.

Night is the dark realm in which desires cohere. It is on the other side from daily life, and its association with dreams and unconscious activity makes of it a mythical alternative to rationalism. The myth of Night encourages Romantics to revel in things secretive, dark and hidden, even though they may have little inkling of their import. In Romantic tales of the fantastic, a phantom reality is laid over normal appearances, creating a

Caspar David Friedrich *Man and Woman gazing at the Moon* 1819

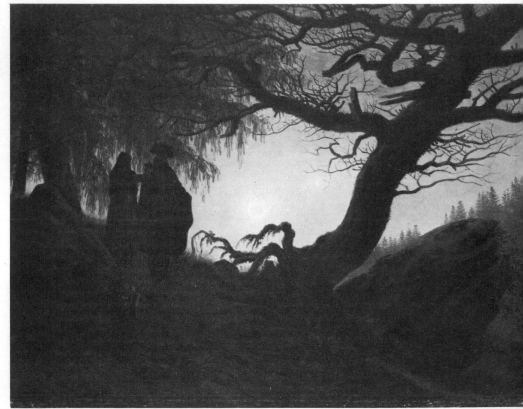

Woodcut illustration to Chamisso's story *Peter Schlemihl* by A. Menzel

shadow world in which witches, alluring sprites, automata that seem to have independent life, animals that speak, can have their being under conditions that suspend disbelief. Night is the privileged realm of uncertainty rendered absolute, and as such it allows the Romantic to do away with all the rules that govern the causality of waking life. In the masquerades of Jean Paul and Hoffmann, the mask becomes a revolutionary symbol of the disruption of the established order. What by day may be a yearning to expand the self into a community may by night take the aberrant form of a longing to expand through multiplication. At parties Hoffmann used to amuse himself by looking through a crystal glass and imagining that the people about him, duplicated many times, were all doubles of himself. In a sense, the theme of the double is implicit in the very idea of one's being aware of oneself, for this means seeing oneself as an object while remaining the subject: the Romantic myth of the *Doppelgänger* makes the separation real, in a frightening way. Chamisso's character Peter Schlemihl focuses these fascinations and these fears, for he is the man who has no shadow. He feels incomplete, the victim of an inner rift.

The feeling of incompleteness is a very real encouragement to dwell in the shadows. The Romantic pursues the being who can complete him, invents a mysterious woman with golden hair and green eyes, who tempts him deeper into the darkness, leading him into the depths of forests, beside uncanny silent lakes, even underground. In Tieck's tale *The Runic Mountain* (*Der Runenberg*), 1804, a demonic queen reveals to the young hero Christian the existence of a treasure hidden within the mountain; again, in Hoffmann's *The Mines at Falun* (*Die Bergwerke zu Falun*), 1819, the descent

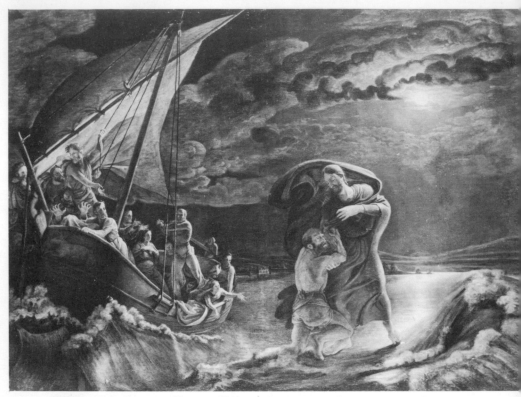

Philipp Otto Runge *Christ walking on the water* 1806–7

into a mine in search of precious stones carries the symbolic meaning of a descent into the secret resources of the personality in search of completeness. At the deepest level, the Romantic begins to sound the note caught most movingly in Novalis' *Hymns to Night* (*Hymnen an die Nacht*), 1800, where fearful awe modulates into tremulous joy as the dreamer enters the very womb of Nature and bathes in the matrix of Being. For the imagination of Night leads finally to an image of primeval fluidity such as the geognost Werner held to be the source from which the material world had derived. It is symbolically appropriate that a yearning for re-absorption in the maternal womb of Night should be associated with water, that Kleist, for example, should have chosen to shoot himself and Henriette Vogel beside the Wannsee, and that the poetess Caroline von Günderode should have killed herself at night beside the Rhine. Yearning for death is the ultimate stage of abandonment to the nocturnal; yet in the Romantic dream, it need not represent extinction. Rather, death is evaluated as a positive experience, a passage from an incomplete to a universal consciousness. After the death of his bride Sophie, Novalis came to long for Death as a means of reunion

and of entry into the greater love of Christ, a commingling of identities which strikes powerful erotic and religious chords.

But Novalis did not pass over so soon into the land of Death; and the Romantic probe into darkness and mystery need not culminate with a renunciation of the self. It is true that many Romantics sought to heal the rift by surrendering their individuality in forms of religious mysticism. Yet it can be argued that the true metaphysics of Romanticism allows for an initiation into the mysteries of Night that does not necessarily entail the abolition of the sense of self nor departure from this life. It is as though deep in the subterranean depths there glows an other-worldly light which the Romantic can carry back with him to the surface and which then allows him to view terrestrial reality with new eyes. This daytime reality can, after all, be changed, rather than abolished or relinquished. One of Novalis' fairy-tales is about a young seeker after truth called Hyazinth, who leaves Rosenblüte, whom he loves, in order to seek Isis, the goddess of Truth. He pursues her across land and sea until, many years later, he arrives at her temple, enters, and lifts the veil which covers her – as he does this, Rosen-blüte herself falls forward into his arms. The tale is an allegory on the paradox of Romantic yearning. The ultimate object of yearning is not necessarily at a distance in time or space: distance may be an illusion of the person who yearns. The Romantic suggestion is that longing is not quenched through external effort but through internal maturation. The Romantic initiate learns that, as Tieck once remarked, 'Utopia often lies right at our feet'.

The Lifting of the Veil

The solution is clear. There exist in man desires which prompt him to reject present conditions. But what he must come to understand is that the final control over those conditions is in fact inside himself. The horizon that cuts him off from his Golden Age lies within. It is only faulty perception which makes reality appear so fragmented and confused; the illumination of Romantic wisdom will permit the initiate to apprehend the world and himself as a harmonious continuum.

Such is the wisdom taught at the temple of Isis at Sais, in Novalis' unfinished novel *The Apprentices at Sais*, in which the wise old Master has his pupils collect stones, shells and leaves in order to enquire into the underlying patterns of Nature. The Master is an expert in perceiving connexions: 'He knows how to bring together the features that have been

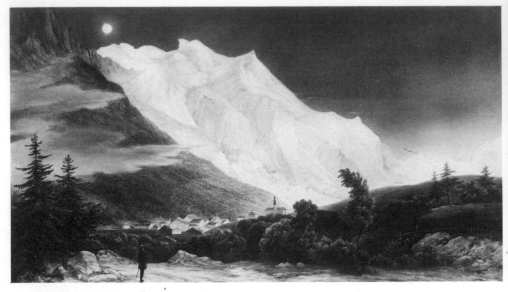

Schnorr von Carolsfeld *The Mont Blanc seen from Chamonix* c. 1848

scattered.' He is able to discern Nature's true physiognomy because he does not see individual objects in isolation, but rather as a pattern of features adding up to a total face. His teaching, derived from the doctrines of Jacob Boehme, presents the world as a vast system of 'signatures' through which all physical reality is offered as a text that man may read. Picking up several recent scientific discoveries as he does so, Novalis gives a marvellous exposition of Romantic Nature Philosophy on the first page of *Sais*, referring to 'that marvellous secret writing that one finds everywhere, upon wings, egg-shells, in clouds, in snow, crystals and the structure of stones, on water when it freezes, on the inside and the outside of mountains, of plants, of animals, of human beings, in the constellations of the sky, on pieces of pitch or glass when touched or rubbed, in iron filings grouped about a magnet, and in the strange conjunctures of chance.' What the apprentices must learn is how to decipher this cryptic writing. This, according to Novalis, was the supreme art; and Schelling's Nature Philosophy was an invitation to scientists to translate phenomena into coherent meaning by elucidating, as it were, the deeper syntax beneath the confused calligraphy of the surface.

The Romantic universe is conceived in the same terms within which Goethe worked when he attempted to unravel the complexity of Nature and to demonstrate that its protean forms in fact derive from a small number of primary shapes. All plants, for example, and all parts of indi-

vidual plants, are so many permutations of the one primal figure, the leaf. The same relation of congruence between the part and the whole operates in Romantic cosmogony. It is as though the macrocosm were composed of an infinite number of perfect microcosms, each constituent in a relation of exact affinity to each other part, and each also to the whole; this is what Ritter meant when he said that 'Each raindrop is a world.' Furthermore, the Romantics try to bear in mind that the universe cannot be reduced to a static model, since it is a dynamic *process* in ceaseless flux. Our image of the universe must then be one of musical variations on a consistent ground-theme, variations that press rhythmically forward in constant renewal. Nature thus conceived embodies a purposive force within its every particle – a 'World Soul', as Schelling called it – which advances towards an ultimate goal, the transition of all physicality on to the plane of spirituality. This is to say that the Romantic sees Nature as a universal motion which passes from the inorganic, up through the organic realm, to reach the spiritual realm of consciousness. Nature, seen as divine being in gross form, transcends itself by being apprehended within man's consciousness. It should be noted that man is in turn expected to transcend *his* physical being and advance to the higher plane of total spirituality, reintegrating himself in the divine consciousness, or Absolute; Carus for one states the point categorically, and most Romantics would probably want to endorse it. However, even if they do believe in this final transition into the divine, many Romantics do tend to linger over the prior stage, where man, as its highest constituent, is granted authority over all creation. For at this stage, man is at the top of a hierarchy, all Nature being an ascent into his consciousness. Anthropocentrism, or the attribution of a central role to man in the universe, is a highly seductive idea, as is evident from Ritter's exclamation: 'The earth exists for man's sake. The earth is but man's organ, his physical body. The earth is man!' Here, the Romantic arrogates to himself the powers of the divine creator. He has declared a marvellous situation whereby external reality is seen as straining to reflect itself within his mind. When Schelling can say that 'the system of Nature is equally the system of our mind', man's imagination becomes the precondition for Nature to be at all. From this it is only a step to saying that the relation between the self and the world is not merely one of affinity, but one of *identity*. The microcosm and the macrocosm then become one. What lies without is the same as what lies within. The idea is expressed in a note to the *Sais* drafts that offers an interesting variant on the symbol of the lifting of the veil:

> One was successful – he lifted the veil of the goddess at Sais.
> But what did he see? He saw – marvel of marvels – himself.

What Novalis is suggesting here is that truth is perfect subjectivity. Given

such a situation of intimacy with the world, man's exploration of Nature need not be directed outward. What use is there in journeying to the ends of the earth, when the universe lies within? If yearning is a painful expansion of the individual being, the pain is stilled and the inner space is filled by the certainty of containing all horizons within that being. The infinity of Nature is matched by the infinity of the human soul, in an exact identification of Kant's two objects of wonder. Reintegration is now complete: the sense of rift is triumphantly overcome.

Magic Idealism

The realization of the identity of mind and world at first prompts an inward-turning posture, an exploration of self in lieu of an exploration of the world. But if there is truly an equivalence of outer and inner reality, the movement must be reciprocal. 'The first step is to look within, to contemplate our self uniquely,' Novalis admits. But he goes on: 'But he who remains at this stage will only have come halfway. The second step must be to project your look outwards, in a spontaneous and sustained contemplation of the external world.' The doctrine thus asks for interior reflection to be complemented by exterior projection; logically, either form of cognition will lead to the same goal, self and Nature being indivisible halves of an integral whole.

In this way the Romantic scientist posits the ideal conditions under which Nature should be investigated; he rejects the damaging one-sidedness of empirical analysis, which to him is no more than a classification of dead bits of Nature showing no respect for its living spirit. The Romantic scientist is a practitioner of Nature Philosophy, which means that at the same time as he studies things, he studies the mind. His techniques of speculation combine observation with meditation, awareness of outer with awareness of inner processes. These are rather special modes of cognition, and they can take various forms, moving between the poles of total lucidity and total extinction of consciousness. Ritter speaks of a condition of 'passive consciousness', a trance-state associated with hypnosis. Wackenroder describes the experience of listening to music as one of rapturous insight in which aesthetic and religious ecstasy are combined. Hoffmann's musician Kreisler speaks of the moments just before sleep, when he sinks into such a magical state of receptivity to sense-impressions that colours, sounds and scents seem to merge into one, like a 'concert' of rays of light. The people in Friedrich's paintings seem to be rapt in contemplation, as

though re-enacting the processes of spiritual vision of which the artist himself speaks. Intuition becomes one of the most important modes of discovery in Romanticism; it functions as a sophisticated receptivity to signals that spring forth from the instinctual depths of the mind, as though the adult's reason were making sense of the innocent remarks of the child within him. At all times, the Romantic places the associative logic of the dream before the pedestrian logic of ordinary thought. 'All thinking is a divining,' wrote Schlegel, 'but man is only just beginning to realize his own divinatory powers'. Love gives another stimulus to a deep reading of Nature's text; the loved one emits a paradisial light in which all things are seen to connect in congruent relations. 'My beloved is an abbreviation of the universe,' declares Novalis, 'the universe a magnification of my beloved.'

All these modes of awareness may be summarized as being manifestations of the one universal sense, Imagination. Perfectly attuned to all aspects of physical reality by virtue of the reciprocity between self and world, Imagination is the sense which replaces all others, being hearing, seeing, feeling and thinking all at once. In learning to respond to what Baader termed the *analogia entis* – the reciprocity of all Being – the student at Sais had finally to realize that he was being trained to be not a scientist, a philosopher, a poet or an artist, but all of these at once.

Nor is this the end of his course of studies, for Novalis sketched further lessons in his notebooks, confirming that the poet is a seer and a kind of priest, but also introducing the new idea of the poet as magician. The concept arises naturally from the proposition that Nature is an objective creation of what Fichte called the 'productive imagination': it is a vast 'thought' perceptible to the senses as to the mind, and depends finally upon the sole imagination of the poet. As he turns from self-cognition to a cognition directed outwards at the world which surrounds him, the poet assumes the status of an all-powerful magus whose transhuman will determines the way things shall be. The extreme formulation of Novalis' ideas about the creative autonomy of the artist-scientist is his theory of Magic Idealism, a theory which, though peculiar to Novalis in the particular expectations he placed on it, may serve as a paradigm of the Romantic conception of imagination. In Novalis' view, the poet is a magician at the centre of a world which lies beneath his sway. Ignoring the question of his own absorption within the Absolute, the Magic Idealist affirms his personal right to control the traffic between the material and the ideal. He has the authority to voice the magic word which can make the world burst into song: that song is, so to speak, his own Orphic composition, so that he is both composer and conductor.

The task of the Magic Idealist, as Novalis tells us, is to effect a *Potenzierung* (an involution, a raising-to-a-higher-power, an intensification) of

reality. 'The world must be romanticized. In this way we will rediscover its original meaning. Romanticization is simply a qualitative involution. . . . When I confer a higher meaning upon the commonplace, a secret aspect upon the ordinary, the dignity of the unknown upon what is familiar, or an appearance of infinity upon the finite, I romanticize it.' To Novalis' poetic genius, the world of things is not alien and rigid, but malleable to the mind. Nature may appear to be 'petrified', as though under a spell, but the poetic word will release it and propel it into change. Magic Idealism is thus a process of transmutation, a kind of alchemical enrichment of the world. And because the relation between spirit and matter is so intimate, the operation can be considered to be twofold, on the one hand involving the translation of external objects into thoughts, and on the other, the projection of thoughts into tangible form.

Like most forms of magic this two-way process of translation is dependent on the creative power of language. The word 'translation' is extremely apt in this context, and indeed our understanding of Magic Idealism will depend on our appreciating how willing the Romantic is to set his faith in language as the prime agency in all dealings between consciousness and reality. Where the apprentices at Sais had learnt to read Nature as a poetic text, the Magic Idealist advances to the insight that the relations between things and thoughts become perceptible for those who have learnt that *all reality behaves in exactly the same way as poetic language*. In this sense, to speak the language of poetry is to speak the language of Nature. From the magician's point of view, to speak is not simply to voice abstract concepts, but to create literal forms out of figures of speech. Poetic utterance is after all a medium of heightened expression which seeks to give maximum reality to metaphors: the Magic Idealist is saying that metaphors become literal truth when uttered by the true poet.

Such notions are an invitation to limitless utterance, for if the poet's language is the language in which Nature conducts all its business, anything the poet happens to say will necessarily correspond to some aspect of natural truth. By wielding what Novalis calls 'the magic wand of analogy', the poet can expect that what he says about a thing can be transferred from its original context to any other and still be appropriate in some way. So flexible a medium is this magical language that it can in Novalis' hands effect wonderful transformations: he turns people into stars and clouds into plants, and so on. When Heinrich von Ofterdingen at last manages to find the blue flower, symbolizing his attainment of full poetic wisdom, the moment is described in the dizziest sort of imagery: 'He plucks the blue flower and becomes a ringing tree, a stone.' The figure of speech is delivered in a matter-of-fact way. We ought to take it quite literally. The poet turns into a tree *because* he has become the centre of a world whose every part turns in accordance with his will.

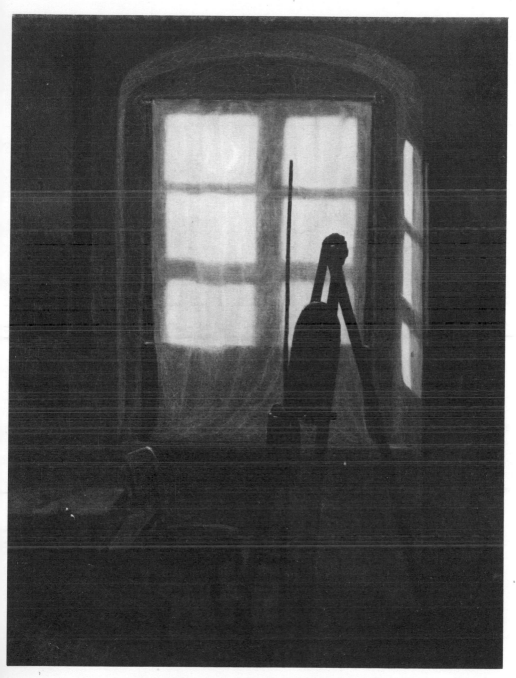

Carl Gustav Carus *Studio by Moonlight* 1826

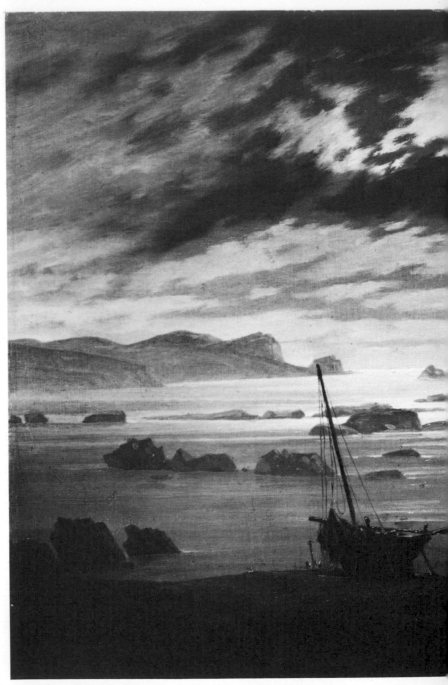

Caspar David Friedrich *Northern Sea in the Moonlight* c. 1823

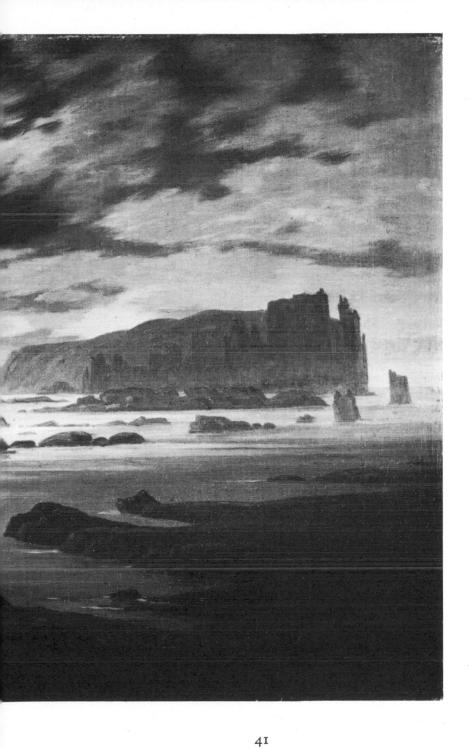

The Representation of the Infinite

In expressing these secrets, the Romantic may often use a disarming frankness of style. It may be imagined that the truly naïve listener will have no trouble in responding directly, whereas the more sophisticated listener will listen to a simple lyric by Eichendorff, for instance, and feel uneasy with the explanation that the literal level of meaning is all that needs attention. In other words, when Eichendorff says 'a song lies sleeping in all things,' or when Novalis says that Heinrich 'plucks the blue flower and becomes a ringing tree,' we can either take the statements as being literally true, or retreat to the position where we concede that their meaning must be figurative (always assuming we do not use the negative escape-route of rejecting these statements as wilful nonsense). In a sense, both responses are valid, or rather they are valid in conjunction, in the same way that the Romantic artist uttering the naïve statement does so with a considerable degree of sophistication. The problem is one of finding a balance between the direct and the roundabout, the explicit and the implicit, and it may well be that we ought to try to hold in our minds the notion that literal and figurative meanings must be reciprocal.

If, however, the literal meaning is hard to swallow, what can be said about figurative processes in Romantic expression? When the Romantic artist turns to his creative medium, he is trying to fix insights that spring from deep within the imagination. In expressing these, he will in a sense be expressing the mystery of creativity itself. For whatever his subject, material or spiritual, it inevitably tells us something about the Romantic imagination, either in the fact that it is moulded by that imagination, or in the way that it is so moulded. But there is a less tautological way of showing that Romantic figuration is about creative figuration, and we may begin with this proposition: that the Romantic artist is trying to represent reality as it is registered by a mind which sees all earthly forms in transition towards transcendence. From this it follows that what the artist must be doing is to depict transitions, to record an appearance of reality that will contain something 'extra' over and above that appearance – an 'aura', if you like. The act of expression then becomes equivalent to the act of lifting a veil upon the visible so as to uncover the invisible. But to achieve this revelation, the artist must begin with the repertoire of objects provided in this world, transmuting them into symbols or mirrors of the higher truth.

Goethe formulates a basic Romantic tenet when he says (in a text on meteorology!) that 'truth, which is identical with the divine, may never be

42

witnessed directly; we perceive it only as reflected in the particular example, the symbol.' Symbolic language thus becomes the prime medium of Romantic art, and ranges from the simple allegorical schemes of Runge's paintings to complicated symbolic structures, as, for instance, in the tale of Atlantis told in Novalis' *Ofterdingen*, which is highly abstruse. Where mysterious symbolism is concerned, it is often tempting to explain its obscurity as an artistic indulgence; but perhaps it is the case that some things cannot be reduced to simple terms. Sometimes there is evidence of a deliberate search for secrecy, for example in the musical ciphers used by Schumann. There is a high degree of gnomic density in the aphorisms of Schlegel, who once compared the Romantic fragment to a hedgehog rolled into a ball and thus, presumably, antagonistic to elucidation. Techniques of obscurity are often attempts to articulate glimpses of the infinite where direct vision is occluded. A truth which can only be seen out of the corner of the eye is not to be captured in static form. The astonishing number of unfinished Romantic works bears witness not to laziness or lack of imagination, but to the intrinsic nature of their subject-matter. An elusive prey may be better pursued by wild shots in the dark than by elaborate traps.

Buoyancy and vitality are characteristics of the best Romantic works. When in the full flight of invention, Schumann can spin melodic arguments that respond flexibly to the rhythmic pulse in an artless yet infinitely intricate manner. The most striking feature of Schlegel's thinking is his gift for illuminating paradox. His ideas often take the form of deliberate logical contradictions, as when he has his character Julius say to Lucinde, 'Only in yearning do we find rest,' or when he refers to the 'chaotic form' of a novel. Indeed Romantic thought positively revels in the tension created by uniting opposites, and often points out the parallel between this mode of thinking and the processes of organic life. Is not nature itself a system of interdependent polarities – day and night, life and death, attraction and repulsion, change and permanence, expansion and contraction? To think in opposites is as meaningful a way of attuning oneself to life as is breathing in and out. The simultaneous validity of conflicting ideas is indeed the very systole and diastole of Romantic truth. The plurality of the singular, the unicity of the plural; the macrocosm within the microcosm, the microcosm within the macrocosm; consciousness and unconsciousness, night and day – all these contraries meet in a kind of mystical marriage. Such notions may prove stumbling-blocks for those who need rational explanations; but thinking in opposites is the only reasonable way of approaching truths which dart in two directions at once.

The ultimate medium of Romantic art is music. Above all other arts, it is able to express forces in conflict, to externalize inwardness, to articulate the infinite and the invisible, and to describe emotions beyond the range of poetry and painting. In its capacity to manipulate directly what Novalis

43

calls the 'acoustics of the soul', music transcends the problem of literalness and figuration. It achieves the paradoxical result of being non-specific, of never telling us what it is talking about, yet of communicating to perfection. 'Music speaks the most general language, affecting the soul in a free and totally undetermined way,' writes Schumann. 'And yet the soul feels as though it were in its homeland.' The explanation, in Romantic terms, is that this most spiritual of arts can achieve what the other arts can only strive towards, namely, the effect of *simultaneous translation* from the secret language of Nature. It is the perfect poetry, at once representation and meaning, symbol and sense. If in the final analysis Romantic art is the rendering of Nature's symbols in the form of artistic symbols, then music emerges as its most 'natural' medium, based as it is on the very same principles of correspondence and harmony that sustain the fabric of Nature itself.

3 German Romantics

Friedrich Schlegel

HANOVER 1772–DRESDEN 1829

Though he provided the decisive definition of Romanticism in its earliest days, Friedrich Schlegel himself resists clear definition. More poet than philosopher, more critic than poet, he directed his considerable range of intellectual skills towards engendering a stream of ideas which effectively hide their generator. Subtle to a fault and addicted to paradox and aphoristic shorthand, Schlegel developed his thoughts with a shrewd sense of the importance of maintaining mobility and keeping conflicting ideas in play. In an age where thinkers were becoming more and more obsessed with the making of systems, Schlegel's system was to have no system. For thought *could* have no definitive form, he believed; since its goals were infinite it could not hope to function as an ordered discipline. This is why Schlegel did not stand for long upon the positions he himself advanced, lest his formulations became stones in a rigid edifice; rather, he treated them as stepping-stones across the restless flux of contradictions and multiple possibilities that is truth. In his view, the infinite lay not at the end of a sequence of careful logical steps, but could only be divined by way of a 'system of fragments', a scatter of meteoric insights which shoot across the mental firmament to illuminate something like the ghost of a system, the factor of unity in a context of chaotic variety. Schlegel's typical thought processes are an experiment in fragmentation and anarchy which seeks to provoke meaning to show itself. A typical Romantic in his tendency to start projects but never to complete them, Schlegel's life is a succession of moments on a curve that takes him from chaos towards form – although that final form, Catholic conservatism, is a disappointing conclusion when assessed in proportion to the preceding effort.

Karl Wilhelm Friedrich Schlegel came from a literary family, and his elder brother August Wilhelm Schlegel himself became a critic and translator of international distinction. Friedrich began his student career by reading Law at Göttingen in 1790, but soon gave himself up to literary studies, devouring books with unsystematic passion, as though trying to assimilate in a year or two the education of a decade. The authors he read

included Herder, Kant, Hemsterhuis, Winckelmann, Dante, Shakespeare and Goethe. In 1791 he moved to Leipzig to study ancient languages, but soon slipped into a period of dissolution, running up enormous gambling debts and becoming involved in unsatisfactory sexual affairs. The intensity of his intellectual energy seems to have burst the containment of his social personality, while his erotic yearnings could find no release in a context of bourgeois respectability. The crisis was nearing a suicidal extreme when August Wilhelm took a hand, paid off some of the debts and persuaded his brother to settle down to a fixed programme of study. The process of stabilization was further advanced by the presence of Caroline Böhmer, whom August Wilhelm was also helping. Caroline had become pregnant after a brief liaison with a French officer during the occupation of Mainz, and had been imprisoned for a time as a Republican agitator. August Wilhelm had been able to secure her release, and find her a safe place to stay in the country outside Leipzig, where he asked Friedrich to watch over her. Caroline's sympathetic and lively personality was to influence the whole circle of writers which grew up around the Schlegels in Jena, where she and August Wilhelm moved on their marriage in 1796.

Friedrich had resolved to establish himself as an independent writer, and, moving to Dresden away from his debts, he launched on a programme of study which encompassed most aspects of ancient Greek culture. Brimming with ambition, he sought to achieve in the literary field what the art historian Winckelmann had done in the field of the plastic arts – to write a brilliant and authoritative work on the Greek example. His essay *On the Study of Greek Poetry* (*Über das Studium der griechischen Poesie*), written in 1795, is a work full of energy and almost fanatical enthusiasm. Though writing about literature, Schlegel brings out the ethical and social aspects of Greek culture, holding up the Classics as models for social harmony. The Greeks, he argues, achieved a remarkable integration of Nature and Culture, reconciling instinctive vigour with the need for cultural unity. His own being seething with conflicting aspirations, Schlegel focuses his yearnings on an idealized, noble Greece, a homogeneous society where artists and poets, in total liberty, developed works of a supra-individual, collective type which, being the embodiment of a shared ideal of beauty, constituted the mirror of the ideal society. Schlegel's classical ideal finds its perfect example in Sophocles, whose tragedies integrate both the Dionysiac mode of impulse and instinct and the Apollonian mode of perfection and form.

Schlegel goes on in this essay to contrast the perfection of Greek art with the art of modern times, about which he begins by speaking disparagingly: the lack of integration in modern society forces its artists to become subjectivist outsiders who can only achieve short-term solutions to idiosyncratic problems, thus never producing an art worthy of social attention and acclaim. The modern writer is too caught up in his own sub-

Friedrich Schlegel. Chalk
drawing by Caroline Rehberg
c. 1790

jectivity; he is capricious, mannered, fantastic, anarchic. As the represen-
tative of this modern type, Schlegel cites Shakespeare, whose *Hamlet* is
the classic expression of the subjectivist dilemma. But somewhere along
the line Schlegel's praise of the Greeks merges into enthusiasm for works
like *Hamlet*, with whose hero he so clearly identified. Thus, in criticizing
the modern or 'interested' style, he argued himself into an interest and an
involvement he had not intended.

Similar ideas were being separately formulated at about this time by
Schiller, whose essay *On Naïve and Sentimental Poetry (Über naive und senti-
mentalische Dichtung)*, 1795–6, distinguishes the 'naïve' poetry of the Greeks,
which has a natural vigour which leads to perfect beauty in its own right,
and is free of authorial idiosyncrasy, and the 'sentimental' poetry of the
moderns, who are no longer in touch with nature yet yearn for it, who are
introspective, self-analytical, and unable to dissociate themselves from
what they create. Schlegel was impressed by the closeness of his findings to
those of Schiller, though he was soon to find the latter's approach to
aesthetic and moral issues far too solemn for any fruitful contact to develop,
despite the fact that both were living in Jena by 1796. Goethe, on the other
hand, remained the object of Schlegel's veneration, above all as author of
Wilhelm Meister's Apprenticeship (1795), which seemed to offer the most
viable lessons for the literature of the new age, in its effort to channel
subjectivism into objective values.

Emerging from his Greek dream, Schlegel began to exercise his critical talent on recent literature; his aim was to read the whole of a writer's output and then, from a position of sensitive omniscience, to 'reconstruct, apprehend and characterize' the writer's thought in all its subtlety. This precise delineation of insights gained from empathy and intuition, 'characterization', as Schlegel called it, established him as one of Germany's leading literary critics. Though Jena was eminently attractive, Schlegel now decided to move to Berlin, as a regular contributor to the literary review *Lyceum*, in which appeared in 1797 the first selection of 'fragments' from his notebooks. The fragment, or short aphoristic text ranging from a phrase to a paragraph, was Schlegel's favourite form of expression at this time. It allowed him to communicate his typical flashes of insight while avoiding the tiresome elaboration of normal prose argument. Good fragments were produced not by reasoning, but by the faculty of wit or 'fragmentary genius'. The virtue of the fragment was that it simply affirmed, scorning proof. In this first selection were notes on a concept which was to affect much of Schlegel's subsequent work, that of Romantic irony. Schlegel held that meaningful fragments could only be formulated by a daring mind which was prepared to combine two apparently antagonistic qualities, enthusiasm and detachment. At one point he advocates ironic distance as the prerequisite for any accurate expression of ideas: sheer enthusiasm is not the mode conducive to proper expression. An author must somehow remain disengaged if he is to maintain his freedom – by which Schlegel means his creative freedom. In Schlegel's post-Fichtian model of the poetic mind persists the notion that the artist is the creator of a personal world within which fantasy reigns supreme. Irony is not merely restricted to non-involvement, but represents the solution to the central conflict of the Romantic writer, the conflict between the Ideal and the Real, between 'the absolute and the relative, between the impossibility of and the necessity for total communication'. Because the Romantic is trying to express ideas of great magnitude, like 'the infinite' or 'the absolute', he cannot help but feel inadequate. He has therefore to adopt a strategy of ironic self-transcendence to overcome the paralysing anxiety about failure. Paradox, self-parody, the very confession of inadequacy, these provide means to bridge the gulf between impetuous inspiration and the destructive recognition of its shortcomings; irony is a mediating principle between what the artist would like to say and what he actually can say. The serious game proposed by Schlegel is nothing more than a method of turning chaos to account so as to ensure that the possibility of eventual order is always kept open. The act of self-reflection which is implied – the stance whereby the artist becomes his own audience, applauding or deriding his own antics – announces the uneven gesturings of Schlegel's own Romantic works, of which none could be said finally to be closed and ordered.

At all moments his 'educated caprice', his coolness-within-enthusiasm operates to ensure that his statements are taken both comically and utterly seriously. He is both silly *and* sophisticated, and his apparent shallowness conceals a great depth.

In Berlin Schlegel shared an apartment with the theologian Schleiermacher, and made the acquaintance of other writers at the literary gatherings of the attractive Henriette Herz. Here he met Rahel Levin, one of the most progressive and cultured women of her time, and Ludwig Tieck, the author of several published novels. Schlegel became accepted as leader of this little group. He also met Dorothea Veit, a married woman, with whom he began a love affair which was to scandalize society when Schlegel

Illustration to an episode in *Lucinde* by Friedrich Schlegel

depicted it in his novel *Lucinde* (1799). Since the author's love life was being publicly exhibited, it was only to be expected that the book would earn a reputation in those prudish times as the novel of free love and a manifesto of obscenity; in fact its message is not to advocate promiscuity, but to outline a philosophy of true love whereby genuine elective attachment between man and woman is distinguished from bourgeois marriage, which is mere legalized coupling. There are some highly emotive passages, in particular a lyrical dialogue in which the lovers Julius and Lucinde discuss the erotic appeal of Night as the source both of yearning and of peace: the lovers aspire to eternal Night as the place of ultimate consummation, the theme of love perfected by death which henceforth was to become a hallmark of Romanticism. Formally, the novel lives up to Schlegel's theories, being a highly fragmented patchwork of letters, dialogue, comment, allegorical tale and a tongue-in-cheek 'Hymn to Sloth'. The narrator, a law unto himself, keeps on stepping elegantly on stage like the ringmaster of his own circus, creating while being manifestly aware of creating, in a double act which combines the activity of projection with that of reflection.

In May 1798 the brothers Schlegel, dissatisfied with collaborating in other people's reviews, founded their own journal, the *Athenaeum*, written exclusively by themselves and their friends. Its brave short run of six issues managed to encompass some of the purest expressions of literary Romanticism. The journal stood for the principle of Symphilosophy, as Schlegel called it, a collective search for truth in which the individual was prepared to accept that his particular name would take second place to the idea; most texts bore at most the author's initials. The organ of a closed élite, the *Athenaeum* was intended to reflect a new community of thought. Its first issue contained fragments by Novalis and a long selection of Schlegel's own *Fragments*, in which he elaborated on earlier notions so as to arrive at a definitive formula for Romantic poetry as 'progressive universal poetry'. The main feature of this new literary ideal was that it should transcend traditional genres in a universal form capable of synthesizing the lyrical, the epic, the philosophical, and so on. Schlegel's terminology is a little confusing, for he refers to this genre of genres by the specific term *Roman*, meaning 'novel' or 'romance'. This is mainly because he sees the novel, especially in such prototypes as *Don Quixote*, as the genre best suited to combine immense variety with perfect unity. In this it might be said that Schlegel saw his new ideal not as simply an alternative to Classical art, but rather as the dialectical synthesis of Classicism, with its requirements of restraint and symmetry, and of its contrary, the expression of enthusiasm and limitless striving. Naturally, Schlegel's definition did not tolerate fixity: his whole intuition of 'progressive universal poetry' is that it should be 'continually becoming, never complete and infinitely free'. While the new poetry would be capable of holding up a mirror to the age,

and thus of being a record of actual events, it must at the same time mirror the imaginative events of its own creation. Schlegel's idea was that one could suggest infinity and unity without falling into fixity and rigidity, provided one maintained a subtle balance of stress whereby the poetry would 'hover on the wings of poetic reflection in the space between the represented (i.e. the poetic material) and the representer (i.e. the artist), raising this reflection to a repeatedly higher power and multiplying it as though in an infinite sequence of mirrors'. This notion of 'poetic reflection' is really Romantic irony in a new guise; it is the aesthetic principle whereby the work incorporates its own critique. Thus if Romantic poetry is to be the attempt to make the Real cohere with the Ideal, to whip up conditions of enthusiasm conducive to transcendence, Schlegel is saying that its effect will be immeasurably increased by the introduction of a sceptical note. In his view, 'the highest maximum of poetry' can only be attained within the finite terms of human language provided its limitations are underlined in the very moment the absolute is invoked. Somehow this procedure will enable poetry to transcend itself constantly and move towards its highest conditions, becoming 'the poetry of poetry', a marriage of the infinite elasticity of poetic creation with the infinite self-reflection of poetic criticism. Hence the notion that Romantic art might be at once instinctive and deliberate. Hence also the notion that authorial caprice must submit to criticism in a dialectical alternation between self-creation and self-destruction. Though Schlegel's theory is an admirable recipe for permanent revolution within the artist, by the same token it lays extraordinary strain on him. He may find that he never completes any of his works, now that the project is more prized than the product, and he may lose all confidence when faced with the demands of self-criticism. (Schlegel has a brutal comment in his notebook: 'Whoever does not annihilate himself, is worth nothing.') On a more trivial level, it might be argued that the theory provides an elegant excuse for artists who are creatively impotent.

In September 1799 the Romantic group was able to meet for a prolonged session of 'symphilosophizing' at the Schlegels' house in Jena. In an atmosphere of exciting intellectual exchange and poetic experiment, the group now attained full consciousness of itself and its aims. The immediate literary fruits of the meeting were Novalis' *Spiritual Canticles* (*Geistliche Lieder*), 1802, shortly followed by the *Hymns to Night*, and Schlegel's *Dialogue on Poetry* (*Gespräch über die Poesie*), 1800, which in part resembles a transcript of the discussions which had taken place. In this work, with its now typical mixture of disparate manners and forms, Schlegel pursues the theory of authorial caprice, insisting that the Romantic author must have total licence to intrude on his text and use it as a mirror, thereby intensifying its effect, as happens in *Don Quixote*, where Part Two incorporates a commentary on Part One, and in *Tristram Shandy*, that classic of authorial

intervention and ironical divagation. In another section of his work, Schlegel gives a 'Speech on Mythology', in which he points out that contemporary man lacks the kind of organic mythology that the Greeks enjoyed. Drawing inspiration from Schelling's Nature Philosophy, Schlegel points to the discoveries of contemporary science, and especially of physics, 'thanks to whose dynamic paradoxes the most holy disclosures of Nature are breaking out on all sides'. Men must now learn to use their divinatory powers, Schlegel goes on, and seek a new intimacy with the world, developing what is in effect the ability to perceive things in symbolic terms. The new mythology advanced by Schlegel rests upon an awareness of the interrelationships between the material and the spiritual worlds, and may be readily equated with what Novalis calls 'romanticization'.

The *Dialogue* appeared in what proved to be the last number of the *Athenaeum*, which folded up in 1800 for lack of public support. This last issue also contained Novalis' *Hymns* and further fragments by Schlegel under the heading *Ideas* (*Ideen*). These reflect the latest state of his thinking on Romantic art, which, by now much influenced by Novalis, insists less on the virtues of critical reflection and more on those of poetic symbolism. The point Schlegel has now reached is that of a mystical celebration of religion, philosophy and poetry in a single creative myth. The act of synthesis is extolled as the secret of progress towards truth. 'Unite the extremes, and you will find the true centre,' is the provocative precept. The influence of Boehme is felt in the way Schlegel now refers to poetry as the 'hieroglyphic expression of Nature around us, in a transfiguration of imagination and love'. Nature, Schlegel is now suggesting, must be apprehended as a pattern of symbols, and the aim of Romantic writing will be to produce a symphilosophical masterpiece, an encyclopedic Book of Books which will embody the collective expression of the Absolute. (These ideas echo Novalis' ideal of the 'scientific Bible'.) In due course Schlegel's lofty terms were to be translated into more practical and relative ones, to become a recommendation that Romantic poets no longer concentrate on the novel, but on the more inherently poetic genres of the fairy-tale and the lyric – which advice was indeed largely followed.

Sadly, this sublime highpoint of Romantic activity could not be sustained, and the Jena circle began to collapse. Schlegel was living on a shoestring, having failed to get a post at the university (despite the excellent private lectures he had given on 'Transcendental Philosophy', which no less a person than Hegel had attended). More importantly, there was the tragic death of Novalis; furthermore, Caroline was divorcing August Wilhelm in favour of her lover Schelling, a situation which her husband seemed to accept more easily than her brother-in-law. Relations with Schleiermacher had cooled, and the young Brentano became a sworn enemy when Schlegel flirted with his fiancée Sophie Mereau. The upshot was that in 1802

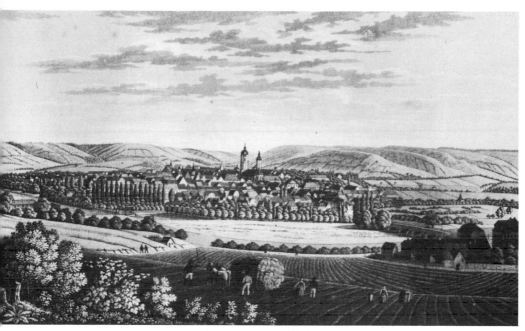

Jena. Engraving by Ludwig Hess

Schlegel, together with Dorothea, left Jena, to all intents and purposes concluding the truly Romantic part of his career. In the next few years he travelled a good deal, started up journals in Paris and Cologne, gave private lectures on European literature, studied Sanskrit and produced a classic study on Oriental culture, *On the Language and Wisdom of India* (*Über die Sprache und Weisheit der Indier*), 1808. But the lively spirit which prompted him in his early years to express support for Republicanism and the ideal of a united, democratic Europe, and to put his faith in a religion which was really a form of subjective magic, gradually gave way to a hankering for order and stability. In 1809 he and Dorothea became converts to Catholicism, and soon afterwards Schlegel began a diplomatic career under Metternich in Vienna. Despite his interesting lectures *On the History of Ancient and Modern Literature* (*Geschichte der alten und neuen Literatur*), 1812, and several other learned works which were important landmarks in the fields of philology and literary history, Schlegel's Romantic progressiveness had run its course. The plump diplomat who represented Austria at the new Frankfurt parliament, the journalist who indulged Catholic dreams about the past glories of the Holy Roman Empire in his conservative magazine *Concordia*, seem to be totally alien to the nervous, witty, unsettled young thinker who had once thrived on discontinuity and untidiness, shunning all systems.

Johann Gottlieb Fichte
Drawing by F. Bury

Johann Gottlieb Fichte

RAMMENAU 1762–BERLIN 1814

Fichte was born in a village not far from Dresden in 1762. His parents were poor and it was only thanks to the support of a local baron who recognized his intelligence that the young boy was able to go to college. He went on to pursue theological studies at the universities of Jena, Wittenberg and Leipzig. Here Fichte found he could not accept doctrinal solutions to problems, and thereupon resolved to become not a pastor but a philosopher. On losing financial support at the baron's death, Fichte worked for a while as a tutor in Zurich, where he became engaged to Johanna Rahn in 1788, and returned to Leipzig. There he came across the work of Kant, which he studied with the intensity and enthusiasm of a sudden convert: his vocation was now certain and, in 1791, to confirm the decision he wrote a philosophical essay, *The Critique of all Revelation (Kritik aller Offenbarung)*, and sent

it to Kant, who responded favourably. By chance the essay was published without the author's name and was at once taken to be Kant's own work. When Kant pointed out to whom credit was due, Fichte became famous almost overnight. He felt he had established himself sufficiently to be able to marry Johanna.

Henceforth the story of his life is the story of his publications, which begin with a passionate justification of the French Revolution, written at a time when counter-revolutionary feeling was beginning to develop. For all his appearance of a sober professional philosopher, Fichte never lost the enthusiasm for the ideal of freedom which he had conceived early in his life as the natural right of all men. Then came his most distinctive contribution to philosophy, the *Doctrine of Knowledge*, or *Wissenschaftslehre*, the foundation of his whole subsequent system. In 1794 the chair of philosophy fell vacant in Jena, and Fichte was lucky enough to be elected at the age of thirty-two. Issuing a text for his students entitled *Fundamentals of the Complete Doctrine of Knowledge* (*Grundlage der gesamten Wissenschaftslehre*), 1794, he embarked on a series of courses backed by publications that soon set the whole town seething with intellectual discussion. Somewhat stern and authoritative, with something of the preacher about him, Fichte now experienced his period of greatest glory, surrounded by a crowd of devoted students which included Schlegel and Novalis. Fichte took to giving his lectures on Sundays, to the chagrin of the local church, which thereby lost its clientele; in time the squabble with religious authority blew up over a supposedly atheistic pamphlet written by Fichte, and though vigorously defended by his students, Fichte was obliged to resign his chair in 1799.

Moving to Berlin, he published *The Vocation of Man* (*Die Bestimmung des Menschen*), 1800, a popularized account of the *Wissenschaftslehre*, but was unable to attract many students, though the private lessons he gave in his own home were attended by a good many of Berlin's more distinguished figures. The decline of his influence coincided with the rise of the new star of Schelling, whose *System of Transcendental Idealism* (*System des transzendentalen Idealismus*) of 1800 ushered in the new notions of *Naturphilosophie* as a corrective and an alternative to the *Wissenschaftslehre*. In 1806 Napoleon's armies moved in on Prussia, and occupied Berlin. Fichte, having failed to get the king to agree to his accompanying the Prussian army as its official orator, made his blow for freedom by delivering his *Addresses to the German Nation*, idealistic lectures which elaborated his concept of freedom in the context of German nationalist ideas, proposing that there should be a democratic union of German states and an end to the dominion of the princes; the latter nuances went unnoticed in the general acclamation of Fichte as the spirit of Resistance to the hated French. When the Prussian king donated a palace and founded the University of Berlin in 1810, Fichte seemed a natural choice for Rector; however he found it difficult to

Berlin, the University. Engraving by A. Carse from *Les Galeries et les Monuments d'Art de Berlin*

make any headway with his Senate, and in particular with Schleiermacher, who was Dean of Theology. Yet again he was obliged to resign. In 1813 the renewal of war prompted him to express once more his support for those who defended their country, with the reservation that they were foolish if they thought they were fighting to protect the monarchy. In 1814 there was a typhus epidemic in Berlin and, while tending his wife (who subsequently recovered), Fichte was infected and died.

It is necessary to approach Fichte's philosophy via a consideration of the ideas of Kant. The thrust of Kant's work had been largely directed against the pretentiousness of all-inclusive metaphysical systems of a purely speculative type: his thinking was guarded and reserved, and developed with a minimum of eager leaps. Addressing himself to the fundamental

problem of the relation between mind and world, Kant made the distinction between the objective reality of things and the subjective reality of our knowledge of things. The objective world enters into our consciousness as into a readymade set of moulds, for the mind's way of grasping sensations and impressions tends to regularize and to impart patterns upon experience. To some extent, Kant argued, it is the mind which creates its own world, in as much as it shapes the raw material of perceptions into its own internal patterns. Kant therefore had to recognize that what is reflected of the outer world within the mind might not exactly correspond to the actual facts of external existence. We can never hope to gain direct absolute knowledge of external things, he said, for even if we apprehend the appearance of the thing, the *Thing in itself* (*Ding an sich*) necessarily resists assimilation by the mind; our knowledge of the world is thus an appearance, a picture whose viability is based not on its appropriateness to the unknowable facts but on its coherence and communicability to other minds.

Though Kant stressed that the categories of understanding were themselves the mere *containers* of experience, and that they still needed an objective world to furnish them with a content, he was helpless to prevent an attractive but distorted version of his theories (according to which human thought was seen as the guarantor of the validity of the real world) from gaining currency. Once reality was indistinguishable from subjective mental experience, the way was open for the elaboration of fantastic speculative systems which sought to supply answers to the problems of external existence in terms of pure thought. The term *Wissenschaft* came to denote not experiential knowledge, but purely speculative knowledge, an approach exemplified in the Romantic approach to natural science, which was to prefer the satisfying symmetry of a hypothetical system to the ill-assorted data of empirical observation.

Though Fichte in his turn suffered a similar fate to Kant in that his ideas were pressed to extremes which transgressed the limits of his theory, it must be admitted that he encouraged the trend by initiating the move from Kantian analytical critique to post-Kantian idealism based on pure speculation. In effect Fichte completely reversed Kant's methodology: whereas the latter worked his way patiently from the perceptual world to the inner reality of moral certainty, Fichte deduced the world absolutely from the sole activity of the Ego, refusing to admit that limitations could be set upon the mind's knowledge. There was no such thing as a Thing in itself. With dramatic flourish, Fichte swept away the residue of the unknowable and proclaimed the Ego as the autonomous formative principle upon which all else depends. Matter and form alike were henceforth subsumed under the one heading of the Ego, the agency which synthesizes both existence and knowledge, objectivity and subjectivity.

What then is one to make of the apparently independent and impersonal

world which exists outside the mind? Fichte's answer was that this was to be termed the Non-Ego, and was to be defined as the product of the Ego, an objective appearance created by a prior act of what he called the 'formative imagination' of the subject. Fichte was obliged to argue that the reason why the Non-Ego appears unfamiliar and separate is simply that the creation of external reality is effected by an unconscious activity of mind, such that consciousness does not afterwards recognize it and can thus experience the Non-Ego as true *Gegenstand* (alien object). The argument is essential to Fichte's explanation of the dynamic function of the Ego, which is seen to carry out a constant dialectical process. The Ego first posits itself; then, finding that consciousness requires an object, it posits the Non-Ego, its reciprocal other half, torn from itself so to speak. Conflict arises when this act of scission produces a situation in which both halves are antagonistic, yet inseparable, each determining the other. The process implies a struggle on the part of the Ego to maintain a balance in a situation where imbalance is initiated in the first place by the Ego itself. The Ego constantly 'overcomes' the Non-Ego in an act of liberation which is precisely the act of becoming conscious, and which restores the objective creation to its former condition of subjectivity, before beginning again by forming new objects against which to test itself. It is this motion of interdependent contraries, this dialectics of definition-through-conflict, which makes for the distinctive dynamism of Fichte's conception. For mind is never merely contemplative, world never merely docile: both interact in a striving which promotes the endless progression of the world process.

The notion of activity is important to Fichte, who conceives of man as a creature who is always striving towards greater freedom and greater consciousness. Where Kant argued somewhat cautiously that the only thing we can know absolutely is the moral imperative within us, and that this knowledge provides a guarantee of man's freedom, to the extent that a moral sense logically presupposes a latitude for moral choice, Fichte unhesitatingly takes freedom as the undisputable point of departure for his ethics: 'Awareness of freedom is an immediate fact of consciousness,' he declares, and goes on to ask that men envisage their freedom as implying a corporate responsibility, since individuals are members of the corporate body of humanity and must accordingly recognize the need to strive for the freedom of all men on equal terms. The implications of his idea of freedom are developed by Fichte into a theory of the ideal State as a body dedicated to ensuring that all men enjoy equal rights and equal economic surety. Such ideas provide an ethical basis for Fichte's *Addresses to the German Nation*, though the patriotic theme is more dominant than the socialistic one. In a less than sober manner, Fichte invokes the completely unphilosophical notion of 'German-ness', the essence of the Germanic cultural heritage, which he sees as the means to inspire the members of what is

potentially a great nation. He asserts that individual support for a unified Germany is nothing less than a duty, just as it is the 'duty' of the German nation to fulfil itself in the historical process. Patriotism, Fichte insists, is the way to achieve the proper expansion demanded by freedom and the responsibilities it creates; it is nothing less than the means to achieve the 'aims of human existence'. The man who (at the time of the Revolution) had been the ardent proponent of a cosmopolitan political view, now finds it necessary to answer the implicit charge of contradicting himself: there is no contradiction, he asserts, for 'the final aim of all national development (*Nationalbildung*) is that it should spread throughout the whole race of man.' The argument is that Germanic liberation is in tune with the theme of Man's liberation. But whether the sphere be Germany or Europe, the suspicion arises that Fichte is losing sight of the individual in this pre-Hegelian vision of the advance of universal history.

The Fichtian argument always tends to focus on something trans-personal, however, and the inability to see this fact accounts for a crucial misconception of his philosophy from which literary Romanticism was happy to profit. When Fichte spoke of the Ego as the formative principle, the Romantic poets took this to mean that the world is a subjective creation, that is, the product of the individual subjectivity. But Fichte did not intend such a point: his concept of the 'Ego' does not pertain to the individual, empirical subject but rather to the subject-principle in general, of which the individual subject is but a limited mode. (If there is any sense in which one could think of 'individuality' here, it would be of the individuality of God.) However Fichte's ideas were of the sort which stimulate less philosophical minds. As Hermann Korff puts it, 'the early Romantic movement was a spiritual forest fire, sparked off by Fichte's philosophy,' and it is hard to believe that Fichte, enthusiastic polemicist and lecturer that he was, was unaware of his capacity to generate sparks in the darkness. It was not hard for the young Romantics to translate the philosopher's concept of 'form-ative imagination' into poetic terms where it denotes the unlimited power of the individual subjectivity to invoke at will any form or shape, in an endless variety of fantasy and caprice. Some Romantics were to insist on taking Fichtian thoughts as a cue for lawless fantasy, finding therein an excuse for narcissistic self-assertion. Novalis and Schlegel, however, while pressing these ideas into the service of essentially poetic intuitions, pro-duced a fascinating variant of Fichtian thought in its own right. 'Ego = Non-Ego: supreme principle of all knowledge', Novalis once wrote in his notes, and proceeded to follow this principle as signifying that knowledge of the world (the Non-Ego) is to be deduced from knowledge of the self (the Ego), and vice-versa. Novalis' poetic version of Fichte, or Magic Idealism, pursued to their often extra-logical extremes many suggestions first ad-vanced by the philosopher. 'We must all learn to fichtify (*fichtisieren*)'

Novalis wrote to Friedrich Schlegel, and to the degree that 'Fichtification' means in essence 'Romanticization', Fichte may be said to have been one of the primary Romantics, in spite of himself. It is probably true to say that the deepest impact of his teaching was not intellectual but emotional: it was the fate of a systematic thinker in those times of great intellectual effervescence, that his doctrine should have been read not as a precise philosophical system but as a powerful myth of creativity.

Novalis

WIEDERSTEDT 1772–WEISSENFELS 1801

Halfway through the novel *Heinrich von Ofterdingen*, the hero meets an old hermit in an underground cave. The old man shows him a book brought back from the Holy Land, and tells him 'As far as I recollect, it is a novel about the wonderful destiny of a poet. In it poetry is celebrated and depicted in all the great variety of its aspects. The end of this manuscript is missing . . .' The book bears no title, and in any case Heinrich cannot read the text, which is in Provençal dialect; but he is fascinated by the illustrations. In each one there recurs a figure who is recognizably *himself* – he sees himself now with people whom he recognizes, now with strangers, in a series of exciting images which, as in a strange dream, mingle the familiar with the unknown. The experience is a disturbing and fascinating one. The episode can be taken as an image for the career and impact of the poet Novalis himself, whose writings include not only the unfinished *Ofterdingen* but a host of other unrealized projects. His very life was a brilliant fragment, incomplete yet brimming with unique promise – a novel which breaks off when the greatest climax seems about to come, a curtailed poem which gestures magically beyond its ruins towards a hypothetical completeness, which would embrace infinity.

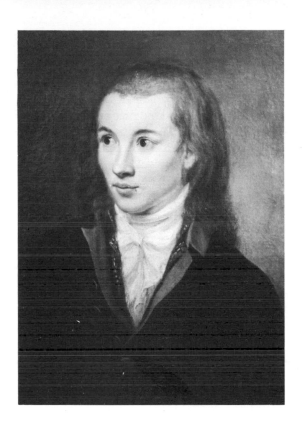

Novalis. Artist unknown

Friedrich von Hardenberg ('Novalis' was his pen-name) was a quiet, somewhat sickly child, whose intellectual and spiritual development seems to have been suddenly stimulated after his recovery from a serious illness at the age of nine. He made excellent progress in school, and went on to the University of Jena in 1790 to study law. Here he attended lectures given by Friedrich Schiller. Novalis fell under the spell of the young professor and poet during his lectures on the History of the Crusades, submitting to an influence which was as morally impressive as it was intellectually stimulating. Later, he would listen to lectures by Fichte and experience a similar engulfing enthusiasm. In 1791 Novalis went on to the University of Leipzig, where he met the young Friedrich Schlegel. By 1794, he had passed his law exams at the University of Wittenberg, and taken a post as actuary in the town of Tennstedt. It was on a business journey to nearby Grüningen that he met and fell in love with a very young girl, Sophie von Kühn. The two became secretly engaged in March 1795, two days before her thirteenth birthday. The love affair developed according to the rhythm of Novalis' trips over from Tennstedt to his fiancée's house; in between, he conducted his business affairs with patience and thoroughness, as well as devoting all

his spare time to a detailed study of the philosophical ideas of Fichte, which were to form the intellectual foundations for the ideal palace of his own thought.

By 1796 Novalis was established in Weissenfels at the salt-works directed by his father; but Sophie had fallen seriously ill, and after many months spent in great pain, she died in March 1797. His agonizing grief intensified by the death soon after of his brother Erasmus, Novalis fell into a state of psychic numbness, from which he emerged only slowly. His revival was assisted by a certainty that Sophie was not irretrievably lost: her physical absence was a sign of the enduring presence of a love made all the more sublime for being invisible. Henceforth yearning for the dead girl became associated with religious yearnings, to the point where Sophie became identified with Christ. At one point, concentration on the image of the dead beloved induced actual hallucinations, recorded with stunning objectivity in a diary where Novalis speaks of the intense physical rapture he felt when kneeling by Sophie's grave. For a time he contemplated following her into the realms of death, but finally resolved that the direction he must now follow was to devote himself to leading an exemplary life.

Still emerging from the crisis, he enrolled at the mining institute at Freiberg, to study under Abraham Gottlob Werner, another impressive teacher in his life. Inspired by Werner's genius for bringing in all sorts of information in his lectures, and demonstrating the reciprocity of the different scientific disciplines, Novalis dedicated himself to a personal programme of research which ranged from the official courses taught at the institute, including physics, metallurgy and practical mining, to unofficial studies on such subjects as alchemy and philosophy. Schelling's philosophy in particular drew his attention. Somehow he found time to make journeys to Leipzig, Jena, Weimar and Dresden, thanks to which, in the space of a couple of years, he managed to meet Goethe, Schiller and Jean Paul, and to establish highly active relations with the young members of the nascent Romantic group, the Schlegel brothers, Schelling and the physicist Ritter. In April 1798 the Romantic movement was truly launched with the first issue of the review *Athenaeum*, which featured a selection of aphorisms by Novalis. Soon after, Novalis wrote part of a novel called *The Apprentices at Sais*. He was also busily accumulating notes which he called his *Miscellaneous Sketches* (*Allgemeiner Brouillon*). By the end of 1798 he had become engaged again to a girl named Julie von Charpentier, and was working hard towards establishing himself in a career in mining, a field in which he had become highly proficient, in both theoretical and practical terms. Despite these professional efforts, in part motivated by the need to set up a home for his bride, he still managed to find time to write a set of hymns under the title *Spiritual Canticles*, the essay *Christendom or Europe* (*Die Christenheit oder Europa*), only published after his death, in which he voiced his vision of a

Europe united in a religious harmony akin to that which had obtained in medieval times, and the *Hymns to Night*; he also began *Heinrich von Ofter-dingen*, his major literary work. In November of 1799 he participated in the memorable conference of the whole Romantic circle at the Schlegels' house in Jena. Yet, supreme Romantic writer though he undoubtedly was, Novalis never seemed to give his literary activities a central place in his existence: this is indicated in a letter alluding to the relative unimportance of his literary activities compared with his practical ones. During June 1800 he made a tiring series of surveying trips as part of the first major geological survey of Saxony; by December 1800 he had been appointed Assistant Administrative Officer to the District of Thuringia, an appointment which indicated that a highly promising career lay before him. However, his health declined, and after a period of increasing illness which he was concerned to equate with deepening spiritual insight, his short life ended, just a few weeks before his twenty-ninth birthday.

It had been Novalis' positive evaluation of sickness and death at the time of Sophie's loss that had formed the basis of his metaphysics. As Tieck observed of his thinking at that time, 'it was natural for him to regard the visible and the invisible world as one; and to distinguish Life and Death only by his longing for the latter.' Similarly, the twilight world of his last illness became a mystical state in which existence was invested with a mysterious light, in such a way that living and dying were seen to co-exist in an uninterrupted continuum. 'The essence of sickness is as mysterious as the essence of life' he wrote. This penetration of mysteries found its most complete expression in the haunting *Hymns to Night*, where the spirit is projected in an ecstatic movement beyond the fixed bounds of day, across the border into the fluid realm of Night, the place of ultimate joy:

> Now I know when the last morning will come – when the day-light ceases to dispel Night and Love – when sleep becomes a single inexhaustible and eternal dream. Already I feel a heavenly tiredness within. – Long and fatiguing was my pilgrimage to the Holy Grave, oppressive the cross. There is a crystal wave, imperceptible to the lower senses, that wells forth within the dark bosom of that hillside at whose foot breaks the earthly tide: he who has tasted its waters, he who has stood on high upon the mountain border of this world and looked across into the new land, into the dwelling-place of Night – truly, he will not return to the bustle of the world, to the land where light dwells in eternal unrest.

The *Hymns* culminate in a mystic vision of an eventual redemption in which heaven and earth are reunited, and man reconciled with God. For Novalis, Christianity is the religion of Night Eternal. Night is equated with Christ;

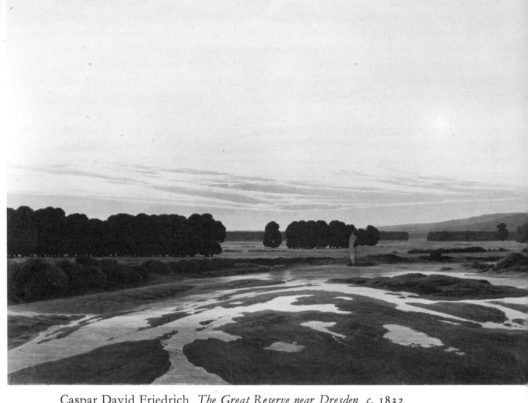

Caspar David Friedrich *The Great Reserve near Dresden* c. 1832

it is equally the maternal source to which man must return. These equations are couched in a voluptuous language which suggests an erotic undercurrent to Novalis' spiritual yearnings. Cosmic love and earthly love – love of Christ and love of Sophie – are indeed deemed to be equivalent. It is the power of Novalis' mysticism to unite two orders of experience, the earthly and the supernatural: 'All that is visible clings to the invisible – the audible to the inaudible – the tangible to the intangible.'

Novalis' thinking is affected by what he called 'galvanization' prompted by the 'spiritual atmosphere', and this accounts for his highly-charged apperception of Nature. For Novalis, no phenomenon can be isolated from what surrounds it – all things co-exist in a 'strange interplay of relations'. The models for this view lie less obviously in traditional Christian teaching than in occult doctrines which teach the interdependence of what lies

below and what lies on high. One of his last great enthusiasms was for the writings of the German mystic Jacob Boehme, whose treatise *Signature of All Things* (*De Signatura Rerum*), 1622, insisted that Nature was an open book in which the Creator had inscribed a message which only the worthy few could read. Novalis developed this notion to the point where the natural world becomes a spiritual poem which the Orphic poet reads out or sings. By 'singing Nature' the poet affirms his affinities with all creation, indeed he may himself be said to create that which he then becomes.

If the natural world was a vast reservoir of spiritual meanings, Novalis – the 'scientific mystic' as Maeterlinck calls him – saw it as his vocation to draw up the catalogue in the form of a universal Encyclopedia. The *Miscellaneous Sketches* which he pursued through notebook after notebook, contain the material for this 'scientific Bible'. The notes are crammed with intuitions and images which cut right across the boundaries between the different sciences. This truly interdisciplinary thinker proposed a hundred new approaches which would cross-fertilize one another: he gathered data on 'moral astronomy', on 'spiritual physics', on 'literary politics', on 'poetic physiology', 'musical chemistry' and so on. The apparent absurdities to which this juggling with categories led Novalis and the impossibility of his ever completing his colossal task are beside the point – the sheer immensity of vision which could project this ultimate encyclopedia, the ambition of a single thinker to possess all Creation in one vast work, provide us with a staggering example.

It is important to understand the exact character of Novalis' mode of thinking. What he himself defined as Magic Idealism is an operation stemming from the Fichtian idea that the Non-Self is the projection of the Self, or, in other words, the actualization of a process of imagining. Novalis' creative philosophy functions on the basis of encouraging a constant motion between concrete images and abstract ideas, and continually translating from one idiom to another. The operation of transforming things into thoughts and thoughts into things implies a curious flexibility of mind, the capacity to entertain analogies between highly divergent orders of experience. For Novalis, analogical thinking is a process of unending metaphorical development. The rising spiral of analogy is symbolically represented in the career of the would-be poet Ofterdingen, who, after passing through many stages of enlightenment, at last (according to abandoned sketches collected by Tieck after his friend's death) enters a cycle of magical metamorphoses, turning into a flower, an animal, a stone, a star – finally achieving an utopian state of cosmic interrelatedness in terms which transcend normal discourse.

Whether or not these last inexpressible miracles can actually be envisaged, Novalis is meanwhile arguing an implicit case for the expansion of poetic thought and the application of, as it were, an amorous approach to science

Novalis. Page from his *Chemistry Notebooks* 1798–9

and philosophy. The sole truth which he recognized was poetic truth. His strange formulations elicit striking new chords from the harmonic register of Nature: 'Water is a wet flame'; 'plants are dead stones'; 'every line is the axis of a world'. The system of 'analogistics', or 'combinatory analysis' as he also called it, meant stimulating the metamorphic functions of the mind, corresponding to the metamorphic functions of the world. The imagination of the world is thus the imagination of imagination, a mode of self-observing consciousness. In this, thought may be said to transcend its normal powers, to become thought to the power of infinity in a self-generating process mimetic of the endless self-generation of the cosmos. Such at least was Novalis' programme. It may be surmised that Novalis could only have truly achieved his aims by carrying out an act of imagination surpassing all others, projecting himself into the position of total correspondence with all Creation.

Caspar David Friedrich

GREIFSWALD 1774–DRESDEN 1840

The great Romantic landscape painter Caspar David Friedrich was born into a devout Protestant family in Greifswald near the Baltic coast. After studying at the Copenhagen Art Academy, Friedrich moved in 1798 to Dresden, which was at the forefront of Romantic activity – the writers Schlegel, Tieck and Novalis and the painter Philipp Otto Runge were about, and Friedrich came into contact with the dramatist Kleist and Gotthilf Heinrich Schubert, who gave lectures on the 'Night-Side of the Natural Sciences'. Friedrich was to make Dresden his home for the rest of his life, leaving it only to make sketching trips to scenic regions such as the Riesengebirge in northern Bohemia, the Harz Mountains and the Baltic island of Ruegen near his birthplace. Not once did he make the fashionable journey to Italy, nor indeed did he even see the Alps, though he painted some Alpine scenes from sketches done by other hands.

Friedrich's landscapes are basically Germanic and pious in conception. Beginning with his early commission for an altar-painting for a chapel at Tetschen, depicting the crucified Christ melodramatically silhouetted against the crimson rays of a sun setting behind a mountain-top, Friedrich produced a style of religious painting which became peculiarly his own with its deployment of special effects of light in particular settings – mist at dusk over a silent sea, the glow of dawn high in the mountains, the shadows of night amidst the ruins of Gothic chapels set among gnarled trees – and its introduction of overt Christian references such as wayside crosses and gravestones. Friedrich's Protestant piety is complemented by the patriotic medievalism alluded to in the old Germanic garb of the on-lookers at these symbolic scenes. A number of paintings celebrating the expulsion of the French army which had occupied Dresden in 1813 are evidence of a firm, though not necessarily lastingly optimistic, commitment to the principles of liberation and German unification.

By 1816 Friedrich had become a member of the Dresden Academy and a respected artist and teacher. He exerted considerable influence on the painter and scientist Carl Gustav Carus, who was in 1831 to compose the *Nine Letters on Landscape Painting (Neun Briefe über Landschaftsmalerei)*, effectively a summary of the teachings of Friedrich and Runge. He was also an important influence on the young Ernst Ferdinand Oehme, a pupil of Johann Christian Claussen Dahl, a Norwegian painter who shared a house with Friedrich from 1823. While Friedrich imparted some elements of technique to such pupils as these, he insisted that his work was not based on an array of devices but rather on emotional responses. He saw the artistic vocation as a matter of spiritual dedication, with feeling as the unique inspiration: 'The only true source of art is the heart, the language of the pure and innocent soul. A painting which does not have its genesis therein can only be vain sleight of hand,' he asserted.

In 1818 Friedrich had married, but within a few years his mental condition began to deteriorate, with symptoms of a persecution complex and un-justified accusations about his wife's infidelity. Carus commented that there had been a cloud hanging over Friedrich's mind for some years, and regretfully drifted away from him. Henceforth human figures seem to grow less frequent in the paintings, though Friedrich's control over his medium reaches its height with such pictures as *The Great Reserve near Dresden (Das grosse Gehege bei Dresden)*, 1832, with its sensitive nuances of colour and the deliberate and hypnotic curvature of the foreground (p. 64). However, public taste had begun to swing away from effects of evocation towards a more clearcut, naturalistic style of painting, and Friedrich's work speedily faded out of fashion after about 1830 – an eclipse which has lasted until quite recent times. In 1835 he suffered a stroke which left him incapacitated, though he continued to paint on a small scale until his death in 1840.

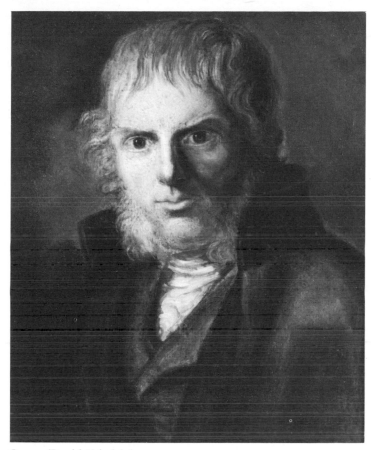

Caspar David Friedrich.
Portrait by Gerhard von Kügelgen *c.* 1830

Though not in fact a churchgoer, Friedrich was a fervent lover of Nature, which he called 'Christ's Bible', and which he saw as a receptacle of Christian symbols which it was his task to communicate. The intention of his religious painting was thus to reveal the divine presence in the natural world. When showing a friend a study of reeds, he would remark: 'God is everywhere, even in a grain of sand. Here I have revealed him in the reeds.' In a way exactly congruent with Novalis' contention that there is a secret continuity between the visible and the invisible, Friedrich saw the landscape painting as an intermediary between man and God, a kind of visual prayer or filter of yearning. Within the narrow frame he was attempting to gain a purchase upon the infinite.

Friedrich's principle effort seems to have been directed at the depiction of distance, envisaged not in terms of a literal reproduction of how horizons appear to the physical eye, but rather in terms of a symbolic representation of the borderline between the terrestrial and the celestial. The 'blue distance' of Romantic yearning became one of Friedrich's favourite themes. The edge of the phenomenal world, often dramatized by being shown in dark silhouette against the intangible light beyond, becomes a precise expression of the desire for transcendence. The physical eye is expected to slip across this borderline and in so doing to allow inner vision to transcend the earthly realm and glimpse the infinite. As Franz Nemitz puts it, 'distance is the means to render the world transparent.' In a typical evocation of twilight – the perfect moment where the visible merges into the invisible – Friedrich paints *Man and Woman gazing at the Moon* (*Mann und Frau in Betrachtung des Mondes*), 1819, in which the two figures appear to be peering over the very edge of this world and into the next (p. 30).

Friedrich's art is really a painter's realization of Novalis' principle of 'qualitative involution'. The artist would begin by gathering together sketches of various elements of landscape done at different times and often in different places. Though the sketches he did on his expeditions into the mountains or the Baltic coast are factual and precise, they function only as a point of departure: the work of the heart has yet to come. For Friedrich's next step is to synthesize the various images gathered from outside in an act of inner vision, an organic re-creation through the imaginative faculty. Now the picture comes into being as an *interior* landscape which is then projected outwards on to the canvas and thence into the eye of the observer. Friedrich's recommendation to painters was akin to a mystical precept: 'Close your physical eye so that you may first see your picture with the spiritual eye. Then bring to the light of day that which you have seen in the darkness, so that it may react upon others from the outside inwards.' The process of qualitative involution entails a movement from the actual to the ideal, whereby the inherent spirituality of phenomena is intensified. In the process, observed data are transmuted into signals of higher mysteries; this is achieved by carefully brushing light on to the surfaces of things until they are rendered luminous, almost transparent, the luminosity announcing spiritual insight.

The tenor of Friedrich's pronouncements on his art seems to have been invariably positive. Yet many of his landscapes are melancholy or dark: there are innumerable ships on darkening seas, desolate crags bathed in impenetrable mists, twilit forests and gloomy interiors. One of his most powerful images is *Monk by the Sea* (*Mönch am Meer*), 1809, in which a solitary figure stands dwarfed in an immensity of sand, sea and sky. When reviewing it in 1809, Kleist had no hesitation in describing this as a frightening picture: 'Nothing can be more sad and more disquieting than this

situation in the world: to be the sole spark of life in the vast realm of death, the lonely centre of a lonely circle.' The idea that we are, in life, also in the midst of death, the recognition that man is ephemeral and the cosmos so vast that the consciousness of the Absolute must imply the extinction of the individual self – such seems to be the gloomy, indeed the nihilistic message of a painting like *Arctic Shipwreck* (*Eismeer*), 1824, which shows the ship of Hope almost totally engulfed by huge blocks of ice. Against such a frozen image, however, one may set the warm vision of *Morning Light* (*Frau in der Morgensonne*), 1815–17, in which a woman greets the dawn with

Caspar David Friedrich *Arctic Shipwreck* 1824

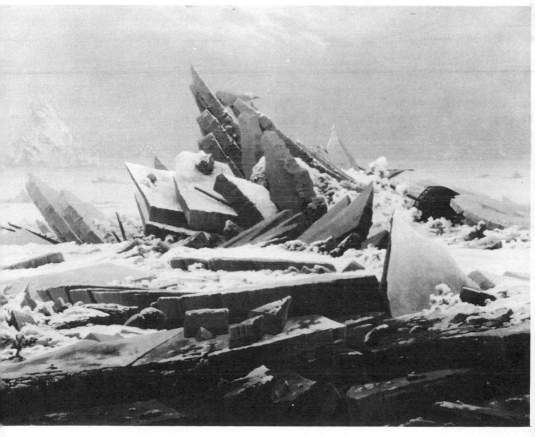

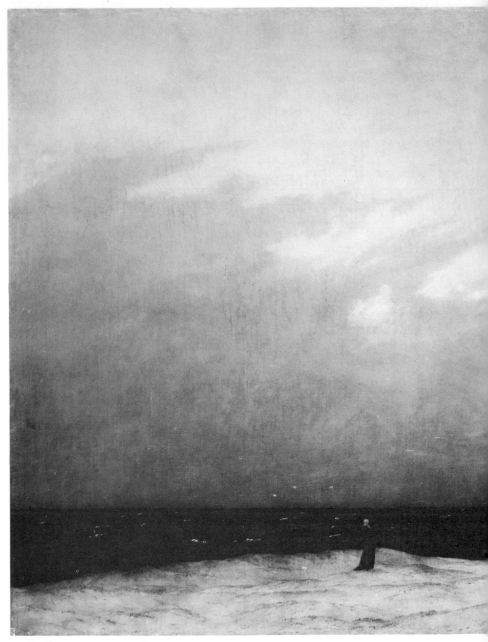

Caspar David Friedrich *Monk by the Sea* 1809

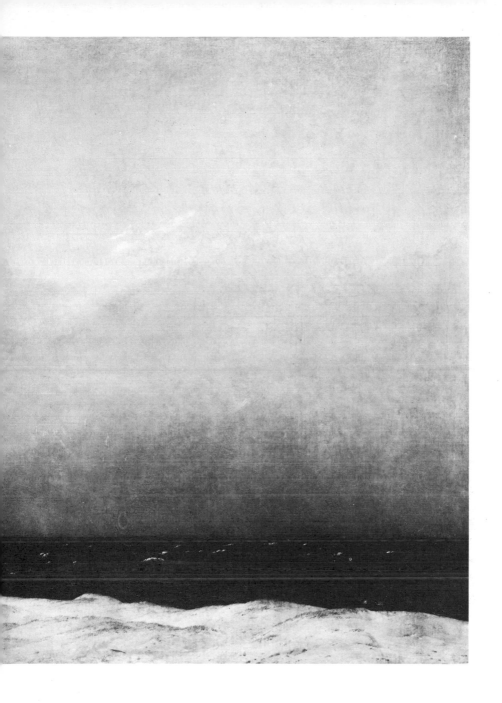

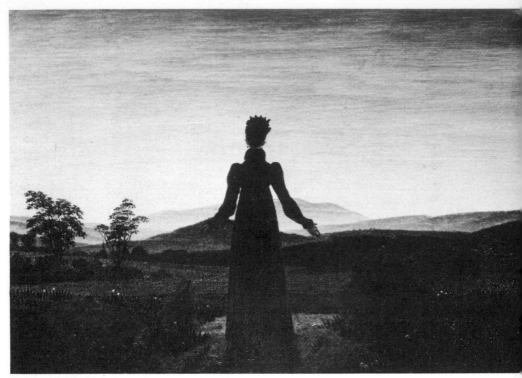

Caspar David Friedrich *Morning Light* c. 1815–17

arms ecstatically outstretched, in what is undoubtedly an expression of harmony and faith. And Friedrich always explained that his depiction of earthly transience ought to be seen as an expression of confidence, stressing his faith in a continuity between this brief existence on earth and the life beyond. Nonetheless, the evidence of the pictures themselves, their actual effect on us regardless of their supposed intention, seems, at the very least, to be to press towards something more mysterious and more uncertain than the message of unflinching Christian belief. An impression of enigma and doubt remains to remind us that the transition from ecstasy to unease is never far off when the Romantic approaches Nature from her 'night-side'.

The haunting strangeness of Friedrich's landscapes is frequently intensified by the presence of the onlookers in the foreground, who are usually in pairs, with their backs turned to us. They seem almost spellbound, lost in contemplation of spaces that are magically still, held in breathless suspension. The marvellous effect of *Chalk Cliffs at Ruegen* (*Kreidefelsen auf Rügen*), 1818–20, in which the dark leaves of trees and ghostly pinnacles of chalk are silhouetted against a background that is indeterminately sea *and*

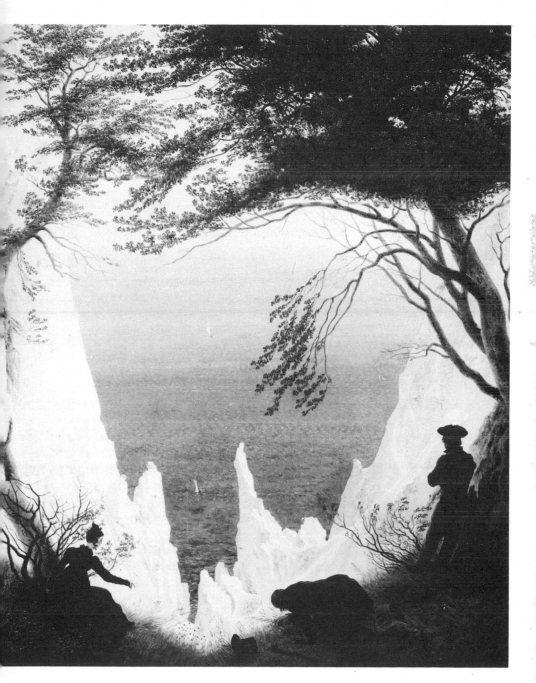

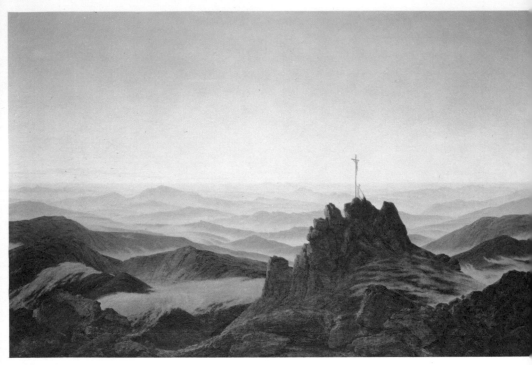

Caspar David Friedrich *Morning in the Riesengebirge* 1810–11

sky, an enormity of space that sucks the eye forward, is subtly heightened by the presence of foreground figures, the woman and the outstretched man who seem intent on invisible mysteries, and the erect man, whom it is permissible to take as Friedrich himself, calmly gazing out to infinity. In his *Nine Letters*, Carus noted that it is often very effective to introduce figures into landscape painting because 'a lonely figure lost in contemplation of the silent scene will prompt the spectator of the picture to think himself in his place.' If we identify with the witnesses of the landscape, we are asked to project our own consciousness outwards – at which point we are called to an awareness of the Romantic conception of Nature as the projection of human imagination. At this point, it seems legitimate to take Friedrich's charmed landscapes as images of inner space: the scene offered to the physical eye is a focus for the imagination, if not an almost literal representation of the imagination conceived as an actual region.

It is possible to argue that Friedrich's landscapes are overtly representations of the immanent touched by divine grace, but covertly representations of man's consciousness of world and self, the one within the other. Such

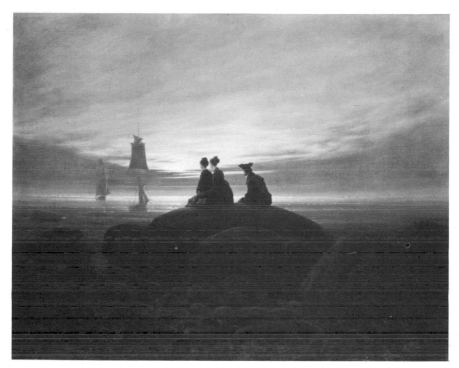

Caspar David Friedrich *Moonrise over the Sea* 1820–6

an interpretation would help us disengage from beneath Friedrich's surface intentions the essentially deeper resonances that, intuitively rather than programmatically (and in this he was more truly Romantic), he was all the while instilling into his pictorial space. For if the pictures execute a passage beyond the immediate phenomenon, so their symbolic reverberations may be said to surpass the explicit meanings given in Friedrich's own recorded pronouncements. The argument here is that Friedrich's art is less important as more or less conventional Christian allegory than as a medium of poetic symbolism whose effect is more obscure and subliminal. Friedrich did paint a good many landscapes in the idiom exemplified by *Morning in the Riesengebirge* (*Morgen im Riesengebirge*), 1810–11, which is certainly a straightforward religious picture. A man is being led by a woman to a cross which rises up against the sky, just as the sun rises over the hilltops – this signifies that Christ, and in turn Woman, are intercessors between man and Heaven; through faith, man can hope to gain redemption at the summit of life's climb. The allegory has a definition and clarity, based as it is on Christian traditions. But what of a picture such as *Moonrise*

over the Sea (Mondaufgang am Meer), 1820–6, which lacks any obvious iconic reference to Christian beliefs? Three people, a man and two women, are sitting on rocks watching the sailing ships offshore, as the moon rises. Knowledge of Friedrich's usage elsewhere indicates that the rocks may be taken as symbols of faith, and the ships coming into harbour as the solace offered by Christ in the face of the transience of human life. Yet somehow such a reading seems inappropriate to the tonality of the emotion engendered by the scene. The figures are attentive, even obsessively attentive, to the imperceptible motion of the ships. The sails are full, yet there is no sense of wind blowing. Everything floats in a calm that nevertheless seems to imply expectancy, as the moonlight filters through cloud to touch the tips of waves and the onlookers' faces. It is fairly evident that the three figures are intended to embody the condition of yearning – but is this yearning explicitly yearning for God? It could be yearning for spiritual comfort, or even for physical comfort outside the religious context.

The point is that some of Friedrich's more powerful images do transcend their specific allegoricism, and instead tend towards a less explicit symbolism that asks for subtler, more poetic responses. Symbolism of this freer type invites the onlooker to participate in a metaphysical reverie that is not served up with the pat solution of faith: below the surface, there are hints of considerable disquiet. If we look again at *Monk by the Sea* we can perhaps see it now as an example of this latter tendency to make non-explicit statements about metaphysical intuitions. The lone monk holding his head as he gazes at the vast sky means more than 'religious faith courageous in the face of the Almighty'. The monk seems rather to be confronting an abyss of uncertainty, a vertiginous emptiness wherein his human imagining can project no identifiable handhold. The message may now read: 'the lack of meaning in an impersonal universe'. If the picture is still about yearning, the distance between that yearning and its target is so extreme that the whole emotional situation takes on a dramatic new tonality. Alternatively, it is possible to see the picture as representing the state of non-specific Being; the painting, almost abstract as it is, then dissolves into an image of pure undifferentiated space. Kleist was amazed by the effect of vastness created mainly by the starkness of the lines and the lack of intermediate ground: 'Since in its uniformity and limitlessness it has no other foreground than the frame, when one gazes at it, it feels as if one's eyelids have been cut away.'

With such a picture the very difficulty of deciphering a message becomes part of its meaning: that is, enigma is at once the quality of style and the message. We are being led so far beyond mechanical interpretation that 'meaning' has become something trans-verbal. At the misted summit of Friedrich's achievement, masterpieces such as this one or the *Great Reserve* offer an experience that one is tempted to describe as visual music.

Friedrich Wilhelm Joseph von Schelling
Portrait by Friedrich Tieck *c.* 1801

Friedrich Wilhelm Joseph von Schelling

LEONBERG 1775–RAGAZ 1854

Like so many of the Romantics, Schelling reached his peak at an extremely early age. The son of a Swabian pastor, he had by the age of fifteen gained entry to the theological institute at Tübingen, where he knew Hölderlin and Hegel, his elders by five years. Schelling's youthful genius developed at first in the Fichtian mould, and this is reflected in the title of his work *On the Ego as Principle of Philosophy* (*Vom Ich als Prinzip der Philosophie*), which appeared in 1795 when he was only twenty. This was followed in the same year by the *Philosophical Letters on Dogmatism and Criticism* (*Philosophische Briefe über Dogmatismus und Kritizismus*), a critical examination of the positions adopted by Spinoza and Fichte towards the Absolute, the

former's being one of a surrender of the self to an impersonal Absolute, the latter's a defence of the freedom of the subject. While sympathetic to Fichte, Schelling grew increasingly aware of the need to keep open both subjective and objective positions, and thus felt he had to de-emphasize the subjectivism he detected in Fichte. A period in Leipzig during which he studied natural science helped Schelling clarify his thinking on this point. The result was the new doctrine of Nature Philosophy (*Naturphilosophie*) which reinstated Nature as being not just the inert object of consciousness of an all-powerful Ego but a productive force in its own right. The argument is developed in *Ideas towards a Philosophy of Nature* (*Ideen zu einer Philosophie der Natur*), 1797, and is followed up in *On the World Soul, a Hypothesis of Higher Physics in Explanation of the Universal Organism* (*Von der Weltseele, eine Hypothese der höheren Physik zur Erklärung des allgemeinen Organismus*), 1798. Schelling achieved instantaneous recognition for his new ideas, and earned the admiration of Fichte and Goethe, who both helped to get him appointed to a special chair of philosophy at Jena in 1798. It happened that Fichte had to leave Jena in the following year, after the episode involving the charge of atheism, and Schelling could not help but step into his shoes as the genius of Jena. During the next few years, Schelling collaborated with Hegel in editing a critical journal of philosophy, and became one of the key figures in the Romantic circle, being a particularly close associate of the Schlegels. From the very beginning he felt a deep attraction towards Caroline, the wife of August Wilhelm Schlegel, and their love developed over the next few years. In 1803, when her marriage was legally dissolved, Schelling was able to marry Caroline and enjoy for a few short years the companionship of a woman whose independence of mind and loving nature made their relationship a perfect intellectual and erotic fulfilment. During the Jena years, Schelling had produced a series of lectures and books, the most important of which was the *System of Transcendental Idealism* of 1800. Schelling, a born synthesizer, argued that Nature Philosophy and the System of Transcendental Idealism were complementary rather than antagonistic: his intention was to cover all the different aspects of philosophy and produce a total vision wherein the sciences and, above all, the arts would join forces with philosophical argument to demonstrate the ultimate truths about the world. Fichte had by now lost his following, his decline coinciding with the public acclaim of the younger man.

The Romantic circle broke up, however, and after rescuing from its ruins what he most needed, namely Caroline, Schelling moved to Würzburg as a lecturer and thereafter devoted all his time to pure philosophizing. His ideas now dealt with the philosophy of religion, and the question of freedom. When Caroline died suddenly in 1809, he was plunged into deep grief, and though he was to marry again a few years later, Schelling's life had lost its impetus. The vogue for his ideas had by now passed, and his

rival Hegel was in the ascendant: the formidable *Phenomenology of Spirit* (*Phänomenologie des Geistes*) had appeared in 1807, containing a sharp criticism of Schelling's ideas. Schelling's energies were diminishing, though he continued to lecture in various cities, finally returning to a chair at Munich, to lecture on the 'Philosophy of Mythology and Revelation'. Then came a revival of interest in his ideas, Schelling having been chosen to counteract the negative philosophy of Hegelian conceptualism with a truly positive philosophy. Hegel was now dead and Schelling's appointment to the University of Berlin in 1841 created a great stir. Everyone expected him to re-establish himself: but he had lost all sparkle and failed miserably. Henceforth he drifted away from lecturing to private writing, retiring from the public arena. His death in Switzerland in 1854 went almost unnoticed.

As far as Romanticism is concerned, Schelling's primary contribution was Nature Philosophy. This doctrine aimed to give Nature back its independent dignity and thus to correct the apparent Fichtian stress on subjectivism. In fact, of course, Fichte's Non-Ego is posited by the Ego as an objective limitation which it requires in order to accede to consciousness; nonetheless, it is true that this object of consciousness, or Non-Ego, always remains dependent on the Ego which conditions it. Where Fichte had been loath to concede any independence to the Non-Ego, Schelling made a clean break and set up the two entities – Ego and Non-Ego, or in Schelling's terminology: Spirit and Nature – on an equal footing.

Arguing from a profound acquaintance with the natural sciences, which Fichte lacked entirely, Schelling declares that all the evidence shows that Nature has a clear teleological (purposive) pattern. In the natural world, raw matter tends always towards regular shapes as though it were intent on some higher goal, to wit, the spiritual. Processes observed in Nature, whether they be the movement of frogs' legs in Galvanism or the movement of distant stars, exhibit an intentionality, a purposiveness which cannot be described as arbitrary. A deep coherence underlies all phenomena, and the purpose of things must be intelligible. Schelling then speaks of the Spirit that moves within Nature, at the same time retaining the notion that Nature has objective reality. In a way that is difficult to convey logically, he manages to combine both the spiritual and the real in his picture of the external world. He now goes on to show how it is that Nature, which in its manifold aspects exhibits a constant potency to transcend itself, to rise from the lower to the higher level, and therefore to offer itself as intelligible to the mind, is in truth an embodiment of the eternal Idea; its purposive motion is directed to the end of 'self-reflection' – *reflection* because that is the activity carried out by the human mind upon Nature, and *self*-reflection in the sense that the human mind is necessarily a *part* of Nature. Thus Schelling's Philosophy of Nature is revealed as being equally a Philosophy of Spirit; he resolves the problem of how we can know a reality that we observe to

be external to our mind by what is finally a very simple equation: 'Nature must be the visible Spirit, Spirit must be invisible Nature. Here, in the absolute identity of the Spirit within us and the Nature without us, the problem of how a Nature external to us can possibly be, is resolved.'

The Nature Philosopher is, then, the man who puts questions to Nature in order that its answers should help it to actualize its potencies and become self-knowing through him. In a single vision that encompasses the disparateness of empirical science, rendering chemistry, physics and mathematics into subordinate functions of the unifying science that is Philosophy, Schelling eloquently and enthusiastically displaces the Fichtian system, making Novalis, for example, now think of Fichte as but 'a terrible whirl of abstraction'. Vivid analogies across different disciplines were Schelling's forte, and it is probably true that he was not always critical enough, that vague parallels often seduced him into making daring speculative leaps; even so, his system impressed many of his contemporaries as one of the great intellectual achievements of the age.

One of Schelling's most powerful poetic images was that of the magnet, a paradigm for the idea of the coincidence of opposite forces in Nature, for which parallels were found in such phenomena as the contraries of acid and alkali in chemistry. The notion was persuasive in its implication that the natural scheme was one of reciprocal relations with an overall harmony; that is, apparent differentness was explained as in fact sameness, contraries were shown to coincide. The Romantic poets found the shape of such an argument hard to resist, the more so when Schelling spoke so lyrically about the World Soul which moves through all levels of Nature, now slumbering in stones, now stirring in living organisms, finally awakening to full reflective consciousness in the mind of man. Schelling's scheme is flattering to man, who from being a minor element in the universe is shown to be its crowning achievement. It is his consciousness that permits Nature to shed its materiality and reveal its ideality. Man alone is the medium of transcendence.

The system of Nature Philosophy was soon followed by the System of Transcendental Idealism. Where previously Schelling had moved from the objective to the subjective, now he starts with the subjective and lets the objective arise from it, showing how it is that the Ego produces the objective world as its means of attaining consciousness of itself. Here Schelling keeps close to Fichte's idea of the unconscious Non-Ego as that which permits self-consciousness; he then goes on to considerations of free will, the moral rights of individuals, the need for a harmonious basis for society, the development of political states towards international federations and so on – his monistic or unity-making tendency generates a continuous logic of argument which affects the smallest to the greatest part of his scheme. The climax of the System is a theory of Art which had

Johann Christian Claussen Dahl *Vesuvius erupting* 1826

a deep effect on the Romantics. Schelling's explanation of consciousness is that it results from the bringing-into-being of objects of consciousness, by an act of production. In the case of unconscious Nature, the act is unconscious; in the case of the conscious artist, the act is conscious. Yet in both cases the productive act is really being advanced by the same power, the World Soul which moves through all manifestations, natural or aesthetic. This means that on the one hand the 'visible spirit' of Nature produces a real world of objects, and on the other, the artistic mind produces an ideal world of objects. Since the work of art is fashioned by the same formative principle as is the totality of all things, it must be a perfect microcosm of all creation, just as the cosmos at large constitutes a vast work of art.

The metaphysical dimension that Romanticism so often gives to Art is introduced when Schelling defines Art as the expression of the infinite spirit made manifest in the finite. Beauty, he concludes, is the point of coincidence of the real with the ideal, the penetration of the infinite into the finite, which we can only apprehend by aesthetic intuition.

In Schelling's aesthetics (which one might equally call metaphysics), the function of poetry is to create equivalents for philosophical ideas. Poetry is, of course, not the same abstract medium as philosophy, but a mode of expressing ideas in 'realistic' form. Schelling defines the symbol as the poetic device of mediation between that which is real and that which is ideal, or between the particular and the universal. Myth too functions as the earthly expression of the transcendental spirit, the means of glimpsing the invisible ideal through the visible real. What finally transpires is that Schelling attributes exceptional powers to the artist, inviting him to undertake the sacred function of Revealer, the seer whose exceptional vision can open doors on to the Absolute. In short, the Romantic artist is being given philosophical backing to become a Magic Idealist and exponent of intellectual intuition, which Schelling terms 'the organ of all transcendental thinking'.

Having produced two systems which were deemed to be reciprocal, Schelling went on to formalize the synthesis in the doctrine of Absolute Identity: all things that are, be they objective or subjective, particular or universal, finite or infinite, real or ideal, must cohere under this single heading. 'Everything that is, is the Absolute Identity itself.' Schelling runs into trouble though, for the definition he offers of Absolute Identity is a debatable one. He is not simply saying that Absolute Identity *underlies* the surface differentiation and multiplicity of the universe, he is saying that Absolute Identity *is* the universe. Is this not to deny the existence of the different objects or different modes of being that are perceptible to empirical consciousness? And what of the empirical consciousness, which is finite – how can it find a place in Absolute Identity, given that this comprises the totality of all things while admitting of no differentiation? No wonder Hegel complained that Schelling's Absolute was a night in which all cows were black!

Schelling's Absolute Identity is thus an eccentric intellectual equation which tots up subjectivity and objectivity, plus all the other contraries, and reasons out their total to be equal to the perfect, indivisible whole. One of Schelling's answers was that the differentiation witnessed in the lower spheres is only one of quantity, not of quality. In other words, a single quality or essence permeates all levels indiscriminately, and only in quantitative terms are there any discernible differences; so that, for example, when we are aware of the differences between a stone and the thought of a stone, the latter is only 'quantitatively' more ideal than the former. Had we

the advantage of a view on the totality (an impossibility, since we exist within it) we would at once realize the perfection of non-distinction whereby each separate 'potency' in fact balances out with respect to all others. Later Schelling gave a new expression to the situation, drawing inspiration from Boehme's doctrine of the Fall: Nature exists as the result of a lapse in the 'absoluteness' of the Absolute: thus the world of temporality and finitude comes into being and is felt to be alien to the eternal and infinite Absolute, from which it derives. Yet, all the separate phenomena existing in creation remain part of the One, the mind of God, and meanwhile must strive in their varying degrees of potency to rise back to the original unity. The argument is still not watertight, for why should there be a striving in time if there is already oneness in eternity? But though the argument may be logically flawed, Schelling's purpose is now clear. He is trying to use the notion of identity as a device to transcend disputes, rendering them harmless by nullifying the distinction between opposed points of view. Whatever the logical failings of such a system, it does provide a powerful, some would say a dangerous encouragement to poetic thought in the way it affirms the identity-principle. In the hands of Novalis and Schlegel, it becomes a permit to use contradiction as a medium of truth. Here, as occurred with Fichte, the philosophical ideas are read as an artistic manifesto. Schelling's own artistic inclinations did a lot to encourage this. The purely philosophical debate apart, there is really little difference between the 'truth' of Novalis' statement that 'we are linked more closely with the invisible than with the visible' and Schelling's dramatic intuitions about the way the infinite impinges upon the finite.

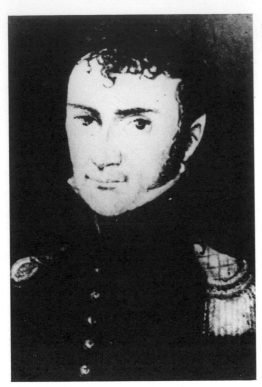

Johann Wilhelm Ritter
Miniature, artist
unknown

Johann Wilhelm Ritter

SAMITZ 1776–MUNICH 1810

Not the least remarkable member of the Jena circle was the young physicist
Johann Wilhelm Ritter. Of Silesian peasant origins, he was a rough diamond
whose social manner was characterized by a distrustful moroseness. Yet
beneath the surface lay a brilliant and impulsive personality: as Dorothea
Veit once remarked, he was like an electrical machine, dull when at rest,
but full of sparks when activated. Ritter manifested extremes of behaviour
in his attitude to his work, passing from intensive bouts of experimentation
in the laboratory to wasteful periods of dissipation given up to frivolous
amorous exploits and drinking bouts.

Ritter carried out important research into several areas of physics, and made a number of memorable discoveries. A major part of his work was devoted to Galvanism. The doctrine of Galvanism, or animal electricity, was launched in 1791 when the Italian physicist Luigi Galvani published the results of experiments he had been carrying out with frogs' legs. Galvani had accidentally discovered that the dissected limbs of a frog, laid out on a table, or hanging from a hook, would twitch convulsively when the exposed crural nerve was touched with a metal scalpel or rod. Even stronger contractions resulted if the leg were placed on a plate of one type of metal and then touched with a rod of another type. Galvani's interpretation of the reaction was that the nerve in the leg was a source of electrical energy, which was released by the application of the metals. Hence the theory of 'animal electricity', a novel and exciting notion which gained currency with great speed. Meanwhile Alessandro Volta was conducting researches in Pavia and by 1793 had published the counter-claim that the electrical charge in these experiments originated not in the animal but in the metal; in other words so-called 'animal electricity' was nothing other than 'metallic electricity' (or electricity pure and simple). Volta's electroscope, a sensitive device for detecting electrical charges, proved that the electricity was solely generated by the contact of two different metals, one positively and the other negatively charged. Volta's great contribution to electrochemistry came in 1796, when he invented the Voltaic pile, a battery formed as a column of alternate pairs of zinc and silver discs separated by pasteboard soaked in fluid. This device at once prompted experiments in England that led in 1800 to the decomposition of water into oxygen and hydrogen. Despite this rival movement, Galvanism found much support in Germany, where in 1797 Alexander von Humboldt had published a lengthy treatise on muscles and nerves, confirming Galvani's conclusion about 'animal electricity', thereby helping to establish Galvanism as a plausible, empirically-demonstrated counterpart to Schelling's speculative Nature Philosophy, now coming into vogue. Ritter, a convinced Galvanist, published in 1798 his own *Proof that the Process of Galvanism accompanies the Vital Processes in the Animal Kingdom at all times* (*Beweis, dass ein beständiger Galvanismus den Lebensprozess in dem Thierreich begleite*).

Ritter was completely obsessed with experimentation, and would send all his Romantic friends off on frog-catching expeditions to help him pursue his researches. In his exhilaration he associated Galvanism with the very principle of life, envisaging the whole organic world as a network of galvanic circuits over which one might eventually hope to gain control: he surmised that doctors might in time discover the exact means to cure a patient by simply measuring his muscular or nervous responses. Ritter was not always so conjectural, for in 1800 he managed to decompose water by magnetic means, collecting the two gases separately (though not apparently

Galvani's experiment with frog's legs. From *Les Phénomènes de la Physique* by H. Guillemin

identifying them) – an experiment which coincides with the experiments carried out in England. In 1803 Ritter devised a storage battery, equivalent to a modern accumulator, with a column of discs of silver and damp cloth, an invention which shows that he was not blind to the reality of Volta's discoveries.

Ritter also made impressive discoveries in the field of optics. In 1800 William Herschel had discovered the existence of infra-red solar rays, and went on to test the distribution of heat across the solar spectrum: radiant heat was least in evidence at the violet end, most below the red end. This

inequality had never before been suspected, and the discovery was a lesson in the indubitable value of empirical experimentation. Following up Herschel's lead, Ritter was able in 1801 to demonstrate the existence of ultra-violet rays by letting the solar spectrum fall upon a plate treated with silver nitrate: the resultant blackening extended beyond the area of violet, thus establishing that the visible spectrum is no more than a small part of a continuum which extends onwards into the invisible. This discovery was certainly the result of empirical research, though one imagines Ritter was not unresponsive to the Romantic undertones of this insight into what G. H. Schubert, an admiring student of Ritter's, would call the 'night-side' of Nature.

Whilst at Jena Ritter was undeniably influenced by Schelling: a sensitive physicist could hardly avoid being affected by the atmosphere of speculation generated by the lectures on Nature Philosophy. Schelling's notions obviously put a premium on intuition as a means of discovery in the natural sciences, placing empirical observation on a very low footing. But despite the attraction of Schelling's style of thinking, Ritter did try for a long time to maintain a critical attitude towards pure speculation, and to test inspiration against experiment, an effort which was to win him some celebrity as one of the first experimental physicists. At Jena he gave methodical lessons in physics and chemistry to a number of students and the discoveries he made are undeniably the result of painstaking and objective work. Yet Ritter somehow managed to combine this with a totally different approach which was more akin to daydreaming. As Henrik Steffens observed, in Ritter's mind 'darkness and penetrating clarity' existed side by side in weird conflict. The evidence suggests that Ritter progressively gave way to reverie as he grew older, and that his strictly scientific career suffered from this propensity – in poetic terms, imagination became more and more necessary to his vision. Ritter's case makes it possible to suppose that the thrill produced by a scientific discovery, when it is fully authenticated by precise observation, will act as an irresistible spur to the imagination. Here the Romantic lesson is that objective knowledge can only be fully 'authenticated' if there is an imaginative response.

Goethe, himself an active researcher into optics, regularly exchanged views with Ritter, and invited him to Weimar on several occasions, even getting him to set up some complicated electrical apparatus for him in 1804. Ritter also knew Herder, was a good friend of the Schlegels, and above all of Novalis, whom he met in 1799. Such contacts were both the result of and the stimulus for the recognition of the common position of both Romantic poet and scientist: each was engaged on a quest for knowledge about the workings of the universe, each was ready to greet the other's specialist information as confirmation of his own findings. Galvanism in particular offered a surprisingly attractive image of the World Spirit as a

manifestation of the reciprocity of chemistry and electricity. It demonstrated a real link between the physical and spiritual. Novalis (who, one should not forget, was a trained scientist as well as a poet) took up the imagery of Galvanism as a poetic property, speaking of the galvanic relation of earthly to heavenly being and of the current which flowed between these two poles. In turn Ritter (who, correspondingly, has a very real claim to be called a poet) would formulate such pronouncements as: 'The infinite sources of electricity are nothing less than the sources of being, now fully disclosed. The very secret of Nature now lies revealed.' From the other Romantics Ritter learned to have faith in intuition and analogy, taking to heart Schlegel's dictum that 'if you wish to penetrate the innermost secrets of physics, you must first initiate yourself into the mysteries of poetry.' Ultimately both enquiries merged into a single mode of investigation which was only too willing to adopt a mystical posture once it was agreed that the world should be seen as a dynamic process and not just as a structure of inert matter.

In 1805 Ritter left Jena to take up an appointment at the Academy of Sciences at Munich. Here he produced a book entitled *Physics as Art* (*Die Physik als Kunst*), 1806, which outlined his view of his work. According to Ritter, man is presently experiencing his separateness from Nature, and his consciousness is what creates the agony of yearning. He must now attempt to attune himself to the cosmic rhythms and allow his soul to be reintegrated into the greater organism. Earth and Man are analogous, indeed a perfect correspondence obtains between the macrocosm of the world and the microcosm of man; it is therefore enough to adduce a description of man in order to arrive at a description of nature. If the deep structures of natural organisms are perceptible to inner vision, man can best make contact with the world from which he is estranged by way of a striving toward total consciousness, which – and here the Romantic argument becomes one of resolving logical contraries – will involve both total knowledge of the self and a mystic dissolution of that self within the cosmic totality. With this Novalis-like programme of 'artistic physics', it is small wonder that Ritter found himself drawing away from the empirical sciences toward something more akin to psychological, if not parapsychological research. In 1806 he travelled to Italy to examine a water-diviner called Campetti, who could pinpoint underground sources through his divining-rod (which is, incidentally, a frequent Romantic symbol for magical intimacy between man and natural forces). Campetti accompanied Ritter back to Munich, to continue experiments with a device called the sidereal pendulum; Ritter published this research as evidence of an observable link between the human nervous system and a sympathetic natural world; this particular man and Nature were poles on the same galvanic circuit. In due course Ritter researched into somnambulism and hypnotism, and developed a theory of 'passive con-

sciousness' which represents a kind of resolution of his own inner hesitation between logical and analogical thought. Passive consciousness is the counter-balance to active consciousness; it is the 'somnambulist within us' which helps us to regain a childlike sense of participation in the world, coming closer to the things which normal consciousness tends to register as alien or distant. Ritter also suggests that sleep, the analogue of death, represents a direct way back to nature; as also does love, that parallel medium through which the solitary self offers itself to absorption within a greater whole.

Since 1800 Ritter had been gathering notes for an aphoristic work in the vein exploited by Schlegel and Novalis. The *Posthumous Fragments of a Young Physicist (Fragmente aus dem Nachlass eines jungen Physikers)*, 1810, is a kaleidoscopic collection of poetical musings, with intriguing definitions such as 'Optics is transcendental chemistry' and samples of scientific lyricism which begin to sound like mediumistic inspirations: 'The light that is released in processes such as combustion is, so to speak, a hole that gives access to another world. A flame is like the opening-up of Heaven'. Schelling's conception of the world process is echoed in the statement that 'in Galvanism the earth attains self-reflection.' This strange and definitely unscientific work appeared in the year of Ritter's death as the summation of his thinking. His was a strange mind indeed. He could, as he once said, read alternately his two favourite novels, *Wilhelm Meister's Apprenticeship* and *Don Quixote*, finding them by turns to be either droll or deadly serious; the remark is revealing, and reflects something that Schlegel posits in the theory of irony, namely the resolution of conflict in the creative personality by the initiation of eccentric movements to compensate for the concentric movements of the mind intent on itself. When Ritter died at the age of thirty-four, after overwork and poverty had ruined his health, he had achieved a remarkable degree of Romantic ambivalence. One is at a loss as to whether to categorize him as a split personality or as a man who finally experienced a higher synthetic vision of life. Like Novalis, another Roman-tic who died young, Ritter was undoubtedly more than a novice at the temple of Isis.

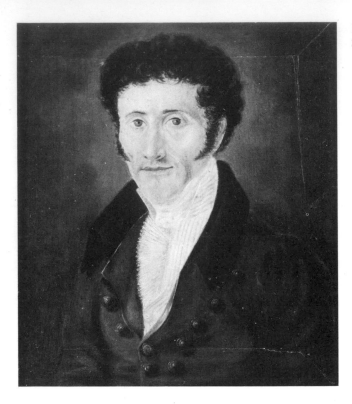

Ernst Theodor Amadeus Hoffmann

KÖNIGSBERG 1776–BERLIN 1822

Hoffmann's life was a succession of disappointments and rebuffs which forced him constantly into a path against which his nature rebelled. Circumstances continually thwarted his most cherished ambition, to be a composer, pressing him into the unwilling role of a legal official in the Prussian civil service. 'It is absolutely typical of my life that what happens is what I least expect, whether for the worst or for the best, and that I am constantly forced to do things that run counter to the laws of my innermost being', he once wrote. It was through an almost ironic compromise that he made his reputation as a writer of fantastic tales, the only solution he could manage to the conflict between his aspirations to the purest art and the necessities of daily existence.

His inebriate father having divorced his mother when Hoffmann was three, she passed on the burden of his upbringing to his uncle, and he grew up an undirected and lonely child. His aunt Sophie sometimes sang to him, and the beauty of her voice merged into his private reveries during hours spent improvising at the piano. The demands of life lay hold on him in 1792, however, when he became a law student at the University of Königsberg; despite his studies, his artistic development continued with piano-playing and drawing-lessons. When sent to another uncle's notary office in Glogau, Silesia, Hoffmann befriended a painter called Molinari, who inspired in him a passion for art by his example of uncompromising dedication. But a legal career seemed unavoidable, for in 1798 the uncle became a judge in Berlin and engineered an opening for his nephew. Thus began a sequence of boring legal posts which Hoffmann occupied for almost ten years, enlivened only by transfers between various towns in Poland, which at this time lay under Prussian administration – Posen, Plock, Warsaw. At whatever spiritual cost, Hoffmann learned how to do the minimum work required to keep his official career going, while cultivating a totally different life in his free time as a Bohemian café-goer. A robot by day, he celebrated his artistic liberty by night in long sessions of intoxicated talk or reverie. The Polish woman he married in 1802 helped him preserve official respectability; she remained faithful till his death, despite a number of minor scandals on his part, some of them amorous escapades.

During all these years Hoffmann was still hoping that somehow he could become a true artist; he wavered between painting and music, not yet envisaging literature at all. In Warsaw he had begun composing seriously, first for piano, later for orchestra, and had founded a music society. When his administrative career was interrupted by the French occupation of the city, he was glad of the chance to move to Berlin and devote himself to music properly, as well as to investigate that city's fine cafés and nocturnal walks.

Hoffmann's great chance came when in 1808 he managed to get appointed as *Kappelmeister* (musical director) in the little Bavarian town of Bamberg. His musical career was finally a reality, and Hoffmann did all he could to make it a success, not only carrying out his duties as conductor and general manager of the theatre, but also designing and painting scenery, translating texts, and generally doing all the odd jobs. He continued to compose his own music and branched out into music criticism, thereby taking a first step towards literature, which was confirmed by the publication of his first story *The Chevalier Gluck* (*Ritter Gluck*) in 1809. He spent the evenings drinking and talking at the Rose Inn, which adjoined the theatre. To supplement his income, he had to give singing lessons, and it was through them that he came to meet a young girl called Julia Marc, whose voice so enchanted him that he at once idealized her as the incarnation of musical

beauty. Admiration developed into infatuation, and became jealous rage when Julia's family intervened and married her off to a dull, boorish fellow called Göpel. Hoffmann disgraced himself in public one day by pretending to be a dog and trying to bite his rival in the leg; but the real Julia was irremediably lost, even though in sublimated form his passion for her continued to inspire him for years.

By now Hoffmann was writing stories fairly regularly, though he was still very much an active musician. But luck began to turn when the Bamberg Theatre was closed down in 1813, and the only post he could find was that of music director to an opera company in Leipzig and Dresden; this was run by an unpleasant manager with whom he quarrelled after a few months. Times were hectic, for these were the days of Napoleon's siege and occupation of Dresden, but Hoffmann kept his distance from political events, and continued to develop as a writer, producing perhaps his best story, *The Golden Pot (Der goldene Topf)*, 1814, and starting a novel, *The Devil's Elixirs (Die Elixiere des Teufels)*, 1814–15. It had now become quite clear that music was a poor means of securing an income, and, it may be surmised, Hoffmann had realized that he was really a writer rather than a musician. His talent for painting, which had never really assumed prime importance, now evinced itself in the caricatures with which he sprinkled his manuscripts. In 1814 Hoffmann decided that a regular administrative job with plenty of spare time was after all the best compromise, and he took up the post of deputy judge at the Court of Appeal in Berlin, returning for good to his favourite city. His creative imagination began to produce ideas at great speed; in the remaining eight years before his death he wrote dozens of tales, fairy-stories, so-called night-pieces (*Nachtstücke*), and several novels. It is ironical that at the time when he had renounced a musical career, his greatest musical success should come, for in 1816 his opera *Undine* ran for twenty-three enthusiastically received performances at the Berlin opera house. Yet Hoffmann must have recognized the final twist of irony when, on the twenty-fourth performance, the theatre burnt down, destroying the costumes and the scenery along with any last hopes he may have toyed with. Now he entered on his final career as drinker and storyteller, a founder member of the Brotherhood of Serapion, a circle of intimates which met each night to tell tales around a bowl of punch. In these Berlin years Hoffmann knew several Romantic writers – Fouqué, Chamisso, Arnim, and Brentano were his friends, and he also met Tieck, Eichendorff, Grabbe and Heine.

In 1820 Hoffmann sat on a legal commission that the police department was trying to pressurize into legalizing various arrests and other repressive measures that had become commonplace in the period of reaction following the Congress of Vienna. Hoffmann did his best for some months to uphold justice against political manipulation, and then, feeling himself to be

E. T. A. Hoffmann. Manuscript score of Symphony in E Flat Major

powerless, withdrew from the Commission in disgust. He was indiscreet
enough to insert a thinly disguised satire on police methods in the story
Master Flea (Meister Floh), 1822. His powerful enemies started proceedings
against him and he struggled to resist; he fell ill and gradually became
paralysed. Confined to his bed, Hoffmann continued dictating a few last
tales right up to his death.

Though rarely performed nowadays, the musical compositions into
which Hoffmann put so much hope are of a sufficiently high quality to merit
his recognition as a minor composer rather than just a dilettante, much in
the way that Carus deserves to rank as a painter rather than an amateur.
Hoffmann composed several piano sonatas, a Symphony in E Flat and a
Mass in D Minor in the Mozartian idiom; a Harp Quintet, a Piano Trio,

choral works in the Italian Baroque manner; and a *Miserere* in B Flat Minor, his best choral work, which shows the influence of Beethoven, whom Hoffmann saluted as the great Romantic composer. His best opera is *Undine*, for which his friend De la Motte Fouqué prepared the libretto from his fairy-tale about a water-sprite who marries a mortal in order to gain a soul, which then becomes the cause of all her woes. The setting, with its contrast between the world of mortals and the magical world of the water-sprite, gave Hoffmann the opportunity to develop appealing orchestral textures, the human voices moving over an orchestral background in which murmuring figures suggest water.

Music was for Hoffmann, as for many Romantics, the highest art, the one which represents the transition from the human to the transcendental. However, the magnificence of this conception was not something his actual talent as a musician could hope to do justice to. Hoffmann was simply unable to meet the demands he assigned to music, and the discrepancy between the ideal and his actual achievement became progressively more blatant during his years as a conductor. His frustration colours several of the literary works to which he then turned. Hoffmann's very first tale *The Chevalier Gluck* is about an old man who claims to be the composer Gluck (who has in fact been dead for twenty-odd years). This queer old gentleman raves incoherently about having visited the Realm of Dreams, where he learnt divine music, yet manages to play Gluck's music on the piano from a score of perfectly blank pages. Eccentric mannerisms and nervous tensions that stem from an inability to cope with the demands of infinite beauty are characteristic of the musician who stands most completely for Hoffmann's own self, the Kapellmeister Johannes Kreisler, who appears in the collection of pieces called *Kreisleriana* (1815). Kreisler is the Romantic artist par excellence, caught between his aspirations to the infinite and the futility of reality. As Hoffmann's other self he objectifies both Hoffmann's sufferings in love and his shortcomings as a composer; by directing a cruel irony against Kreisler, Hoffmann tries to distance himself from his problems. Yet they manifestly remain to haunt him, just as Kreisler is haunted to the point of insanity by the incomparable beauty of a girl's voice heard in a dream, which he knows he cannot translate into real music. The secret affinity with Kreisler which hides behind authorial scorn is also apparent in *My Views on Life by the Tom-Cat Murr* (*Lebensansichten des Katers Murr*), 1819–21. Here, Hoffmann poses as the publisher of the memoirs of a complacent cat whose story has been composed on sheets torn out at random from a book which turns out to be none other than the biography of Kreisler: the printer has by mistake reproduced the two texts as one. Thus the Kreisler story, given only in this fragmented and purely accidental way, is made to seem of peripheral interest, though the descriptions of Kreisler's passion for the beautiful Julia betray Hoffmann's real emotions.

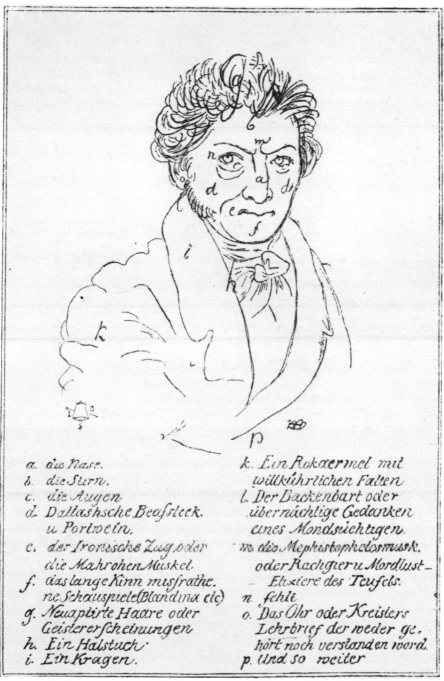

a. die Nase.
b. die Stirn.
c. die Augen
d. Dallashsche Beafsteek.
 u Portwein.
e. der Ironische Zug, oder
 die Mahrohen Muskel
f. das lange Kinn missrathe.
 ne Schauspiele (Blandina etc)
g. Neuapürte Haare oder
 Geistererscheinungen
h. Ein Halstuch·
i. Ein Kragen.

k. Ein Rokærmel mit
 willkührlichen Falten
l. Der Backenbart oder
 übernächtige Gedanken
 eines Mondsüchtigen.
m. die Mephistophelesmusk.
 oder Rachgier u Mordlust_
 _ Elixiere des Teufels.
n. fehlt
o. Das Ohr oder Kreislers
 Lehrbrief der weder ge.
 hört noch verstanden word.
p. Und so weiter

E. T. A. Hoffmann. Self-portrait with humorous key to details.

E. T. A. Hoffmann. Handwritten announcement of the death of his cat, Murr, in 1821

There is a peculiar dualism in Hoffmann's work, for although he uses writing as a medium to express his secret desires, he feels a concomitant need to enfold this medium in a wrapping of derision and self-distancing irony. It is as though he has to dissociate himself from his innermost being in order to protect it. A complex psychic conflict underlies Hoffmann's predilection for the motif of the *Doppelgänger*, the double who is at once equivalent to the self and its opposite, a relation which might be said to parody Fichte's Ego and Non-Ego. Hoffmann's literary doubles may often be taken simply to represent the conflict between the transcendental and the terrestrial, or in plainer terms, good and evil. If one wishes, one can read a parable of Good versus Evil into the struggle between the monk Medardus and his double Viktorin in *The Devil's Elixirs*, a novel in which dozens of characters all turn out to be blood relations of one sort or another: their genealogical tree fairly bristles with incestuous cross-connections. Elsewhere, the *Doppelgänger* theme is presented in terms of the two sides of a

split personality. In *Mademoiselle de Scudéry* (*Das Fräulein von Scuderi*), 1818, the master-jeweler Cardillac is another version of the Hoffmannian artist, the creator possessed by his art. Cardillac is so jealous of the perfect works he makes that he is prepared to kill to recover the jewels that men buy from him. Creative and destructive instincts co-exist in him, and the only solution to his inner conflict must be his death.

Hoffmann specializes in portraying aberrant behaviour, having once studied mental disturbance at first hand when a friend of his was director of the lunatic asylum outside Bamberg. For Hoffmann, madness is a state of receptivity to knowledge which is not available to normal consciousness. Similarly, states of hypnosis, he believed, give the mind access to unearthly regions, since trance means a return to the unconscious, that is, to Nature, a reunion with the World Soul. Hoffmann also associated inspiration and insight with other phenomena such as clairvoyance, dreams and poetic visions. All these provide glimpses of a second reality which eludes normal perception. The problem is how to communicate these glimpses in words. In his tales Hoffmann tried to follow a literary principle defined during the sessions of the Brotherhood of Serapion: the 'Serapiontic Principle'. According to this, the author may portray only what he can claim to have *seen* with his mind's eye; at the same time, his portrayal must clearly distinguish between what is imaginary and what is real. In other words, the principle tends to exacerbate a conflict between reality and unreality, at once persuading the reader that everything that happens is literally true, while giving him ample evidence that this is not the case. The process of reading Hoffmann's tales is therefore one of vacillation between the credible and the incredible, a vacillation which may eventually lead to a paradoxical result similar to the one Schlegel expected of Romantic irony. The continual reminders that the author is *not* demanding that the reader should believe everything he says, tends to disarm the reader's critical faculty in such a way that he may even begin to accept the supernatural as on a par with the natural. In accordance with Schlegel's precepts, Hoffmann's work combines inventive spontaneity, at its most excessive and arbitrary, with self-possessed reflection which shapes chaos into controlled form so that even the most pointless-seeming tale reveals a hidden purpose in the end. A conscious skill is evident in the careful way he builds up the two parallel orders of experience, the natural and the supernatural, now introducing events which at first appear normal, but which are not; or which appear impossible at first, but turn out to be perfectly plausible later on. A short story called *My Cousin's Window* (*Des Vetters Eckfenster*), 1822, describes a method of observation which is really very similar to that of someone like Ritter. The narrator visits his cousin, who is confined to his bed, and relates to him what is going on in the market-place below: these objective observations are spun by the cousin into an interpretative thread which links

them into a dramatic story. Rigorous observation is thereby shown to furnish a strong impetus to the flight of the imagination. This suggests that when Hoffmann gives precise details of streets, the names of cafés and the like in his stories, this is partly a device to set the reader up for a shock when unreality obtrudes, but partly also to goad his own fantasy into action by underlining its polar opposite, as though he needed to stimulate his escape-mechanisms by harping on humdrum reality.

The popular notion is that Hoffmann wrote spooky tales which frighten a little and amuse us. It is true that many of his stories confirm the impression of a minor entertainer who happened to stumble on certain tricks of the horror-tale and the whodunit that were to be developed to better effect by Stevenson, Poe and a whole line of later writers. But there are signs of a deeper seriousness. Now, when Hoffmann introduces aberrations into his stories, he will often insert a safety-clause that insures the sceptical reader against having to read the tale as an illustration of supernatural events. When this safety-clause exists, that reader is at liberty to dismiss the uncanny as a purely literary device. But such a dismissal may be premature, and the more sensitive reader will realize that to explain, for example, Cardillac's murders or Gluck's ravings as manifestations of lunacy is not necessarily to reduce them totally to the known. A mystery persists, despite the apparent clarifications. In Hoffmann's most impressive tale, *The Golden Pot*, it becomes clear that aberration is a signal of an authentic transition between the known world and an unknown reality which transcends it. In such a story Hoffmann is evidently trying to do more than provoke a few transitory shivers; rather, he is seeking to express genuine mysteries, indeed to outline a veritable mystical doctrine.

The Golden Pot probably stands up to a deep symbolic probe better than any other of the tales. Briefly, it tells the story of Anselmus, the clumsy dreamer who cannot cope with earthly matters, and the conflicting loves he feels for, on the one hand, Veronika, the pretty daughter of a philistine citizen of Dresden, and on the other Serpentina, the green and gold snake with beautiful dark-blue eyes, daughter of a salamander who is temporarily incarnated as the Archivist Lindhorst, living in that city. The bare mention of a few discrepant data cannot hope to convey the force of the story, in which Hoffmann maintains the plausibility of both domains, real and mythical, until Anselmus finally makes the leap of magical initiation and chooses Serpentina rather than Veronika. In one scene, Serpentina enchants Anselmus by singing to him from the water as he crosses the river in a boat: here Hoffmann is able to sport majestically with the reader's credulity, and Anselmus himself, in a moment of commonsense, decides that the whispering and glinting are not produced by a snake at all, but by

Caspar David Friedrich *View through the studio window* 1806

the wind in the trees and the sunlight on the water. But as the tale develops, Hoffmann stresses more and more resolutely his allegiance to mystical truth. Taking up the myth of Atlantis which Novalis had used in *Ofterdingen*, the realm of the Golden Age before the Fall, Hoffmann – for once discarding his usual armour of distancing irony – gives way to powerful poetic reverie in passages of synaesthetic imagery which conjure up a vision of a higher world which is both the realm of Harmony and of Poetry, and the realm of the Unconscious. A variant on the myth occurs in the story *The Mines at Falun*, this time in conjunction with Hoffmann's more typical effects of creepy suspense. The hero, Elis Fröbom, leaves his fiancée in order to seek a bright red stone in the depths of the mine; he never returns. Many years later she witnesses the recovery of his petrified body, which turns to dust when exposed to the air. He has become one with the elemental realm: his search for the stone is seen as a quest for absorption into Nature. In the terms of Carus, man's ultimate access to higher Truth must be accompanied by the loss of personal individuality within the unity of the Absolute.

It is in visions such as these that Hoffmann can be considered a Romantic of the genuine visionary type. It is true that he is not always eager to deal wholeheartedly in miraculous events; he often gives the impression of being more of a conjuror than a Magic Idealist. Yet the concessions he may have made to convention – whether in his actual life or his writings – were made as a means of gaining the psychic stability he needed before he could make incursions into realms of supernatural splendour and beauty. Of the Romantics, he was the one who most hesitated to accept that Night might offer enrichment rather than terror; yet he felt no less strongly than the others the yearning for a superior reality. The eccentricity that has consolidated the image of Hoffmann as a rather pathetic entertainer who only dabbled in the occult may under closer scrutiny turn out to be the distorted expression of a yearning to prove to himself that the ideal world of music and of art is truth, not illusion.

Carl Philipp Fohr
Self-portrait *c.* 1816

Carl Philipp Fohr

HEIDELBERG 1795–ROME 1818

Fohr learned to draw as a child in Heidelberg, and his brilliant caricatures frequently delighted his classmates. His father, a schoolmaster, realized that his son was unlikely to benefit from a conventional education, and entrusted him to a drawing-teacher, who encouraged him to wander off into the near-by countryside and learn to draw by copying from nature. Fohr wandered from village to village around Heidelberg, moving up and down the river Neckar with its castles and forested hills, collecting sketches and watercolours in little albums. Later, a painter called Wilhelm Issel, recognizing his talent, invited the boy to Darmstadt for proper lessons. Fohr was eager to learn and his landscapes soon gained a remarkable maturity and depth. When he made the gift of an album from his Neckar wanderings to the Princess of Hesse, she commissioned a series of scenes from her native region of Baden. The young man spent weeks wandering in the

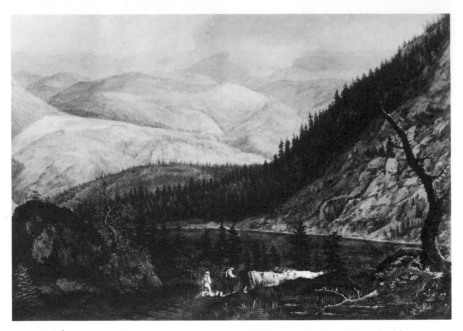

Carl Philipp Fohr *The Mummelsee* *c.* 1814. With inscription 'The darkly shadowed mirror of the water lies unmoving'

Black Forest conscientiously filling up the album. One watercolour from this trip shows the control and intensity that he already commanded. It is *Der Mummelsee* (*c.* 1814), a lonely lake to which is attached the legend of a sprite who dies of love for a young shepherd. In Fohr's picture, two peasants follow their cattle down towards the water, which nestles amid forests in the silent gloom. 'The darkly shadowed mirror of the water lies unmoving' are the words he wrote under this eerie image. Despite the element of gloom, the watercolour is strangely pure in tone, being tinted throughout with a queer, delicate blue which establishes the mood of a minor key while lending the whole image an exquisite translucent beauty.

The Princess having agreed to give him a small grant, Fohr moved in 1815 to the famous Academy at Munich, there to submit to the strictures of disciplined study. But he slipped away from classes whenever he could, either to consult the Old Masters in the public museums, or else to set off, as he did that summer, on a hiking tour of the Tyrol, an experience of release through space that he captures in exuberant watercolour drawings with an exhilarating range of colours and an almost melodic uplift of line. These drawings are perfect examples of what might be called 'open-air Romanticism' of the kind celebrated in the tales and poems of Eichendorff.

Back in Munich, Fohr fell under the influence of the popular artist Johann Anton Koch, a specialist in massive landscapes which insist on the sublime effects of rainbows or spectacular waterfalls and abysses, and nowadays create an impression of exaggerated rhetoric. This influence was counteracted to some extent, however, by Fohr's sudden passion for old Germanic myths and folk-tales; with a friend called Ruhl he did a number of line engravings as illustrations to the Nibelung myths, and tales by Fouqué and Tieck. Ruhl also introduced Fohr to oil-painting, which he mastered almost at once. But the authorities frowned upon Fohr's extramural activities and he was obliged to withdraw from the Academy in 1816.

Carl Philipp Fohr *Italian landscape with convent* c. 1817, pencil drawing

Carl Philipp Fohr
*Mountain Landscape
with Shepherds
(Landscape at
Rocca Canterano)*
1818

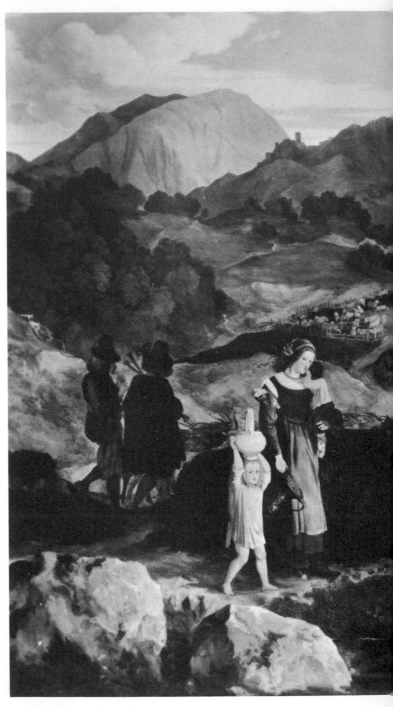

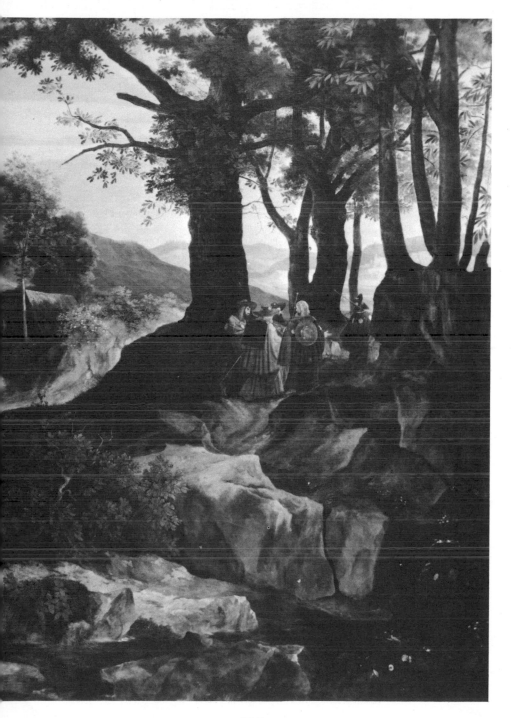

He went home to Heidelberg, where his family had moved to a charming house by the entrance to the castle. Fohr was in his element in this old university town where students roamed about in their newly-formed student associations or *Burschenschaften*, dedicated to democracy and German unification; he adopted their uniform of archaic German dress and long hair, joined in their libertarian drinking-songs and followed them on mock-heroic adventures down the Neckar. His lively sketches of these picnics reflect their gaiety as well as the deeper seriousness that underlay the students' flouting of philistine disapproval.

Late in 1816, Fohr set off on foot, with only a dog for company, hiking down through the Black Forest and Switzerland, and on to Rome, unable to resist any longer the pull of the South which had preoccupied a whole generation. In Rome he got to know the Nazarenes with their monastic dress and long hair and he did a number of pencil portraits of members of the group, showing a remarkable alertness of eye and controlled sharpness of line. He also came once more under the influence of Koch, in whose studio he worked for a time. His oil-painting *Mountain Landscape with Shepherds* (*Landschaft bei Rocca Canterano*), 1818, has something of Koch's monumental idealization about it, though the use of glowing reds and greens and a sense of rhythm in the placing of figures and details in a complex interplay of near and far, give the structure of the landscape a surprising buoyancy. Fohr was coming to the height of his powers at the age of twenty-three, and seemed on the point of establishing a telling equipoise between heavy northern atmosphere and urgency and southern clarity and calm – the kind of painting one imagines Friedrich might have done had he ever succumbed to the lure of Italy. There is at least the possibility that Fohr would have gone on to achieve the synthesis of precise observation and intuitive command of natural form that Carus had theorized about but himself failed to achieve. As it was, Fohr's astonishing progress as an artist was cut drastically short. One hot afternoon in 1818 he put aside a drawing and went down to the Tiber for a swim; his body was recovered from the river a few days later. Ironically, the unfinished drawing was on the mythical theme of Hagen being enticed by the water-maidens into the Danube.

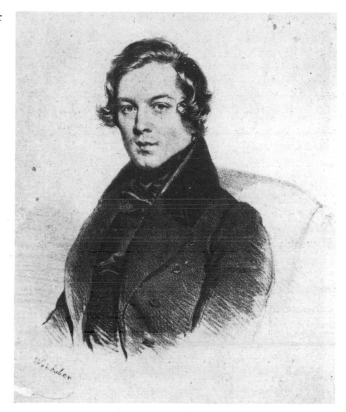

Robert Alexander
Schumann
Lithograph by
Kriehuber 1839

Robert Schumann

ZWICKAU 1810–ENDENICH 1856

Robert Schumann's birthplace was a peaceful country town in Saxony, where his father ran a bookshop and small publishing business. As a child Schumann was allowed to browse through the books in the shop, and developed an early taste for the colourful historical novels of Scott and the extravagant poetry of Byron. He began keeping a diary in which he recorded his own poems, usually inspired by walks in the idyllic countryside around the town. He also started to play the piano, and, with occasional lessons, developed to the point where he could sight-read and so explore the sheet music in his father's shop. The piano soon became his confidant and spiritual medium, though he continued to pursue his literary interests through such authors as Schiller and Jean Paul. The latter was his most ardent love:

for the world of Jean Paul's novels, in which the depiction of idealized relationships in idyllic settings is shot through with sly quips and whimsical jokes, exactly corresponded to his own temperament. The sonorous, musical qualities of Jean Paul's prose, especially in the poetic descriptions of dream experiences, led Schumann to the later comment that 'from Jean Paul I learnt more counterpoint than from my music teacher.' Schumann started several literary projects, beginning at least two novels, and writing three plays, as well as many poems. In 1826 his elder sister Emilie committed suicide, and his father died soon after. The dual shock left Schumann melancholy and passive for some time. Then, acceding to his mother's wishes, he enrolled as a law student at the University of Leipzig, thus placing himself in exactly the same dilemma as had faced Wackenroder and Hoffmann – the choice between Law and Art. The discovery of the music of Franz Schubert in 1827 confirmed his overwhelming preference for art, and specifically the *non*-verbal art of music as against literature. Not that the effect of Schubert was really very different from that of Schumann's literary hero: 'When I play Schubert,' he would say, 'I feel as if I were reading a novel scored by Jean Paul.' And in choosing music, Schumann did not abandon literature completely; in 1828 he made a special pilgrimage to the cosy little room in the inn outside Bayreuth which Jean Paul had visited every day to do his writing. On the same trip he met the lyric poet Heinrich Heine, who was developing his own special mannerism, the late Romantic grimace. Years later, Schumann would set his poems to music, but at this meeting his own youthful Romanticism was slow to respond to the older man's sour ironies. For a time Schumann lived in Heidelberg, his law studies progressively giving way to musical interests. After a concert by the virtuoso violinist Paganini Schumann decided to write to his mother explaining that music meant more to him than law ever could; she agreed that he take piano lessons for a trial period. Schumann became a pupil of Friedrich Wieck in Leipzig, who had a reputation for almost brutal strictness. Wieck, at this time, was zealously promoting the career of his own daughter Clara, a child prodigy at the piano who at the age of twelve was giving concert tours in France and performing at Weimar before Goethe. Schumann was soon able to demonstrate to his mother the correctness of his choice of career by publishing two works for the piano, the *Abegg Variations* of 1831 (based on the musical motiv ABEGG, the surname of Meta Abegg, a girl Schumann had known in Heidelberg) and the suite *Papillons* (1832). This collection of magical little pieces, with swift changes of tempo and a kaleidoscopic variety of moods ranging through anxiety, passion, melancholy, boisterousness and irony, was based on a chapter in Schumann's favourite Jean Paul novel, *Unfledged Years*, in which Walt the dreamer and Vult his energetic spiritual twin exchange disguises at a masquerade in order to establish which of them their beloved Wina really loves. The

twirling succession of pieces creates an impression of lighthearted play undershot with a tragic sense of uncertainty and unfulfilled yearning. This is the impression that lingers when the last chords chime away into silence.

By 1832 Schumann had given up his lessons, resolving to improve his technique himself by setting up a mechanical contraption to develop the agility of his fingers, a kind of sling which immobilized the fourth finger while the other fingers carried out exercises. The unfortunate result was that his third finger became paralysed, thus putting an end to his hopes of becoming a concert pianist. The injury was followed by the first serious signs of psychic unbalance, with a short period of depression which featured suicidal reveries and unjustified panic at the news of a cholera epidemic spreading from Russia.

In Leipzig, Schumann initiated the 'League of David', a group of young musicians who met daily at a restaurant to discuss means of promoting new ideas in a world made gloomy by Philistine culture. The *New Journal of Music* was set up as a polemical organ, with Schumann as editor and principle contributor. His great achievement was to establish a new type of music criticism, neither superficial nor pedantically analytical, but which took its cue from Hoffmann's remark that music critics should be 'enraptured visionaries' by basing commentaries on music upon a combination of passionate enthusiasm and lucid intuition. Many of Schumann's musical reviews took the form of lively dialogues between different characters, often between Eusebius and Florestan, twin characters *à la* Jean Paul from one of Schumann's unfinished novels. These two reflected the two sides of Schumann's character, the first his reticence and tenderness, the second his fiery impetuosity. An example of Schumann's poetic approach to criticism comes from his celebrated essay on Chopin, where he explains the effect of listening to Chopin's music in terms of visual images suggested by the black notes scattered on the page: 'It was as though all kinds of strange eyes were looking at me in a wonderful way, eyes of flowers, basilisk eyes, eyes of a peacock, eyes of a girl. . . .' The more aggressive side of Schumann's personality came out in polemical articles which fought to distinguish the genuine from the fake in a time characterized by much meaningless showmanship and virtuosity on the part of both composers and performers. The impact of the journal was enhanced by its anonymity, for pseudonyms were the order of the day; this gave the League of David the character of a militant secret society engaged in cultural warfare with the Philistines.

Schumann's passion for codes and cryptograms strongly affected *Carnaval* (1834–5), another piano work in the 'masquerade' manner, comprising a gallery of portraits of his friends. At the time, Schumann was engaged to a girl called Ernestine, who came from the town of Asch. Schumann was delighted when he found the letters of this word corresponded to the only musical letters in his own name (SCHumAnn), and that, furthermore, they

gave scope for no less than three equivalent musical spellings. The piano score is thus built up as a network of enigmatic allusions to people and emotions. Not only are simple ciphers and motto phrases used, but Schumann develops a veritable secret language of musical devices to convey (or rather, to disguise) quite specific messages. This dabbling in aural hieroglyphics took a serious turn following his realization that Wieck's daughter Clara, identifiable as 'Chiarina' in one of the *Carnaval* portraits, had become the object of his deep and yearning love. Wieck was furious when he discovered this, and did all he could to disrupt the relationship. For several years he combined cunning with brutality, trying to convince Clara of Robert's indifference, sending her off on long concert tours abroad, preventing her from writing to him and even forcing her to return his letters. The medium through which the lovers were able to maintain faith in each other's love, over several years of enforced separation, was the piano. Though she might be in some distant foreign capital, Clara could send a message of love to Robert by playing one of his compositions in concert, knowing that he would read of it in the papers; and Schumann in turn made contact with her in a way Wieck could not prevent, by composing love letters in the form of piano pieces.

The compositions of this period form an intimate diary of doubts, desires and sufferings, articulated in music. One five-note phrase recurs so often that it cannot but be a code to denote Clara's name; and in the letters that were occasionally smuggled past Wieck, Schumann repeatedly exhorts Clara to read his music more carefully so as to uncover the messages he has hidden in the notes. The piano thus becomes the next best thing to verbal communication, and the evidence of the later song-writing, where a given word or phrase is set in correspondence with a given musical effect, makes it legitimate to suppose that Schumann based his music on a highly developed vocabulary of equivalents. Certain keys can be seen to denote particular moods: A major is always sunny, E minor always crepuscular. A tremolo in the treble may suggest a passing breeze, a sequence of silvery chords the chiming of bells. These are obvious effects, but some are more subtle, as for instance the use of soft, half-extinguished notes to suggest evanescence, a common device at the close of a piece, the diminished seventh chord with its connotations of wistful perplexity, and the flattened seventh that indicates a majestic uplift on to a transcendental plane. Insistent martial rhythms convey the virile urgency associated with Florestan; lingering, hesitant ones are reminders of Eusebius. The overlaying of separate rhythms, syncopation and shifts in accent create an impression of irregularity and disquiet, one of Schumann's most distinctive traits. Of course, not all listeners would wish to take Schumann's music in this literal way; but it is important to realize that this most Romantic of composers did not write solely in a state of inspired *Träumerei* (reverie) but was intellectually con-

scious of manipulating a code of meanings. The 'literary' or rather poetical character of his work is further enhanced by a departure from tradition in the use of German rather than Italian words to identify the quality of a piece. Many of these are intrinsically emotive: *innig* (tenderly, intimately), *flüsternd* (in a whisper), *durchaus fantastisch und leidenschaftlich* (in a thoroughly fantastical and·passionate manner), *wie aus der Ferne* (as though from a distance), etc.

The magical obscurity which is the great charm of Schumann's piano music characterizes his next compositions, the yearning *Fantasia* in C Major (1836), the *Davidsbündlertänze* (*Dances of the League of David*) (1837) and the *Fantasiestücke* (*Fantasy Pieces*) (1837). The title of these last was taken from Hoffmann, as was that of the masterly *Kreisleriana*, which Schumann composed in four days in 1838. Drawing on the analogies he felt between his own dissonant personality and that of Hoffmann's character, the mad musician Kreisler, Schumann contrives a mercurial sequence of contrasted moods – frenetic, indolent, tragic, calm, nervous – to create a febrile compendium of introspective states. The composition typifies the best piano work of Schumann: within its miniature compass, each fragment attains a maximum distillation of mood, rising up and fading away almost at once, a tiny yet successful assault on the inexpressible. Often dissymmetrical and disquieting, with sudden swerves from one key into another which is totally unexpected, in a manner reminiscent of Jean Paul's jests, these fragments have a strange overall coherence, for which the only explanation is the composer's affective commitment to each facet of the whole: he is all these separate selves, he embraces each separate mood.

In 1838 Schumann travelled to Vienna to see if he could establish his journal there, but found the cultural life of the Austrian capital far too mediocre. All he brought back from the trip was the manuscript of Schubert's C Major symphony, unearthed from among his papers, and a steel pen which he found on Beethoven's tombstone, and which became a talisman used for copying up his most ambitious scores. The tendency to superstition, a variant of the basic Romantic susceptibility to seeing inner meanings in external things, was beginning to grow in Schumann. Indeed it took on an uncanny aspect, entirely congruent with his affinity for Hoffmann, when in 1839 he had a premonition of his brother's death during the composition of a work called 'Corpse Fantasy', later renamed *Nachtstücke* (*Night-Pieces*), another of Hoffmann's titles.

Practical affairs occupied Schumann nonetheless, and at one time he even considered taking up law again in order to seek a way round the odious Wieck, whose animosity was reaching paroxysmic heights. In 1840 Schumann managed to obtain an honorary doctorate from the University of Jena as an emblem of his respectability, and when the law proceedings he had initiated in order to marry Clara finally reached court, the tribunal decided

in his favour. At last the lovers could marry. Schumann's wedding-present for Clara was the song-cycle *Myrthen*, settings of poems by Heine including the love lyric 'Du bist wie eine Blume' ('You are like a flower'). In this single year, 1840, Schumann completed an extraordinary total of 138 songs, the texts being by Heine, Eichendorff, Chamisso and others, mostly simple lyrics in the folk-song idiom. It was as though secrecy were no longer necessary, and feeling could now issue forth in words.

Now that he had ensured his emotional security, Schumann addressed himself to more ambitious tasks, composing two orchestral symphonies in 1841. The first, the *Spring Symphony (Frühlingssymphonie)*, opens with a trumpet-call to awaken thoughts of spring and goes on to evoke different aspects of that season. Yet this is more than mere programme music, for that which is immediately signified by the music – Spring – should in turn be taken as signifying something more: the sense of growth, of becoming, a theme which is also enacted in the very unfolding of the musical themes. Taken in this sense, the music celebrates not just a literal spring, but the processes of creation, both natural and artistic. The next symphony, revised in 1851 when it was numbered the *Symphony No. 4*, achieves a marvellous coherence which confirms Schumann's maturation from a kaleidoscopic to a truly organic style. With no interruptions between movements, the symphony is a pattern of interleaved variants on two motto themes. A Kreislerian duality emerges at several points, however, for instance in the second movement, the 'Romance', where a trivial-seeming oboe figure is then stretched out by the violins into a plaintive, yearning sequence of tones, a deepening of the flippant into the profoundly serious; then comes a triplet figuration that seems to turn over and over itself in tiny wavelets; it is taken up again in the Scherzo in alternation with a long unravelling statement which is given an appearance of seriousness before being brought to a sudden, flippant curtailment. Schumann often uses this odd effect of profundity juxtaposed with triviality, in a way reminiscent of a Kreisler making puns in the midst of emotional upheaval; perhaps this is Romantic irony, being brought to bear on moments of intensity by a composer fearful lest his tragic register sound pompous and hollow to others. The landscape of the symphonies is thus one of cloudscapes and sunny vistas in the grand Romantic manner, with merry jesters and tragi-comic fools entering the scene not so much to belittle it as to throw its magnificence into relief.

A period of great productivity now followed, with the Piano Concerto, the oriental oratorio *Paradise and the Peri (Das Paradies und die Peri)*, 1841, and several pieces of chamber music. Leipzig had now become the musical capital of Europe; Schumann saw Mendelssohn frequently and was visited by such celebrities as Berlioz and Liszt. His relations with his wife were good, though he often felt overshadowed by her concert successes, thanks to which she was becoming regarded as the greatest woman pianist of the

Robert Schumann. Manuscript score of the *Spring Symphony*, Symphony No. 1
in B Flat Major

time. Schumann went almost unnoticed when he accompanied her on her Russian tour in 1844, and on returning to Germany had a nervous breakdown, complaining of hearing the trumpet note C in his head. More and more, Schumann needed quiet, and the couple therefore decided to exchange Leipzig for Dresden, which after being a centre of Romantic activities earlier in the century had by now slowed down into a conservative, rather reactionary city. Resolving to pull himself together, Schumann called on his third persona, Master Raro, only occasionally mentioned in the *Davidsbund* days, the sober, integrative element of his being, to exert control over the manic-depressive twins Florestan and Eusebius. Preoccupied with compression and unity rather than inventiveness, Schumann devoted himself to contrapuntal studies, producing his one work for organ, the *Six Fugues on the name of Bach* (*Sechs Orgelfugen über BACH*), 1845. In 1848 he wrote his only opera, *Genoveva*, based on a medieval legend, and the incidental music to *Manfred*, based on Byron's grandiose story of a tormented hero who is passionately in love with his sister and who is driven half-mad by the attraction of good and the temptation of evil. Schumann eschews Byron's disastrous ending in which Manfred dies cursing, refusing all redemption, and gives the piece a subdued, sacral finale with bells ringing solemnly. Visions of the abyss were too extreme for Schumann to accept, as they had been for Goethe, on whose *Faust* he had worked for several years to produce a setting for chorus and orchestra. A separate offshoot of this homage to the Master was the choral *Requiem for Mignon* (1849), which celebrated the elusive heroine of Goethe's novel *Wilhelm Meister*. A piano work, *Waldscenen* (*Scenes of the Forest*), 1849, also avoids anything stormy, conveying a Romantic's vision of the forest as a domain of tranquil enchantment. Florestan's one manifestation was the *Four Marches* (*Vier Klaviermärsche*) known as the 'Barricade Marches' with which Schumann saluted the brief flowering of revolution in Dresden in 1849. In fact, he had avoided being involved in the actual fighting at the time, though his young friend Wagner was active on the barricades.

In 1850 Schumann accepted an offer to become conductor at Düsseldorf, in the peaceful Rhineland. The *Cello Concerto* and the *Rhenish Symphony* (*Symphonie Nr 3, die Rheinische*), were written here, and Schumann enjoyed a brief period of happiness with his family and his new friends the violinist Joachim and the young composer Brahms. However it became embarrassingly obvious to all concerned that Schumann was much too reflective, too indecisive to be a conductor, and after some disastrous performances he was persuaded to resign his post. Now he developed a passion for spiritualism, and spent hours trying to establish contact with the supernatural world through table-turning. His mental condition deteriorated and he began to experience difficulties in speaking, and then auditory hallucinations. He could hear music in his head, he said, being dictated to him by the angels:

it was ineffably beautiful, and caused him 'marvellous sufferings'. Now Schumann experienced at first hand the madness that Hoffmann had imagined for Kreisler. He tried to copy down the transcendental music, but it resisted transcription; it gave him ecstasy, yet also pain, for it was destructive of his earthly being. One night, seized by delirium – or perhaps, propelled by a lucid courage – he went down to the river and jumped in. He was rescued, and soon thereafter, at his own request, was taken to a clinic at Endenich near Bonn. Henceforth his mind, exhausted by the Romantic struggle of opposed forces – Florestan and Eusebius, elation and depression, major and minor, good and evil, the infinite and the finite – was incapable of any significant reaction to what went on around him. He composed a little, but spent most of the time sitting quietly, his mood varying minimally between melancholy and a vague good humour. He received a few last visits from Brahms, Joachim and Bettina von Arnim; when Clara came to take her leave as he lay dying, he could say nothing to her. His end was one of perfect silence.

Achim von Arnim

BERLIN 1781–WIEPERSDORF 1831

Reactionary landowner and poetic dreamer, Prussian nationalist and alienated artist – the contradictions in our image of Arnim make him one of the most difficult Romantics to pin down. Like all Romantics he recognized the importance of inner feelings and intuitions; unlike many of them he recognized the need for restraint to prevent individual caprice from developing into a socially disruptive force. Yet for all his professed allegiance to the principles of stabilization and security, he was himself too enthusiastic, too impulsive to complete any coherent and balanced work. Goethe once compared him to a barrel with loose hoops whose contents burst out on all sides.

Achim von Arnim
Portrait by
P. E. Ströhling

Ludwig Joachim von Arnim was born in Berlin in 1781 into a rich Prussian family of the *Junker* class, the landed aristocracy. His mother having died at his birth, he was brought up by a strict grandmother who constantly reminded him of his social rank and responsibilities. At the age of seventeen he went to the University of Halle, where he distinguished himself as a diligent and precocious student in Natural Science and Law. Within a year his passion for physics had prompted him to write and publish a *Sketch for a Theory of Electrical Manifestations* (*Versuch einer Theorie der elektrischen Erscheinungen*), 1799, a clear and sober essay on electricity and the dynamic impulses within Nature which avoided metaphysical speculation, though Arnim was soon to learn of Schelling's Nature Philosophy and his ideas of the World Soul. In 1800 Arnim moved on to Göttingen, where he began to drift away from science to literature; his warm friendship with Clemens Brentano soon confirmed his vocation as a poet. In 1801 Arnim's father provided him and his elder brother with a coach and servants so that they could make the customary Grand Tour to round off their education: they were away from home for three years. Dresden, Munich

and Vienna were cultural goals, while Frankfurt meant a friendly call at the Brentano home, where Arnim met his friend's striking seventeen-year-old sister, Bettina. Arnim and Brentano went off on a trip on the Rhine, sporting themselves as wandering poets and developing a keen interest in the songs of the boatmen. Then the Arnim brothers moved on again, travelling slowly through Switzerland, France, England, Wales and Scotland. By the time they got back to Berlin, where their father had meanwhile died, Arnim had accumulated enough yearning for his homeland to mark him a Prussian nationalist for life, and enough poems to consider himself a man of letters. Though he was now heir to the family estates, he decided not to become involved in running them himself but to rely on the income to support his literary ventures.

In 1805, Arnim and Brentano were reunited in Heidelberg, where they busied themselves with an anthology of German folk-songs. That year they published the first volume of *The Young Lad's Magic Horn* (*Des Knaben Wunderhorn*). It contained authentic songs of the people, revised and even elaborated upon by Arnim, who seems to have felt no qualms about participating in the collective creation. Thus Heidelberg became a centre to promote Herder's idea that folk-culture was an expression of the popular spirit in which all Germans should take pride, parallel efforts being made by Görres, and by the brothers Grimm in Göttingen. In 1806, Arnim had an opportunity to manifest his patriotism when Prussia faced up to Napoleon's army at Jena, but, curiously, he restricted his participation to writing some patriotic *War Songs*. In 1808 a second volume of the *Magic Horn* appeared and, together with Brentano and Görres, Arnim edited a literary paper, the *Hermits' Journal*, which for five months acted as a forum for most of the major Romantic writers of the time. By now Arnim had been courting Bettina Brentano for several years, and in 1811 the two were married. Returning to Berlin, Arnim founded the Christian-German Dining Club, a group of patriots which included Kleist and Müller and which stood for the re-awakening of the Prussian spirit after the demoralizing defeat of Jena, and vociferously opposed the liberal reforms of Chancellor Hardenberg. The organ of the Club was the *Berlin Evening Paper* (*Berliner Abendblätter*) under the direction of Kleist, of whom Arnim became a close friend in the months before his spectacular suicide. A poor playwright himself, Arnim published at this time an unwieldy and episodic drama on contemporary life called *Halle and Jerusalem* (1811), a moralistic injunction to social and spiritual regeneration. War broke out once more in 1813, and this time Arnim enlisted as an officer in an infantry battalion, though he very soon opted to serve the Prussian cause by his pen rather than his sword. He became editor of the political paper *The Prussian Correspondent* (*Der Preussische Korrespondent*), writing articles which warned the nobility of the dire consequences of a tolerant attitude towards liberalism. In lighter

Title-page of the second volume of *The Young Lad's Magic Horn* 1808.
Engraving designed by Clemens Brentano with W. Grimm and A. Weise

vein, he published a collection of comic sketches on patriotic themes for the puppet or shadow-play theatre. Then, in 1814, apparently weary of the struggle against the reform movement, he suddenly retired, though still young and energetic, moving from Berlin to his country estate at Wiepersdorf south of the capital, where he devoted the last seventeen years of his life to the problems of farm management and the education of a family which eventually numbered seven children. His writing during this last period bears no obvious relationship to his practical concerns.

Arnim's prose works testify further to the paradoxical nature of this forcible yet curiously passive man. His first novel, with the tongue-in-cheek title of *The Poverty, Riches, Guilt and Repentance of the Countess Dolores, A True Story for the Instruction and Entertainment of Poor Spinsters* (*Armut, Reichtum, Schuld und Busse der Gräfin Dolores*), 1810, is in fact a highly serious allegory which can be taken on two levels. The plot, summarized in the title, concerns a poor but enterprising girl who contrives to marry a rich and cultivated count, is unfaithful to him, and then repents, only to fall prey to the agonies of jealousy when she suspects the Count himself of infidelity. While recognizing the power of the passions, Arnim views extra-marital relationships like those extolled in Schlegel's *Lucinde* as a recipe for disaster; he firmly supports the traditional bonds of marriage as the means to accommodate human urges within the social and divine law. More subtly, the novel points a political message, the folly of indulging revolutionary ideas in a Prussia whose stability can only be maintained by traditional feudalistic ideology. The fact that the adultery occurs on 14 July seems to equate the assault on marriage with the French Revolution's assault on the *ancien régime*.

The manner of the book, however, runs completely contrary to its ostensible message. While the argument may be for order, the development of the narrative obeys no law. Disparate, spasmodic, uneven, it is a carefree response to Schlegel's idea that the novel should gather all other literary forms into itself, and become a kind of book of books. Arnim crams his novel with playlets, poems, songs, verse dialogues, and even fragments from one of his own previously-published works. The welter of bits and pieces naturally destroys any hope of a homogeneous texture; but there are literary rewards, for this unrestrained approach provides the impetus for some entirely original prose experiments. One particularly striking passage is the Count's interior monologue after he has learnt of his wife's adultery in a dream. The dream also tells him he must go away, and so he departs in haste by coach. In this state of upheaval his mind gives itself up to a flow of thoughts which he does nothing to restrain. The Count's abandonment of emotional control is reflected in Arnim's abandonment of linguistic control, as these fragments demonstrate:

Über Stock, über Stein, drein, drein, ohne Bewusstsein; knackt's, bricht's, wirft's um, ich sitze stumm; meiner Blicke einzige Sprache ist ewiges Wachen, ein nordischer Tag ohne Nacht in hallender rastloser Jagd.

* * *

Wie bin ich zur Küste des Meeres gekommen allhier, oder kam das Meer zu mir? – Ich seh mich im Spiegel des Meeres an, ein jeder über sich selbst wohl lachen kann; ich meinte, das Glück mir lächle zurück. Wie Stossvögel drüber die Sorgen viel trüber, sie dringen hernieder und weichen nicht wieder. Die Narben und Falten sich zeigen und halten, selbst von den Toten nicht scheiden; doch spurlos sind Freuden, ein gleitender Strahl hin übers zerrissene Felsental.

* * *

. . . Mir wird nun endlich bange, dass ich gar nichts hab besessen. Hab ich einstmals doch gesessen meinem Glücke in dem Schoss und hier sitz ich nackt und bloss. Neun Monat lag ich im Mutterschoss und hab ihn mit Weinen verlassen, so liess mich die Liebe nackt und bloss am Berge in Nebelmassen; die Schwalben streifen nur daran, wie um das Grab des Geliebten; sie hören mich singen und wissen nicht wo, und kreuzen durch die Lüfte und verlieren sich im Klaren.

(Over stone and stump, bump, bump, unawares; there's a crack, there's a snap, it's overturned, I sit like a mute; my only words are in my eyes that endlessly watch, a nordic day bereft of night, an echoing frenzied chase. (. . .) How did I get here, to the coast of this sea, or did the sea come to me? – I look at myself in the watery mirror, anyone can laugh at himself; I thought my luck was grinning back at me. Like birds of prey above, far gloomier woes pressing down relentlessly. Scars and wrinkles appear and stay, they never even leave the dead; but joys leave no trace, a gleam of light that shoots across the jagged gorge. (. . .) I am gripped now by fear that I have possessed nothing. Yet once I sat in the womb of my joy, and now sit here naked and exposed. Nine months I lay in my mother's womb and left it weeping, just as love has left me naked and exposed on this mountain in a sea of fog; the swallows skim over it, as though circling a loved one's grave; they hear me sing and know not where, they streak through the air and are lost in the blue.)

Real and imaginary events are confused in the Count's consciousness. We witness his numbed awareness of a bumpy road, his bewildered examination of his reflection in water, his anguish and exhaustion on a mountain

shrouded in heavy mist. The effect of alienation is supreme. A somnambulistic voice, blank and pitiful, seems to mutter, with the rhymes and rhythms of a feverish uncontrolled language, which exposes the emotional torment in shrill sounds and glaring pictures. Here Arnim's prose achieves a poetic density that is quite exceptional.

The Romantic's general dreaminess is tempered in Arnim by his own peculiar sharpness of vision. A love of tales from the national past drew him to study ancient documents, and on these he based some of his narratives, such as the unfinished novel *The Guardians of the Crown* (*Die Kronenwächter*), 1817. Whereas the picture of medieval life painted by Novalis, for example, is bathed in an idealizing golden haze, Arnim's picture is clear-cut and multi-coloured, with detailed descriptions of costumes, buildings, architecture and social behaviour. Not that Arnim was simply a pedantic arranger of factual evidence: as he said, he was less interested in writing history than in filling in the gaps in history. The story is told of a journey he made to Waiblingen in search of material for this novel, after he had already described that town in an earlier part of the story. From his carriage window, he saw that the place looked entirely different from how he had imagined it, and he promptly gave the order to turn about and drive away. Imagination was, after all, the higher authority.

In adopting the Romantic precept, derived from Fichte, that the creative genius has a perfect right to regard its own creations as objective fact, Arnim relies on his imagination to carry him over problems, such as gaps in historical knowledge, which threaten his hold on the narrative. His work is thus marked by continual transitions, sometimes barely perceptible, sometimes blatant, between what is normal and orderly and what can only be called fantastic. Arnim seems to have realized there is little point in seeking to exercise total control over the two modes of inventiveness, the realistic and the fantastic; rather he tried to gauge at what point he should give way to the arbitrary and the uncontrolled, and when he should switch back.

The poles of fantasy and realism are explored in the two stories *Isabella of Egypt* (*Isabella von Ägypten*), 1812, and *The Crazy Invalid at Fort Ratonneau* (*Der tolle Invalide auf dem Fort Ratonneau*), 1818. The former is crammed with enough of the supernatural and uncanny to fill a dozen tales by Hoffmann: there is a gypsy-witch, a golem, a mandrake, a zombie, a dog possessed by the devil, not to mention hypnotic trances, magic prophecies, and wild disguises. In *The Crazy Invalid*, a rational explanation is provided for the freakish happenings: the crazy sergeant who runs amok and threatens to bombard the city of Marseille with fireworks and cannonballs is shown not to be possessed by the devil, as was initially hinted, but suffering from the effect of an old headwound. He instantly recovers when, in a frenzy, he tears out handfuls of hair, thus reopening the scar and relieving pressure on

the brain – a realistic solution as likely to make the reader's skin crawl as would an uncanny one. The work in which a balance between the two poles is most perfectly achieved is the weird story *The Majorat Heirs* (*Die Majoratsherren*), 1820, which maintains confusion in such a way that supernatural happenings appear quite normal, while normal ones are fraught with fearful mystery. The young Heir has for many years made a study of spiritualism and mesmerism. Is it his impressionable imagination which makes him see souls pulling at people's coat-tails in the streets, or a raven perched on the head of old Vasthi, Esther's evil stepmother? It is simply the acuity of his hearing, Arnim tells us, which enables him to hear the angel of death flying overhead. At one point the Heir asserts that he can distinguish precisely between what he really sees and what he imagines he sees: here Arnim is deliberately placing extra strain on the reader, who is already struggling to make just such a distinction within the story. Night after night the Heir gazes from his window across the narrow street at Esther in her bedroom enacting a nightly charade with imaginary visitors, whose voices she mimics to perfection. So brilliant are her performances that the Heir is almost convinced of their reality, and when one night she announces that the Heir himself is at her door, a cold shiver runs down his back: 'He was afraid that he would see himself come in; it was as though he were being turned inside out by his own hand, like a glove when it is pulled off.' One night he hears people shouting that Esther is dead, and looking across he sees Vasthi throttling the girl, like a vulture crushing a dove. He *sees* how the angel of death lets the bitter drop fall from its sword into Esther's mouth, and how it washes the sword in a bowl of water. As the real and the supernatural, the objective and the hallucinatory merge into one, imagination is celebrated as the sublime medium for apprehending the invisible reality that is immanent in the visible world. Then the Heir's mind suddenly snaps, he leaps across from his window into Esther's room, drinks from the bowl and dies. Arnim offers no explanation for the cause of his death.

As if these events were not enough to wrestle with, Arnim adds a secondary plot for comic relief, in which the Heir's cousin, an eccentric bachelor who collects coats-of-arms and keeps turkeys under the rafters, pays court to a waspish old lady who makes him comb her pet poodle every Sunday afternoon. When the cousin inherits the house after the Heir's death, the poodle and a retinue of other pets take over completely, and the cousin is made to wait at table on them. The author's sardonic detachment is evident in this grotesque epilogue, which undercuts the tale with yet another level of uncertainty. The effect is harrowing, but once we recover, we wonder why Arnim has dissociated himself so deliberately from the world he has created. Is this another case of Romantic irony? If it is, the effect of dissociation is not achieved by the author intervening to comment

on his work, as Arnim does in the early novel *Dolores*; in this late story he seems to be blocking up all the fissures through which he might be tempted to gain entry into the tale. One senses that the projected fantasy has begun literally to frighten him by its hallucinatory clarity. He therefore has to go on building up the structure of alternate layers of reality and unreality, normality and abnormality, carefully folding them over and inwards so as to form an inextricable and impenetrable whole: such a story cannot be broken down and analysed, even if we know it to be an amalgam of conflicting components. Somehow this image of the closely-knit artefact does not seem incongruent with family life on the self-contained estate at Wiepersdorf. The whole secret of Arnim may lie in this effort to hold together things as they strain apart. Whether one thinks of his tales which veer between fantasy and realism, or of his life with its alternating impulses towards poetry and politics, towards establishing a literary name and up-holding the family name, there seems to be a fundamental vacillation between what can be broadly categorized as, on the one hand, the sense of freedom that can lead to anarchy, and on the other, the sense of responsibility that can lead to dogma and tyranny. Impossible as it was for Arnim to tighten the hoops round his barrel, his life and work give a fascinating image in miniature of the spiritual and political conflicts that gripped his age at large.

Carl Gustav Carus

LEIPZIG 1789–DRESDEN 1869

Born in the year of the French Revolution, Carl Gustav Carus lived long enough to become the last of the pure Romantics. One of the most culti-vated men of his time, he was a practising physician, nature philosopher, psychologist, writer and painter, who managed in his maturity to attain a serene overall view of most of the regions explored by younger Romantics. His writings during the forties and fifties give an impression less of personal originality than of collective wisdom. He was the man who could tie the different strands of Romantic thought into one powerful thread, and fill in the composite pattern which many of his predecessors had only vaguely

sketched. He is thus heir to, and custodian of, the whole range of Romantic intuitions and discoveries.

Even as a child Carus showed a gift for perceiving forms and structures in the external world, and in the countryside around his native Leipzig he made drawings of plants, trees and rocks. At the University of Leipzig, he enrolled at the age of fifteen for a series of different courses – botany, zoology, geology, physics, chemistry, medicine – finally settling to study the last in depth in 1806. After graduating, he took up medical practice, and gave lectures on comparative anatomy. By 1814, at the age of twenty-five, he had been appointed Professor of Obstetrics and Director of the new Academy for Surgery and Medicine in Dresden, where he then settled permanently. Here, besides his considerable professional duties, he managed to find time to pursue many personal research projects, writing scientific and philosophical books and painting pictures. In 1817 he met Friedrich, and they developed a warm friendship in which Friedrich, fifteen years his elder, took the role of mentor. Carus acquired a taste for the landscapes that Friedrich was fond of – desolate hills with lonely wanderers, cemeteries under snow, Nordic seascapes, and so on. (Carus tells how Friedrich would

give him tips, for instance how to create the effect of moonlight on canvas by applying a dark glaze over the picture surface, beginning close to the source of light and working up deeper darkness towards the edge of the picture.) The two painters often went on sketching trips together in Saxony and Bohemia, and on Friedrich's urging, Carus journeyed in 1819 to the island of Ruegen, following Friedrich's previous itinerary almost step by step, and delighting in the stark outlines of the cliffs and the stone-age mounds that give the island its peculiar 'Ossianic' atmosphere. A year later, Carus again emulated his master by travelling through the Riesengebirge, where he painted basalt outcrops and other rock formations, acknowledging the importance of geological science for the appreciation of scenery. Through the twenties, the two artists continued to collaborate, making use of each other's sketches for their oil-paintings, to the point where their pictures sometimes turned out to be almost identical. They also painted local views of Dresden, and some interiors. When Friedrich drifted into his later melancholy, Carus drew away from him. His own painting subsequently veered towards a naturalistic style announcing the Biedermeier idiom which was to follow upon Romanticism.

Concurrently with these artistic pursuits, Carus was producing important scientific works such as a *Textbook of Animal Anatomy* (*Lehrbuch der Zootomie*), 1818, and a *Textbook of Gynaecology* (*Lehrbuch der Gynäkologie*), 1820, for which he prepared his own careful and accurate engravings. This work brought him into contact with Goethe, who was keenly interested in all researches into the forms of natural life, and a correspondence developed which lasted until Goethe's death in 1832. Carus also corresponded regularly with other eminent scientific figures such as Oken and Humboldt. From 1827 till his death in 1869, Carus was fortunate to hold the position of personal physician to the King of Saxony, which position carried the advantage of occasional journeys abroad to Italy and Scotland; on one of these he visited Fingal's Cave in the Hebrides and marvelled at this masterpiece of natural structure. The post also gave him the leisure to write books whose titles testify to an extraordinary breadth of interests: *Basic Comparative Anatomy* (*Grundzüge der vergleichenden Anatomie*), 1828, *Nine Letters on Landscape Painting* (*Neun Briefe über Landschaftsmalerei*), 1831, *Friedrich the Landscape Painter* (*Friedrich der Landschaftsmaler*), written on Friedrich's death in 1841, *Towards a Closer Understanding of Goethe* (*Goethe. Zu dessen näherem Verständnis*), 1843, *Psyche. A Contribution towards the History of the Development of the Soul* (*Psyche. Zur Entwicklungsgeschichte der Seele*), 1846, *Physis. A Contribution to the History of Physical Life* (*Physis. Zur Geschichte des leiblichen Lebens*), 1851, *The Organon of Cognition of Nature and Spirit* (*Organon der Erkenntnis der Natur und des Geistes*), 1856, and *Nature and Idea, or the Laws of Becoming* (*Natur und Idee, oder das Werdende und sein Gesetz*), 1861. With his ability to combine convincingly the disciplines of physiology and

Carl Gustav Carus *Alpine Valley* 1822

psychology, physics and metaphysics, natural science and philosophy, Carus was able to give Romantic thought that sober, reflective, even majestic expression which prompts Alexander Gode-von Aesch to call him 'the classical executor of Romanticism'.

It is instructive to compare the painterly styles of Friedrich and Carus. Friedrich's is one of simple grandeur in which landscape is reduced to its most austere essentials, while appearances are given a kind of transcendental glimmer which seems to allude to a space lying beyond visible space. Carus, while often using similar compositional forms, tends to concentrate on superfluous detail which slackens spiritual intensity. In a picture like *Alpine Valley* (*Hochgebirgstal*), 1822, he seems so intent on the accurate depiction of rock formations, on rendering their specific texture and hardness, that he produces impervious things-in-themselves rather than forms which invite a symbolic interpretation. Friedrich's effect of spiritual universality may thus be contrasted with Carus' attention to concrete particulars, the former's distraught depths with the latter's surface realism. However,

it must be said in Carus' defence that it was never his intention to be merely naturalistic, but rather to combine accurate observation with a deeper intuition of the organicity of Nature. His drawing of the basalt formations of Fingal's Cave is more successful in this respect, for if it is pedantically accurate as a record of objective phenomena, it also gives some sense of the mystery inherent in the natural architecture.

The theory formulated by Carus in his *Nine Letters* may be taken as the central Romantic doctrine on landscape painting, though strictly speaking it is a combination of ideas current in the Dresden school in the twenties (Friedrich, Dahl, Carus, Ochme) and later reflections developed by Carus

Carl Gustav Carus *Basalt Formations inside Fingal's Cave c. 1844*

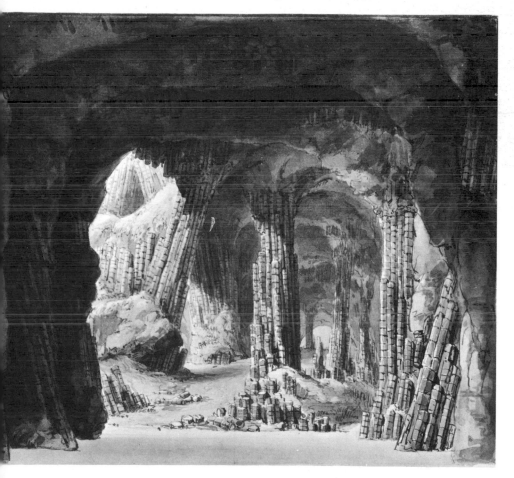

under the influence of Goethe's scientific ideas. In these *Letters*, Carus speaks of the painted landscape as apprehending what he calls the Idea underlying the view depicted. Whereas a mirror image of a given scene is only a fragmented piece of Nature abstracted from its organic context and hence lacking completeness as a representation of Nature, the painted landscape is a microcosm in its own right, an intensification of the particular which brings out an inner meaning, in such a way that the viewer is given the sense of being lifted above his material existence and borne on to a higher spiritual plane. Carus proposes that a new word, *Erdlebenbild* (or image of the living forces of the earth), be used to describe this sort of picture. The term implies not only that the painted landscape should have a spiritual effect, but that it should be at the same time a faithful piece of observation. Carus refers enthusiastically to a poem by Goethe about clouds, insisting that in order to write it the poet had first to carry out thorough studies of atmospheric conditions, after which 'the spiritual eye collected together all the distinct rays of the phenomenon and reflected back the essence of the whole in an aesthetic apotheosis.' The description of this procedure is a model for the painter, and Carus goes on to recommend that the artist study vegetation, climate, rock formation, and the like, as a means to knowing Nature as a reality both concrete and spiritual. Describing this as the Orphic view of landscape, whereby the earth is experienced not as something inert but as a living organism, Carus calls for a synthesis of science and art that will lead the artist-scientist to gain fluency in 'Nature's language'.

The influence of Goethe is paramount in Carus' work. Like the Romantics, Goethe saw Nature in terms of interrelated forms. Creation was purposeful, and he divined behind its multiformity a single primal figure, the *Urphänomen*. In pursuing his dominant interest in morphology, the study of structures, Goethe went to Italy in search of the *Urpflanze*, the primal plant from which he surmised that all the variety of plant forms derived; eventually he decided that it did not exist as such, but that all plants are variants on a single primordial unit, the leaf: that is, petals, stamens, seed capsules and actual leaves are all elaborations of this basic part. Goethe applied similar reasoning to the field of vertebrate anatomy, where he posited a primal type from which all skeletal forms derive, thus establishing a model of the animal body as an organic form whose components are interrelated and similar, and add up to an integral whole. Further ideas along these lines were advanced by the Nature Philosopher Lorenz Oken, Professor of Medicine at Jena, who advocated a speculative approach to animal morphology. He developed the theory that all organic forms were spherical, all inorganic ones, angular. His work on animal vertebrae led him to the conclusion that the cranium was nothing other than a modification of the spinal column, being composed of four verte-

brae. Carus' later revision of the theory proposed six sections of the skull as vertebrae.

Such apparently wild ideas were in fact founded upon a single precept, namely that in organic form lay the secret of the patternings of the natural world. Whether he opted for the sphere or the ellipse, whether he sought the *Urpflanze* or the *Urskelett* (one of Carus' ideas was that the skeleton was a development out of what had originated as a simple ellipse, the egg-shell), the principle underlying the Romantic scientist's attitude remained constant: all parts of wholes are interdependent, and in turn all these wholes are interdependent parts of the greater whole, Nature at large. Carus defined the scientist's task as being to gather data about the external world and to discover universals from which 'the inner coherence of the totality of Nature' could be demonstrated. A firm believer in God, Carus identified the life principle in Nature with the divine, advancing his version of Nature Philosophy as a *Philosophie des Werdenden* (Philosophy of Becoming), referring to the purposive energies in the world in their motion towards the divine generator. The premise of organicity meant that universal rhythms must be reflected in the movement of the tiniest particles of life, including man's own inner life. In a way that reflects Schelling's concept of Absolute Identity, Carus postulates a universe contained within, though not to be identified with, the godhead. Nature incarnates the divine Idea, but forfeits some measure of purity in this incarnation, so that the processes it now undergoes are an ascent back to perfection, or reintegration in God. It would be misleading to think of this as Pantheism if this implies a static universe, for if all things are divine already, there is no need of any striving. Carus himself speaks of 'Panentheism', which means that all things in the world partake of the divine without being fully equivalent to God. God is centre and animator of all things, but is not reducible to the universe. As the Absolute Being, he mysteriously contains this one imperfection.

The motive force which shapes all things is known as the Idea, in Carus' terminology. He suggests that if one agrees that Nature is the incarnation of the Idea, then whether one refers to matter or idea is only a question of viewpoint since both are manifestations of the one entity. The task of man is to understand this, and to learn to witness within himself and in external life, those aspects which reveal pure Idea. To this end, man must develop his faculty of psychic insight, and so rise in consciousness of the Idea, eventually to transcend this earthly existence. Meanwhile, he continues to live within Nature, or objective, non-conscious reality.

In his later works, Carus develops an intriguing and suggestive picture of the human psyche which constitutes the apex of his speculations. A human being, he says, develops through several stages in his advance to adulthood. Beginning with the unconscious vegetative state of an embryo, he progresses in his physiological development to the consciousness of the

world that babies have, which is more instinct than free consciousness, and finally emerges in adulthood as a free being, conscious of self, able to develop his awareness of the world and himself in total liberty. These stages of human growth, which are paralleled in the three levels of external life: plants, animals, human beings, are a progression from bodily to spiritual existence in which each stage subsumes rather than supersedes the previous stages. Hence Carus' striking claim that embryology is really a branch of psychology – or rather, that each is a study contributing to a total science of consciousness.

Our lives, argues Carus, develop through a kind of dialogue between our conscious and our unconscious mind. Certain activities are necessarily unconscious in their character: the acquisition of skills such as composing the letters in a word when writing, or playing notes on a piano correctly, usually implies an effort to establish non-conscious reflexes or to turn conscious knowledge into unconscious knowledge. For knowledge is never truly integrated into our being until we can absorb it into our unconscious; otherwise it remains static, purely conceptual. Carus has a remarkably dynamic view of the interaction of the conscious and unconscious levels of mental activity. He explains the phenomena of memory and anticipation as functions of this interaction. Consciousness is characterized by the sense of measurable time and space, whereas in the unconscious time and space become an indivisible unity. Psychic oddities such as premonition and clairvoyance are the result of an individual mind gaining temporary access to the universal unconscious of humanity and Nature. Another way of putting this is to say that certain people are endowed with a non-intellectual faculty of response to cosmic rhythms, thanks to which they can divine events that are impenetrable to the empirical observer. Far-fetched though these ideas may sound, Carus finds it entirely 'natural' that there should be communication between the human micro-organism and the universal macro-organism, given their fundamental affinity, and the continuity between the upper, conscious levels and the lower, unconscious levels of mind, rooted in Nature itself.

The most common states in which access is gained to the unconscious are those of sleep and dream. Sleep, Carus maintains, is a regenerative activity. As consciousness recedes, the individual's vital energy is restored by contact with the incessant processes of unconscious life. (Other sources of renewal are powerful emotional experiences such as love.) Carus explains dreaming as an unconscious activity in which there persists a degree of consciousness without intellectual direction. Dreams thus take place somewhere between total consciousness and total lack of consciousness, and it seems appropriate to speak of the dreamer as leading a double life. Carus insists that this duality is only apparent, for the two orders of experience are to be seen as a continuum, rather than in opposition.

Carus does make a clear distinction between two levels of unconscious activity, the 'relative' unconscious personal to the dreamer – the vast residue of psychic material which remains more or less available to the conscious mind – and the 'general' unconscious, which goes beyond the personal, and is well beyond the reach of the conscious mind. The two levels markedly resemble those distinguished by the modern psychologist C. G. Jung. Jung speaks of the 'personal' and the 'collective' unconscious, the one made up of data unique to the individual, the other of material shared by humanity at large. Carus' account of the process of artistic creation is also similar to Jung's. He suggests that creative insights first come to maturity in the non-rational climate of the unconscious, and then rise triumphantly to consciousness like a light borne up over the waters of the psyche, that reach back into the deep, rich darkness.

Carus' ideas are, for all their intrinsic appeal to emotion, couched in a generally sober style modelled on Goethe's Olympian manner. The effect is of clarity and balance, as though the impulsive intuitions of a G. H. Schubert or a Ritter were being held in check by a measured gravity, achieving a confident balance of enthusiasm and sagacity. Indeed, Carus sees balance as his fundamental principle. He insists that thinking in such terms as 'low' and 'high', 'imperfect' and 'perfect' is an inevitable result of our present perspective. If we could share the divine viewpoint, such contraries would be seen as one: indeed a distinction like that between 'unconscious' and 'conscious' is one of purely limited relevance, since in the Absolute, all polarities must merge into unity. As human beings, it is only natural for us to conceive of our situation as a choice between a descent into total unconsciousness or an ascent into greater consciousness. In fact, if one accepts Carus' point that man cannot return to the vegetative state, the latter solution imposes itself. Yet the ultimate goal would be the same in both cases, the absorption of the individual psyche within the greater unity which is God. What Carus does is to close the circle by equating the deep Unconscious from which we originated with the Absolute or pure consciousness of God. This is a characteristically Romantic paradox, whereby submission is equated with transcendence, what lies below with what lies on high. Carus is trying to point beyond the region of human consciousness, with its sharp distinctions and frightening contrasts, to a realm of reunion and peace where all conflicts are resolved. This surrender of the self is no headlong flight into blackness, but a marvellous flowering of the spirit in a supernatural dimension in which shade and light become superfluous distinctions.

Joseph Freiherr von
Eichendorff Portrait by
Franz Kugler 1832

Joseph Freiherr von Eichendorff

LUBOWITZ CASTLE 1788–NEISSE 1857

Eichendorff, generally recognized as the last major writer of the Romantic movement in Germany, and its most popular poet, was born in 1788 of an aristocratic family near Ratibor in Upper Silesia, a province of Prussia. He spent a blissful childhood in and around the family castle of Lubowitz, a rococo château set amid forested mountains high above the Oder valley in scenery which became imprinted on his mind as the image of the *Heimat* or homeland. Sent to a Catholic school in Breslau, he developed a youthful passion for music and visited the local theatre two or three times a week. In 1805 he and his brother Wilhelm enrolled at the University of Halle, notorious for its wild student population. The brothers steered clear of any turbulence, concentrating on their law studies while also taking in Schleiermacher's lectures on theology and the highly lyrical lectures of the Nature Philosopher Henrik Steffens. A rare concession to idleness came with the walking tour the brothers undertook in the Harz mountains that summer, probably the only time Eichendorff actually indulged in the sort of un-

hurried meandering that was to become a favourite theme in his writings. In 1807 the brothers moved on to Heidelberg, where Joseph was a pupil of Joseph von Görres, who inspired in him a love of traditional folk-poetry. Equally influential were the poets Arnim and Brentano, whose *Magic Horn* anthology virtually became Eichendorff's Bible. Though too young to hope to contribute to *The Hermits' Journal*, Eichendorff was totally immersed in the reigning climate of enthusiasm and invention in which everyone seemed to be writing poems. With its old castle above the winding Neckar, Heidelberg was the perfect image of the Romantic town, and Eichendorff's poetic world remained permanently coloured by this year in which he discovered his vocation. To round off their studies, the brothers went on a Grand Tour in 1808, visiting Paris, Nuremberg and Vienna, before returning to Lubowitz. Their father was hoping that they would now take over the running of the estate, but this proved not to be their ambition; Joseph at least was too busy writing poetry. In due course they moved on to Vienna, to prepare for a law examination which would ensure them comfortable careers in the Prussian civil service. As a devout,

Heidelberg. Watercolour by Karl Rottmann, 1815

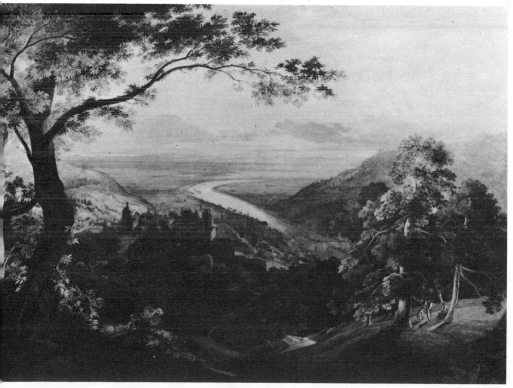

though never fanatical, Catholic, Eichendorff moved in Viennese Catholic circles where there was a great influx of recent converts, such as Friedrich and Dorothea Schlegel. They got to know Eichendorff quite well, and Dorothea read and commented on the young writer's first novel *Presentiment and Presence* (*Ahnung und Gegenwart*), which was eventually published in 1815. Eichendorff was especially friendly with the young painter Philipp Veit, Dorothea's son by her first marriage. During 1812 he attended Schlegel's lectures on the 'History of Ancient and Modern Literature', given before the most fashionable Viennese society, and Adam Müller's lectures on poetic style.

When war broke out in 1813, Eichendorff's patriotism was aroused by Frederick William III's appeal to the Prussian people; he immediately enlisted and remained in the army until the final defeat of Napoleon in 1815. Now he opted for a settled career, and entered service as a government official; he was to remain in the Prussian administration for twenty-eight years, filling various posts in a succession of cities – Breslau, Danzig, Berlin, Königsberg. A respected and efficient bureaucrat, Eichendorff managed to carry on an entirely separate private activity as the poet of nature and love. The restricted horizon of his public work was, as it were, annulled each evening by his literary dreams. The strong element of nostalgia in his work was endorsed by the final sale of the Lubowitz estate in 1822, following the death of his parents; sensing that the past was irrecoverable in tangible terms, Eichendorff never again went back to his actual home. His yearning became totally idealized; it took the typical Romantic form of reveries about far-off days of romance and chivalry when his job required him to supervise the restoration of the former castle of the Teutonic knights at Marienburg. This led to the writing of a historical drama *The Last Hero of Marienburg* (*Der letzte Held von Marienburg*), 1830. After his retirement in 1844, Eichendorff, by now a famous poet, stayed for long periods in Berlin and Vienna, meeting the Austrian writers Stifter and Grillparzer. By this time he had largely given up poetical writing in favour of somewhat idiosyncratic studies of German literary history, seen from the Catholic viewpoint. One of his last projects, before his death in 1844 in his native Silesia, was to translate the religious plays of Calderón.

Eichendorff's major prose-work is *Presentiment and Presence*, whose original German title, suggested to him by Dorothea Schlegel, formulates a characteristic Romantic problem, how to reconcile what is present and actual (*Gegenwart*) with what is, for the time being, only perceptible to the faculties of intuition and divination (*Ahnung*). The two orders of experience are interleaved in the book, which is quite firmly set in the Germany of 1810 at the same time as it insists on transmuting this Germany into something more akin to the romance land of Novalis' *Ofterdingen*. Like most Romantic novels, *Presentiment and Presence* is the story of the development of an artistic

sensibility. The actual plot is extremely complicated, being a sequence of mysterious encounters and improbable reactions strung on a hidden thread which is only seen to have held everything together when the reader arrives at the end. Scene follows upon scene, each more magical, more haunting than the last. The hero, Friedrich, falls in love with a girl with beautiful eyes who stares at him when her boat passes by on the river; a little later he is on a balcony in an inn when she materializes out of the shadows, kisses him on the lips, and then vanishes into the night. When the strange youth called Erwin falls into a swoon after being poisoned, Friedrich loosens his doublet and so accidentally discovers that Erwin is in fact a girl. With his companion Leontin, Friedrich is caught up in a labyrinthine garden lying in the deepest wilderness; when they finally extricate themselves from the ingenious maze, they come upon a ruined castle and a figure carved on a grave: the carving depicts a dead woman entwined with a snake and a broken shield bearing what Friedrich dimly recognizes as his own family crest. . . . The whole novel abounds in such obliquely significant episodes, presented without explanation, and suggestive of a subtle code of private allusions.

Usually Eichendorff's heroes are very different from the tormented types exemplified in Hoffmann's Medardus (*The Devil's Elixirs*) or Chamisso's Peter Schlemihl. They tend to be innocents in the manner of Hoffmann's Anselmus (*The Golden Pot*) or Tieck's Christian (*The Runic Mountain*), although this innocence does not always guarantee immunity to the temptations of the shadowy side of life. Several of Eichendorff's tales show a fascination for the uncanny which, although perhaps not as multifariously productive as Hoffmann's and Tieck's, is every bit as authentically felt. The early *Sorcery in Autumn* (*Die Zauberei im Herbste*), 1809, is a tale of passion and erotic demonicism in the grand Romantic tradition of the Venusberg and Lorelei myths. The knight Raimund falls under the spell of a beautiful maiden to whom he is led by a horn sounded deep in the forest. When he surprises her gazing at her naked reflection in the river, he falls into a frenzy of desire, as a result of which he imagines that he kills one of his friends, a rival for her favours. The couple live blissfully in a solitary castle in the forest until autumn begins to turn into winter, at which the maiden's beauty fades and she turns to stone. After living for a year as a hermit full of despair and remorse, Raimund tells his tale to a knight who turns out to be none other than the man he thought he had killed; the revelation does not shake him out of his obsession, however, and at the end he returns to the forest in a delirium of desire, once more to seek the alluring sorceress of autumn. Eichendorff points no moral to the allegory (if it is one), but does so in the later tale *The Château of Durande* (*Das Schloss Dürande*), 1837, a Gothic tragedy in which the huntsman Renald seeks revenge on the Count Durande whom he (unjustifiably) suspects of having seduced his sister

Gabriele. At the climax, he shoots Gabriele, who is disguised as the Count, then the Count himself; he then sets fire to the Count's château and perishes in the flames. Take care, Eichendorff warns his reader at the close of these horrors, take care lest you awaken the beast that sleeps within you, for it is capable of tearing you to shreds. Other tales are less catastrophic, as for example that other excursion into erotic sorcery, *The Marble Figure* (*Das Marmorbild*), 1819, where the innocent Florio is sorely tempted by the Lady Venus, whose snow-white body gleams in the night like a statue, but finally decides to remain faithful to the fair Bianka, whose love is strictly diurnal.

Eichendorff's best-known tale, *Memoirs of a Good-for-Nothing* (*Aus dem Leben eines Taugenichts*), 1826, is in an entirely different vein. It is the simple story of a simple lad, though its simplicity of narrative style, or rather the total lack of author involvement, is only achieved through highly sophisticated handling. The good-for-nothing hero – we never even learn his name – lives life like an eternal Sunday, never thinking of the future except to wonder vaguely if he will see again the young countess whose beauty so disturbs him. With his customary apparent inconsequentiality, Eichendorff sends him off on unlikely adventures; he is carried off in a coach to a strange castle, he hikes south on the road to Italy, and so on. All the time a convention obtains whereby all disguises, especially the author's favourite one of women dressed as youths, are deemed impenetrable; but there is never any doubt in the mind of both hero and reader that things will turn out right in the end, however confusing they may be in the meantime. Finally the countess is declared to be in fact of low birth, and all obstacle to the lovers' union is removed. A providential outcome that has never been in doubt, may be taken as a straightforward indication of Eichendorff's faith in a divine orderliness in life. Though one might expect his career to have encouraged a pessimistic if not cynical attitude towards the conditions of human existence, he seems always to have maintained a crystalline vision of fundamental goodness. The world epitomized in *Memoirs of a Good-for-Nothing* and the large majority of his poems may be 'escapist', but it does have a serenity and a stability which seem curiously impregnable.

Whereas in reality Eichendorff made his journeys by rail to specific destinations, he explores again and again in his writings the theme of the aimless journey, of departure for departure's sake. On this journey nothing has to be arranged, and one's companions – students, gypsies, musicians – always turn up en route. The only thing one should not forget is one's guitar or fiddle, though one can make do with an improvised song. Spontaneity would indeed appear to be the characteristic feature of Eichendorff's work: for just as the characters in the tales burst forth into song at the slightest provocation (some narratives are so peppered with interpolated songs that they read like libretti), so the act of writing itself conveys a sense

of joyful improvisation, as though nothing had to be planned in advance. When his imagination wanders into the popular idiom of folk-tale and song, the poet often seems deliberately to lower his intellectual guard – though there are signs that the effect of spontaneity is in fact something consciously contrived.

The poems of Eichendorff are indeed so many polished versions of rough diamonds found in the mine of the collective imagination. One of the most famous is *The Broken Ring* (*Das zerbrochene Ringlein*), with its engagingly naïve opening:

> In einem kühlen Grunde
> Da geht ein Mühlenrad,
> Mein' Liebste ist verschwunden,
> Die dort gewohnet hat.

(In a cool hollow/A mill-wheel is turning,/My love is gone/Who once lived there.) As it happens, the verse is based on an actual folk-song from the *Magic Horn* anthology; it is ironical that the poem has since become so popular that it is itself now rated as a folk-song. Set to music by Schumann, the *Volkslied* becomes cultural *Lied*, then, with the spread of culture, becomes *Volkslied* once more. This is possible because at no stage does the song become complicated or self-conscious: its magic is its simplicity. The popularity that Eichendorff's poetry still enjoys can only be explained in terms of this artless appeal. There is a sense of improvisation, as in any folk-music, but never over-elaboration or discord. The titles of Eichendorff's poems are stereotyped – 'Longing', 'Departure', 'The Homeland', 'In the Forest', 'Night Magic' – and the range of vocabulary rather narrow. His skill lies in deploying this limited material in new patterns, developing techniques of permutation or variation that genuinely merit the abused epithet 'musical'. Each poem draws on our awareness of the others we have read, and each fresh rendering of a known theme carries with it the echo of all previous statements of that theme, as well as a kind of anticipated echo of associated themes which are sensed as imminent in the progression of the poem.

The analogy between poetry and music, dear to the Romantic poets, is basic to a whole set of images that surround Eichendorff's central intuition concerning the nature of the external world. Model apprentice at Sais that he was, Eichendorff saw Nature as a text that the poet had to decipher. But where Novalis laid stress on the deciphering and its difficulties, Eichendorff, with the innocent's ability not to be distracted by intellectual niceties, simply reads it off. Indeed so spontaneous is this act of reading Nature's signs, that he speaks of Nature not so much as a text that he must read, but a song that he only has to listen to.

Joseph Freiherr von Eichendorff. Autograph copy of the poem 'Schläft ein Lied'

> Schläft ein Lied in allen Dingen,
> Die da träumen fort und fort,
> Und die Welt hebt an zu singen,
> Triffst du nur das Zauberwort.

(A song lies sleeping in all things/That dream their endless dreams away,/ And all the world will start to sing/If you but find the magic word.) The magic idealist is here a magic conductor who has only to sound the first note for the whole world to burst into song.

To speak of the simplicity of Eichendorff's approach to Nature is, of course, to speak of the simplicity of the representation he offers his reader. His range is that of the song, but never of the extended choral work. Alternatively, the point could be explored in terms of painting, where the analogue for Eichendorff's image of Nature would be the work of Philipp Otto Runge. A picture such as *The Rest on the Flight into Egypt* (*Ruhe auf der Flucht nach Ägypten*), 1805–6, has very similar qualities of clarity and confidence. No detail or outline is smudged, not even in the far background of the scene. The image is very different from Friedrich's troubled and shadowy landscapes, where meanings have to be drawn out from below the surface. With Runge and Eichendorff, the literal surface is godly enough in itself. Eichendorff accepted that art and religion were one and the same – 'true poetry is absolutely religious, just as religion is poetic' – and he saw no point in decking out his style with abstruse mystical metaphors. He is an innocent who sees no problem about poetry and never doubts that its magic powers will operate to resolve conflict so that 'this world and the next sound in wonderful unison, and time and space and all contraries vanish in the mystery of eternal love.'

Nonetheless, there occur across the many hundreds of poems in the collected works many deviations from the standard norm of sunny piety. These poems are attractive by virtue of their indirectness, their hesitancy, their shadowiness. They seem to occur when Eichendorff is dealing with themes which touch him intimately, the theme of the homeland, of the castle in the forest, of the forest itself, and, finally, in its most intense modulation, the theme of the forest as embodiment of shadow and night.

One such nostalgic piece is a poem written for his brother in reminiscence of the sites of their childhood:

> Denkst du des Schlosses noch auf stiller Höh?
> Das Horn lockt nächtlich dort, als ob's dich riefe,
> Am Abgrund grast das Reh,
> Es rauscht der Wald verwirrend aus der Tiefe –
> O still, wecke nicht, es war als schliefe
> Da drunten ein unnennbar Weh.

Philipp Otto Runge *Rest on the Flight into Egypt* 1805–6

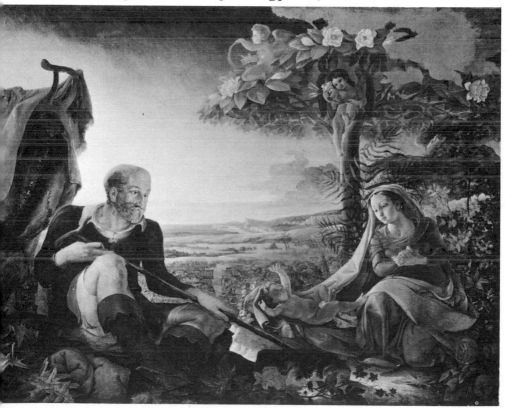

141

(Are you still mindful of that castle on its silent peak?/ The alluring horn sounds there by night as though calling to you,/The deer grazes by the chasm's edge,/The forest is a confused murmuring from the depths –/ O be still, do not wake, it was as though there slept/A nameless pain in the depths below.) Far from conveying a few shared memories directly, the poet whispers to his brother without waking him from his sleep. The brother is probably fortunate to be able to linger in the state of non-remembering, for the distant castle to which memory transports the poet stands on a giddy height above the chasm of time, in which he divines something of the infinite, unutterable sorrow caused by spatial and temporal distance, and the impossible tangle of past emotions. The landscape, though stylized, is a powerful emblem of feeling, all the stronger for the absence of explicit signposts of meaning.

Caspar David Friedrich *Trees in the twilight* c. 1824

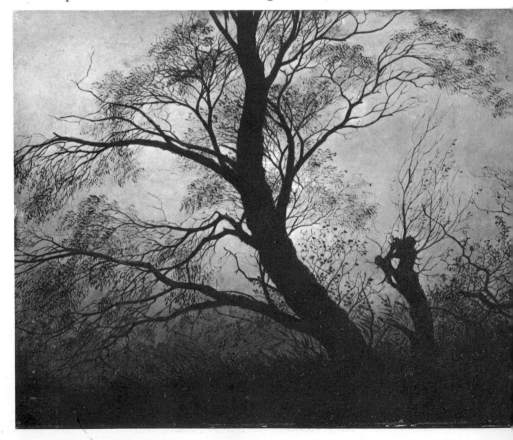

Eichendorff specializes in poems about the forest, the dark whispering world of trees and undergrowth that forms the correlative of his inner yearnings, the perfect place, as Marcel Brion has said, to discover what Novalis calls 'the mysterious path that leads within'. Doubtless because they recover a profound personal experience, Eichendorff's poems on *Waldeinsamkeit*, the half-joyful, half-fearful pleasure of being alone in the forest, create an intensely poetic emotion.

Der Abend

Schweigt der Menschen laute Lust:
Rauscht die Erde wie in Träumen
Wunderbar mit allen Bäumen,
Was dem Herzen kaum bewusst,
Alte Zeiten, linde Trauer,
Und es schweifen leise Schauer
Wetterleuchtend durch die Brust.

(*Evening*/ The loud delights of men fall silent:/ The earth sighs as though in dreams/ Wonderfully with all the trees,/ Things the heart scarcely knows,/ Distant days, tender grief,/And then shudders softly drift/Like summer lightning through one's breast.) Emerging from the shadowy silence, the sighing of the forest is like a dream shared by all men. It is as though at night we gain entry to the collective unconscious, and experience the joys and sufferings, the tenderness and the grief of all ages of humanity. As this dimly-sensed intuition rises up to consciousness, there is a thrill of fear. In such moments, the Romantic spirit senses its affinity with the Unconscious which is Nature, but in yearning for the unifying darkness, the individual still feels terror at the thought of losing his identity.

The poem makes no mention of any particular person, nor of any specific time, any specific grief. Its lack of outline, together with the fluid murmuring of the sounds, creates an impression of indistinct reverie. The vocabulary is a careful balancing of the abstract with the concrete that unfolds a landscape of contemplation in which inner and outer become one, the earth dreams, and summer lightning seems to pass through the physical body. Here it is no longer a question of the poet simply transcribing the surface song. Instead he is rendering things transparent, raising their immanent reality to the higher potency that conduces to transcendence. Yet at this stage of intensity, the revelation seems more than just religious. It takes on a deeper resonance as a note in the collective chord that Romanticism seeks to strike in the imagination of men, a chord which will link them together within the cosmic scheme. Eichendorff would have been a better poet had he struck more often this elusive note which renders man's sense of solitariness yet also his emotional certainty that there is a possibility of turning *Ahnung* into *Gegenwart*, of actualizing the premonition of unity.

Bettina

Born four years before the French Revolution, Bettina experienced the early growth of Romanticism in Germany, being made directly aware of artistic developments through her brother Clemens, her husband Arnim, and her friendship with Goethe; she outlived each of these, as indeed she outlived nearly all the other Romantics, to become an amazingly energetic political writer in her old age. As a young woman, her manner was often an embarrassment to her acquaintances, yet she always shrugged off criticism and remained supremely herself, recognizing no restraints. A pretty girl, she modelled herself on the character Mignon in Goethe's *Wilhelm Meister*. She was capricious, juvenile and erratic, calling on people at odd hours, asking indiscreet questions in an innocent voice, contesting their conventions and prejudices with guileless straightforwardness. Arnim once joked that she was 'half witch, half angel; half seeress, half liar; half child, half actress; half adventuress, half nun; half sleepwalker, half coquette'. But whatever people thought of her, Bettina kept up her childishness long enough for it to mature into an innocent wisdom that was more than mere childish play. Her development was not towards stabilization, but was a search for effective ways to remain flexible, whether in personal relations or in the widest social and political spheres; and in this search, she became perhaps the most remarkable of the Romantics for the virile toughness with which she defended Romantic ideals.

Bettina's mother died when she was eight, and she was educated first in a convent and then at home with her grandmother. It was only in 1798 that she met her brother Clemens, but the relationship was at once an intimate and lively one, as their letters show. Brentano wanted to educate Bettina out of her alarming indiscretions, giving her books to read and getting her to compose verse. He even tried to arrange a match between her and a sober friend called Savigny, who was advancing on the respectable career that was in due course to lead to the post of Prussian Minister of Justice. Bettina, however, would have nothing to do with such a plan and Savigny married her sister instead. In any case, Brentano was only making gestures to try to compensate for his own over-sensitivity and unreliability. Whereas Bettina would declare resolutely, 'I put my trust in the part of myself that wants to kick over the traces,' he was fearful of his own lackadaisical temperament. The stability he gained from marriage to Sophie Mereau lasted for only two years before her premature death, whereupon he sought security in Catholicism, becoming completely estranged from his sister. At the last, he devoted himself to compiling an exhaustive record

Bettina von
Arnim-Brentano
Engraving by
L. E. Grimm
1809

of the heavenly visions of the stigmatized nun Anna Emmerich. For all her capriciousness, Bettina kept her own feet much closer to the ground.

Her intimate friend for some years was a girl five years her elder, Caroline von Günderode, who wrote melancholy poems influenced by Hölderlin and Novalis, pantheist meditations on death and night and a return to primeval unity. When Caroline fell victim to an unhappy love for the theologian Creuzer, who refused to leave his wife for her sake, she calmly went down to the Rhine one night and killed herself with a dagger. Not inclined to wallow in depression, Bettina accepted this death, and that of her grandmother in 1807, and proceeded to look for another figure to fulfil the role of her confidant and spiritual mentor. The person she chose was Goethe's mother, a fine old lady who would talk at length about her son's childhood. Bettina soon made Goethe the object of a devoted hero-worship that seems at first to have flattered him. Goethe was in his late fifties and Bettina twenty-two, and erotic flirtation was certainly a part of their relationship. For the most part, however, it consisted in Bettina's either demanding wisdom from him in a way which nonplussed the respected poet, or else in her trying to bully him into taking an interest in

such subjects as music for which he had little time. Bettina was herself a good singer, could improvise well on guitar and piano, and even composed a little. Like Hoffmann, she was an early admirer of the genius of Beethoven; and she even persuaded Goethe to meet him when they were both staying at the spa of Teplitz. However, the encounter of the two giants was unproductive. Goethe's own Storm and Stress days were long since past, and his present life as courtier, diplomat and Great Poet disposed him to find Beethoven's music far too loud and unsettling for comfort. Besides her interest in music, Bettina drew and modelled in clay; generally, however, she hated organizing her talents, favouring undisciplined prose rather than strict verse. One finds it hard to believe therefore that she had any tastes in common with the master of Classicism. Nonetheless their rather bizarre relationship lasted for several years, settling into an exchange of letters when daily visits were ruled out.

Bettina had known Achim von Arnim for some years, since his first visit to Frankfurt in 1802, and she had helped collect folk-songs for the *Magic Horn*. Though Arnim's temperament was inclined to be reserved and serious, the very opposite of Bettina's openness and volatility, he had sensed a deep affinity with her, and the letters they exchanged over a period of years grew more and more intimate. After they married in 1811, Bettina became a contented wife and mother, though she was too restless to stay forever on the Wiepersdorf estate to which Arnim had moved in 1814. The amicable arrangement was that she should spend as much time as she needed in Berlin, since she thrived on meeting people. For some time Bettina had been trying to renew her friendship with Goethe, though he had openly discouraged her and continued to keep his distance until his death.

After Arnim's death in 1831, Bettina settled permanently in Berlin. Approaching fifty, and having lost all the figures who had played tutor to her skittish pupil, she now embarked on a kind of revision course, going over the different lessons she had received and summing-up what they had taught her and what she had learnt for herself. This process of integrating the past within her present self culminated in a set of books based on the letters she had exchanged with her mentors. The first of these was *Goethe's Correspondence with a Young Child* (*Goethes Briefwechsel mit einem Kinde*), 1835, a rather toned-down version of their actual relationship, which brought Bettina immediate celebrity. She then published *The Günderode Letters* (*Die Günderode*), 1840, and *A Springtime Garland for Clemens Brentano* (*Clemens Brentanos Frühlingskranz*), 1844, each time using original material dating back as much as forty years. If she modified the letters, she saw her new versions not as falsifications but as intensifications of the truth.

Thus it was that through absorption in reminiscences and reflections on her own secret being, as evinced in letters which include free-ranging explorations of events, people, natural scenes, and fantasies, Bettina came

to know herself fully, as though examining herself in a mirror. It turned out that her unruly development had been a process of spontaneous growth like that of a plant – an image she often liked to use. In a letter to Caroline von Günderode she writes, 'Is it not the sole purpose of human nature to learn to engender itself?' Bettina's childish flouting of convention had been only a trivial aspect of an important recognition of the self as something free and organic that must be permitted to grow unencumbered.

Having made these spiritual and psychological discoveries, Bettina was now ready to put them to practical use, directing her energies towards goals lying outside her own private existence. In Berlin she established a salon that became the prime centre for the left-wing intelligentsia of the city. Though still very much a Romantic idealist, Bettina proved through her activities on behalf of the oppressed and the deprived that she was very much above idle reverie. Already in 1831 she had worked as a nurse in the slum areas of the capital during a cholera outbreak. She had expressed enthusiasm for the heroic Tyrolean resistance to Napoleon in 1809, and sided with the Polish insurgents in 1830. On a more personal level, she interceded on behalf of the Grimm brothers to get them posts at the University of Berlin when they were expelled from Göttingen in 1837 for expressing liberal views.

She trusted her political instincts implicitly, reacting at all times not to any formalized doctrine but simply to her immediate emotional picture of a given situation. And since she believed in speaking out about the things that moved her, whom better to address than the highest authority in the land? Having at one time kept up a correspondence with the former Crown Prince, she felt in a position to communicate freely with Frederick William IV now that he was King of Prussia. The King had started his reign by conceding a few liberal reforms, but he seemed to have forgotten all about the constitution that his father had pledged in 1815. To jog his memory, Bettina dedicated a book to him under the bold title *This Book belongs to the King!* (*Dies Buch gehört dem König!*), 1843. Dodging the political censors by the transparent device of expressing her views through an imaginary conversation between Goethe's mother, a Lutheran pastor and a city mayor, Bettina laid out her ideas on kingship and the state. She refused to believe that Prussian despotism was the fault of the King, whom she considered to be essentially a worthy leader; it was the fault of his reactionary advisers, and her book was intended to cut directly across them. Ideally, she argued, the King and his People should form one community, with the King as the wise and attentive guardian of the human rights of each of his subjects. Bettina's plans for a mixture of monarchy and democracy were hardly realistic, when one considers how reactionary Prussia really was at that time, with militarism, rigid discrimination against minorities and the lower orders, censorship of books and mail, and so on. Yet with her unself-

conscious idealism Bettina raised many of the issues that became standard concerns of liberal reformists after 1848. She sharply criticized the arrogant nobility; she campaigned for more flexible divorce laws; she protested against censorship, and put forward a very modern argument about crime, insisting that it is the State's responsibility not merely to punish the criminal in order to protect the status quo, but to change the social conditions that lead to crime. The book contains an important appendix in which Bettina gives an objective account of the appalling conditions in the Berlin slums; she lists names and addresses, numbers in a family, weekly income, degree of malnutrition, etc., basing her documentation on information gained personally during the cholera epidemic, and on facts gathered by a Swiss friend. In its Orwellian mode of presentation this is a good example of what Richard Benz has called Bettina's 'applied Romanticism', a version of the Heidelberg dream of participating in the *Volksseele* (popular spirit). Bettina also gathered material for a documentary *Book about the Poor* (*Das Armenbuch*), with contributions from her many left-wing contacts, which made its points on the basis of telling statistics. But, anticipating that the censor would pounce on this at once, she abandoned the project.*

Turning to more practical questions, Bettina tried to persuade the King to take a lenient view of the uprising of starving Silesian weavers in 1844; in 1846 she appealed to him to pardon the Polish revolutionary Mieroslavski, and in 1849 the poet Kinkel, sentenced to death for his part in the 1848 events. In 1850 she wrote one of her rare poems in honour of the Hungarian poet and freedom fighter Alexander Petöfi, a victim of the brutal suppression of the Hungarian army by Austrian and Prussian forces in 1849. One of her most forthright pieces of writing was a pamphlet on the Polish problem, issued under a pseudonym in 1848 and calling for an investigation of certain atrocities committed by the Prussian army in Poland, and for positive moves towards recognizing the Polish territories not as a Prussian colony but as an independent state. Her last book, *Conversation with Demons* (*Gespräche mit Dämonen*), 1852, expresses her ideas on the Jewish problem, free speech, and a number of social reforms, by way of another imaginary dialogue in which a spirit of good whispers advice in the ear of the sleeping King – the implication being that only in his bed does the monarch escape the clutches of his evil ministers.

In all these interventions, Bettina was principally concerned with simple humanitarian feeling, not with the complexities of politics in the usual sense. Her beliefs can be broadly categorized: anti-militarism; anti-exploitation of the proletariat; penal reform; abolition of censorship; equal rights for all members of the community, and so on. But she never liked to classify her ideas, never joined a party, and rarely even read the newspapers. Her

* *Bettina von Arnims Armenbuch* was eventually published in 1969 in an edition by Werner Vordtriede.

politics were those of the emotions and all the slogans she needed were those of the French Revolution that she had learnt as a child. Avoiding any confrontation with separate government bodies, she tried to influence the royal conscience directly and from time to time she succeeded in achieving concrete results. Admittedly she enjoyed a certain immunity because of her noble background (though she never flaunted this) and because Savigny, the Minister of Justice, was her brother-in-law. But Savigny had no sympathy for her ideas at all, and there is no doubt that in the Prussia of the fifties she often came close to the limits of official tolerance. A tenaciously militant Romantic as well as an independent individualist, Bettina is the refutation of any charge that German Romanticism necessarily implies introspection and retrogression. Her greatest achievement lies in having put the case for the viability of dreams in its least tentative form. Men must learn to build upon their fantasies, for only through imaginative self-reliance can there be progress. 'Is it not the sole purpose of human nature to learn to engender itself?' In applying the 'magic idealism' of Novalis to social issues, Bettina discovered a 'magic realism' which also represents a force for the Romanticization of the world.

Postscript

Träume sind Schäume – dreams are just empty froth! scoffs the poet's father when Heinrich von Ofterdingen tries to persuade him that dreams have an intrinsically meaningful content. Many critics have dismissed the ideas of Romanticism in very much the same manner, insisting that the movement was no more than a capricious flight from reality, an illusion without substance. At best, they contend, its products may be tolerated as entertainments, provided it is understood that they have nothing whatsoever to say about the real problems of life. Such a dismissive attitude is, I would suggest, foolish and uncreative, for it effectively censors the Romantic message. Of course, Romanticism gave rise to a good deal of froth that we would be wrong to swallow uncritically. Religious transcendentalism and nationalism, for instance, are no longer palatable solutions. Yet, at a distance of a century and a half, it would be pitifully unproductive to condemn those of the Romantics who succumbed to the easy options available in their particular age; we cannot be sure that we are ourselves immune to similar temptations in whatever guise they adopt in our own century. The productive approach must surely be one that takes account of the deeper implications of Romanticism, rather than of surface deficiencies which were often strictly determined by particular cultural and historical circumstances. For, transcending the limits of its specific context, Romanticism initiated certain ideas which are of genuinely lasting import. One of these is the intuition that imagination and reality can be reciprocally illuminating. Against all empiricist caution and rational dissent, the poets, scientists and philosophers of the Romantic age placed their faith in reverie and speculation as media of insight into the mysteries of Nature and Man. We ought likewise to envisage dreams not as empty froth but as streams which, springing from the deepest levels of the psyche, are powerful enough to introduce a magical fluidity into the apparently rigid circumstances of existence.

'World becomes dream, dream becomes world' is the utopian equation posited by Novalis. How literally do we dare take such a proposition? The creative posture before such statements must, I feel, be one which is prepared to admit either a literal or a figurative reading, in such a way as to maximize the potential for insight at any given moment. Is there not a very real stimulus to be gained from reading Arnim's statement that 'we are all sleepwalkers in broad daylight' as literal truth? Conversely, if it is ridiculous to suggest that all Romantic ideas should be taken literally, there is no doubt that they have deep affective import for us as elements in a vast allegory about the role of the creative imagination in life. Despite all

allegations of escapism, the Romantics deserve full credit for their exemplary opposition to that philistine mentality which seeks to oppose poetry to provable truth, to stifle speculation in the name of fact, and to quell the freedom of the subject in the name of a faceless objectivity. The ultimate Romantic lesson is of permanent relevance in both artistic, political and moral terms: it is that not only is imagination worth taking seriously, it offers the only final guarantee of human freedom.

Acknowledgements

I wish to thank the many archives and museums which have made possible the illustration of this book: specific indications of sources are given in the list below. I am especially grateful for the kind response I received from Professor Gerhard Schulz and Professor Ernst Behler. I would also like to thank Mrs M. H. Windle and Miss Dora Musi for helping me with correspondence and typing; Mr Jim Styles for photographic work; and Mr Peter Bridgecross and Mrs Anne Kilborn for reading through the manuscript and offering numerous wise suggestions.

Illustrations

Archiv für Kunst und Geschichte, Berlin, 97; Ernst Behler, 49; Brüder-Grimm-Museum, Kassel, 26; Deutsche Staatsbibliothek, Berlin East, 95; Eichendorff-Archiv, Wangel/Allgäu, 134; Freies Deutsches Hochstift Frankfurter Goethemuseum, 66, 118; Gemäldegalerie Dresden, 17 (photo courtesy Deutsche Fotothek, Dresden); Goethe-Museum, Düsseldorf, 145; Collection I.K.H. Prinzessin Ludwig von Hessen und bei Rhein, Schloss Wolfsgarten, 106 (photo courtesy of Arts Council of Great Britain); Kunsthalle, Hamburg, 29, 32, 71, 141; Kunsthistorisches Museum, Vienna, 101; Kunstmuseum, Düsseldorf, 128; Kupferstichkabinett, Basle, 129; Kupferstichkabinett, Dresden, 126; Kurpfälzisches Museum, Heidelberg, 103, 120, 135; Library of Congress, Washington, 115; Sigbert Mohn Verlag, 31 (from Chamisso *Werke*); Museum Folkwang, Essen, 74; Museum für Geschichte der Stadt Leipzig, 19; Národní Galerie, Prague, 40; Nationalgalerie, Berlin, 30 (photo Walter Steinkopf), 92; Nationalgalerie, Staatliche Museen Preussischer Kulturbesitz, Berlin West, 77 (photo Walter Steinkopf); Oskar Reinhart Foundation, Winterthur, 69, 75, 104; Österreichische Galerie, Vienna, 34; Österreichische Nationalbibliothek, Vienna, 140 (photo Alpenland Vienna); Robert-Schumann-Haus, Zwickau, 21, 109; Rowohlt Verlag, 16 (photo collection Gerhard Schulz); Schiller-Nationalmuseum, Marbach, 79; Gerhard Schulz, 86; Staatliche Kunsthalle, Karlsruhe, 39; Staatliche Kunstsammlungen, Dresden, 64; Staatliche Museen zu Berlin, 47; Staatliche Schlösser und Gärten, Berlin, Schloss Charlottenburg, 72, 76 (photos Walter Steinkopf); Staatsbibliothek, Berlin, 54; Städelsches Kunstinstitut, Frankfurt, 83, 105; Stadtmuseum, Jena, 53; Wallraf-Richartz-Museum, Cologne, 142 (photo Rheinisches Bildarchiv); Weissenfels Museum, 61 (photo courtesy Gerhard Schulz); Winkler-Verlag, Munich, 98.

Select Bibliography

Works by German Romantics

GERMAN TEXTS

This is a list of collected works in modern editions, with just a few works listed singly. Many of the more popular Romantic works are available separately in these inexpensive paperback series: Reclams Universalbibliothek, Rowohlts Klassiker and Goldmanns Gelbe Taschenbücher.

Arnim, A. von *Sämtliche Romane und Erzählungen* Hanser, Munich 1962–5
Arnim, A. von and Brentano, C., eds *Des Knaben Wunderhorn* Winkler, Munich 1964. *Zeitung für Einsiedler* Cotta, Stuttgart 1962
Arnim, Bettina von *Werke und Briefe* Bartmann, Cologne 1959–61. *Bettina von Arnims Armenbuch* Frankfurt 1969
Baader, F. X. von *Sämtliche Werke* Scientia, Aalen 1963
Brentano, C. *Werke* Hoffmann & Campe, Hamburg n.d.
Carus, C. G. *Briefe über Landschaftsmalerei* Lambert Schneider, Heidelberg 1972. *Psyche* Wissenschaftliche Buchgesellschaft, Darmstadt 1964
Chamisso, A. von *Gesammelte Werke* Sigbert Mohn, Gütersloh 1964
Eichendorff, J. F. von *Werke* Hanser, Munich 1971
Fichte, J. G. *Sämtliche Werke* De Gruyter, Berlin 1965–6
Fouqué, F. H. K. de la Motte *Undine* Nelson, London/Edinburgh 1956
Friedrich, C. D. *Caspar David Friedrich in Briefen und Bekenntnissen* Henschel, Berlin 1968
Grimm, J. *Deutsche Mythologie* Wissenschaftliche Buchgesellschaft, Darmstadt 1953
Günderode, C. von *Gesammelte Werke* Herbert Lang, Bern 1970
Hauff, W. *Werke* Cotta, Stuttgart 1961–2
Heine, H. *Werke* Hoffmann & Campe, Hamburg 1956
Hoffmann, E. T. A. *Poetische Werke* De Gruyter, Berlin 1957–62
Kleist, H. von *Werke* Hanser, Munich 1966
Moritz, K. P. *Anton Reiser* Reclam, Stuttgart 1972
Novalis *Werke und Briefe* Winkler, Munich 1962
Richter, J. P. (Jean Paul) *Werke* Hanser, Munich 1967–71
Ritter, J. W. *Fragmente aus dem Nachlasse eines jungen Physikers* Lambert Schneider, Heidelberg 1969
Runge, P. O. *Hinterlassene Schriften* Vandenhoeck & Ruprecht, Göttingen/Zürich 1965
Schelling, F. W. von *Schelling-Studienausgabe* Wissenschaftliche Buchgesellschaft, Darmstadt 1966–8

Schlegel, F. *Schriften und Fragmente* Kröner, Stuttgart 1956. *Literary Notebooks 1797–1801* Athlone Press, London 1957
Schlegel, F. and A. W., eds *Athenaeum* Cotta, Stuttgart 1963
Schlegel, F. and Novalis *Biographie einer Romantikerfreundschaft in ihren Briefen* Gentner, Darmstadt 1957
Schubert, G. H. *Ansichten von der Nachtseite der Naturwissenschaften* Wissenschaftliche Buchgesellschaft, Darmstadt 1967. *Die Symbolik des Traumes* Lambert Schneider, Heidelberg 1968
Tieck, L. *Werke* Hoffmann & Campe, Hamburg 1967
Uhland, L. *Dichtungen, Briefe, Reden* Steinkopf, Stuttgart 1963
Wackenroder, W. H. *Werke und Briefe* Lambert Schneider, Heidelberg 1967
Werner, Z. *Dramen* Wissenschaftliche Buchgesellschaft, Darmstadt 1964

TEXTS IN ENGLISH TRANSLATION

The following by no means reflects a choice of the most significant Romantic texts – many authors, such as Arnim, seem never to have been translated – but is a selection of works available to the English reader.

Bonaventura *Nightwatches* tr. G. Gillespie, Edinburgh University Press, Edinburgh 1972
Brentano, C. *Schoolmaster Whackwell's Wonderful Sons* Random House, New York 1962
Chamisso, A. von *Peter Schlemihl* tr. L. von L. Wertheim, Calder, London 1970
Eichendorff, J. F. von *Memoirs of a Good-for-Nothing* tr. R. Taylor, Calder, London 1966
Fichte, J. G. *The Science of Knowledge* Appleton, New York 1969. *The Vocation of Man* Bobbs-Merrill, New York 1956. *Addresses to the German Nation* tr. R. F. Jones and G. H. Turnbull, Harper & Row, New York 1968
Grimm, J. and W. eds *Fairy Tales* tr. E. Taylor, Penguin, Harmondsworth 1971
Hauff, W. *Fairy Tales* tr. J. Emerson and others, Cape, London 1971
Heine, H. *Prose and Poetry* Dent, London 1961. *Selected Verse* tr. P. Branscombe, Penguin, Harmondsworth 1968. *The North Sea* tr. V. Watkins, Faber, London 1955
Hoffmann, E. T. A. *The Tales of Hoffmann* tr. M. Bullock, Ungar, New York 1963. *Tales of Hoffmann* tr. J. Kirkup, Blackie, London 1966. *The Devil's Elixirs* tr. R. Taylor, Calder, London 1963. *The King's Bride* tr. P. Turner, Calder, London 1959
Kleist, H. von 'The Marionette Theatre' tr. D. Gifford in M. Armitage *Five Essays on Klee* Duell Sloan & Pearce, New York 1950. *The Prince of Homburg* tr. C. E. Passage, Bobbs-Merrill, New York 1956
Novalis *Hymns to the Night and Selected Writings* Bobbs-Merrill, New York 1960. *The Novices of Sais* tr. R. Manheim, Valentin, New York 1949. *Henry von Ofterdingen* tr. P. Hilty, Ungar, New York
Schelling, F. W. J. von 'Concerning the relation of the plastic arts to nature' tr. M. Bullock in H. Read *The True Voice of Feeling* Faber, London 1953

Schlegel, F. *Lucinde and Fragments* tr. P. Firchow, University of Minnesota Press, Minneapolis 1972. *Dialogue on Poetry and Literary Aphorisms* tr. E. Behler and R. Struc, Pennsylvania State University Press, University Park 1968
Schleiermacher, F. *On Religion* tr. T. N. Tice, John Knox Press, Richmond 1969
Schumann, R. *On Music and Musicians* Norton Library, New York 1969
Wackenroder, W. H. *Confessions and Fantasies* tr. M. H. Schubert, Pennsylvania State University Press, University Park 1972

Other Works

Bauer, F. *Caspar David Friedrich – ein Maler der Romantik* Stuttgart 1961
Béguin, A. *L'Ame romantique et le rêve* Corti, Paris 1963
Béguin, A. ed. *Le Romantisme allemand* Bibliothèque 10–18, Paris 1966
Behler, E. *Friedrich Schlegel* Rowohlt, Hamburg 1966
Benz, R. *Die deutsche Romantik. Geschichte einer geistigen Bewegung* Reclam, Stuttgart 1956
Benz, R. ed. *Lebenswelt der Romantik* Nymphenburger Verlagshandlung, Munich 1948
Berman, A. 'Lettres à Fouad El-Etr sur le Romantisme allemand' in *La Délirante* No. 3, 1968
Besset, M. *Novalis et la pensée mystique* Editions Montaigne, Paris 1947
Bianquis, G. *Amours en Allemagne à l'époque romantique* Hachette, Paris 1961
Bietak, W. ed. *Romantische Wissenschaft* Wissenschaftliche Buchgesellschaft, Darmstadt 1966
Brion, M. *Robert Schumann et l'Ame romantique* Albin Michel, Paris 1954. *L'Allemagne romantique* Albin Michel, Paris 1962–3. *Peinture romantique* Albin Michel, Paris 1967
Buchwald, E. *Naturschau mit Goethe* Kohlhammer, Stuttgart 1960
Chissell, J. *Schumann Piano Music* BBC Publications, London 1972
Cooper, M. *Ideas and Music* Barrie & Rockliff, London 1965
Copleston, F. *A History of Philosophy* Vol. 7 'Fichte to Nietzsche' Burns & Oates, London 1963
Eichner, H. *Friedrich Schlegel* Twayne, New York 1970
Eismann, G. *Robert Schumann – a Biography in Word and Picture* Veb Edition, Leipzig 1964
Emmrich, I. *Caspar David Friedrich* Weimar 1964
Faber, R. *Novalis: die Phantasie an die Macht* J. B. Metzler, Stuttgart 1970
Furst, L. R. *Romanticism in perspective* Macmillan, London 1969
Gode-von Aesch, A. *Natural Science in German Romanticism* Ams Press, New York 1966
Grimm, R. *et al. Romantik heute* Inter Nationes, Bonn/Bad Godesberg 1972
Grundmann, G. *Das Riesengebirge in der Malerei der Romantik* Munich 1958
Gundolf, F. *Romantiker* Heinrich Keller, Berlin 1930–1
Hartmann, N. *Die Philosophie des deutschen Idealismus* De Gruyter, Berlin 1960
Haywood, B. *Novalis: the Veil of Imagery* Mouton, The Hague 1959
Helps, A. and Howard, E. J. *Bettina: a portrait* Chatto & Windus, London 1957

Huch, R. *Die Romantik – Ausbreitung, Blütezeit und Verfall* Rainer Wunderlich, Tübingen 1951

Jaspers, K. *Schelling: Grösse und Verhängnis* R. Piper, Munich 1955

Kluckhohn, P. *Das Ideengut der deutschen Romantik* M. Niemeyer, Tübingen 1966

Köhler, W. *Joseph von Eichendorff* Oberschlesischer Heimatverlag, Augsburg 1957

Korff, H. A. *Geist der Goethezeit* Koehler & Amelang, Leipzig 1949–57

Lion, F. *Romantik als deutsches Schicksal* Kohlhammer, Stuttgart 1963

Lohmeyer, K. *Heidelberger Maler der Romantik* Heidelberg 1935

Negus, K. *E. T. A. Hoffmann's Other World* Pennsylvania University Press, Philadelphia 1965

Nemitz, F. *Caspar David Friedrich – die unendliche Landschaft* Munich 1949

Neubauer, J. *Bifocal Vision – Novalis' Philosophy of Nature and Disease* University of North Carolina Press, Chapel Hill 1971

Piana, T. *E. T. A. Hoffmann als bildender Künstler* Berlin 1954

Prang, H. *Die romantische Ironie* Wissenschaftliche Buchgesellschaft, Darmstadt 1972

Prause, M. *Carl Gustav Carus – Leben und Werk* Deutscher Verein für Kunstwissenschaft, Berlin 1968

Prawer, S. ed. *The Romantic Period in Germany* Weidenfeld & Nicolson, London 1970

Ritter, H. *Der unbekannte Novalis* Sachse & Pohl, Göttingen 1967

Ritterbush, P. C. *The Art of Organic Forms* Smithsonian Institution Press, Washington 1968

Rudolph, G. *Studien zur dichterischen Welt Achim von Arnims* De Gruyter, Berlin 1958

Sams, E. *The Songs of Robert Schumann* Methuen, London 1969

Schanze, H. ed. *Die andere Romantik. Eine Dokumentation* Insel Verlag, Frankfurt 1967

Schrade, H. *Deutsche Maler der Romantik* Du Mont Schauberg, Cologne 1967

Schulz, G. *Novalis* Rowohlt, Hamburg 1969

Schwarzweller, K. et al. *Karl Philipp Fohr 1795–1818* Städelsches Kunstinstitut, Frankfurt 1968

Seidel, I. *Drei Dichter der Romantik* Deutsche Verlags-Anstalt, Stuttgart 1944

Stahl, E. L. and Yuill, W. E. *German Literature of the Eighteenth and Nineteenth Centuries* Cresset Press, London 1970

Steffen, H. ed. *Die deutsche Romantik: Poetik, Formen und Motive* Vandenhoeck & Ruprecht, Göttingen 1967

Stöcklein, P. ed. *Eichendorff heute* Wissenschaftliche Buchgesellschaft, Darmstadt 1966

Talmon, J. L. *Romanticism and Revolt. Europe 1815–1848* Thames & Hudson, London 1967

Taylor, R. *Hoffmann* Bowes & Bowes, London 1963

Taylor, R. ed. *The Romantic Tradition in Germany* Methuen, London 1970

Thalmann, M. *Zeichensprache der Romantik* Lothar Stiehm, Heidelberg 1967. *Romantiker als Poetologen* Lothar Stiehm, Heidelberg 1970

Vaughan, W. et al. *Caspar David Friedrich 1774–1840* Tate Gallery, London 1972

Wiese, B. von ed. *Deutsche Dichter der Romantik* Erich Schmidt, Berlin 1971

Index

Numbers in italics refer to illustrations